SHOOT WHAT
YOU LOVE

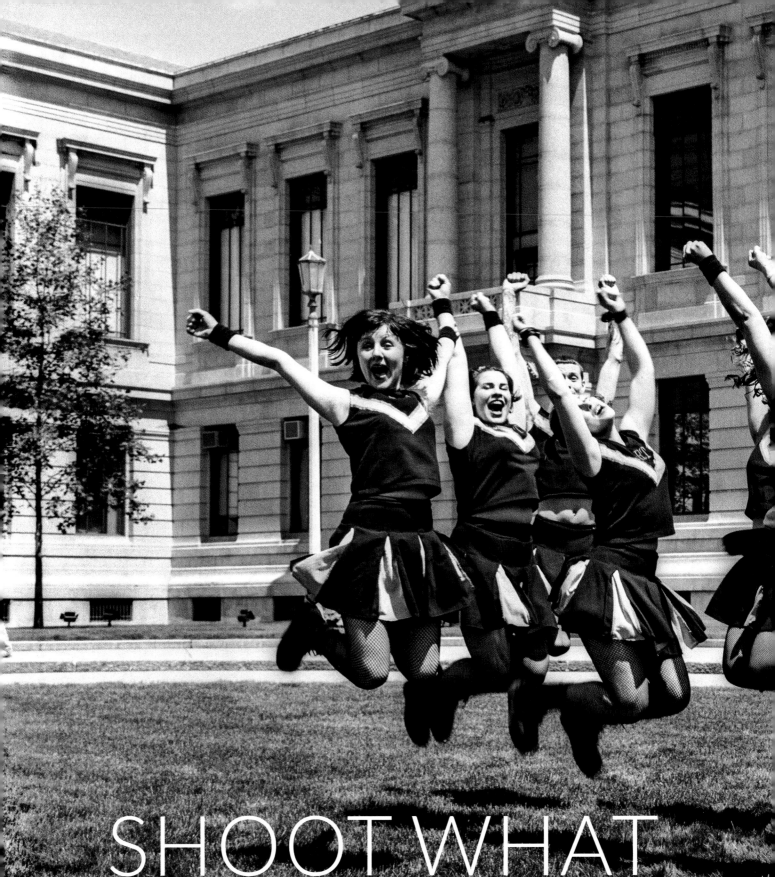

SHOOT WHAT
YOU LOVE

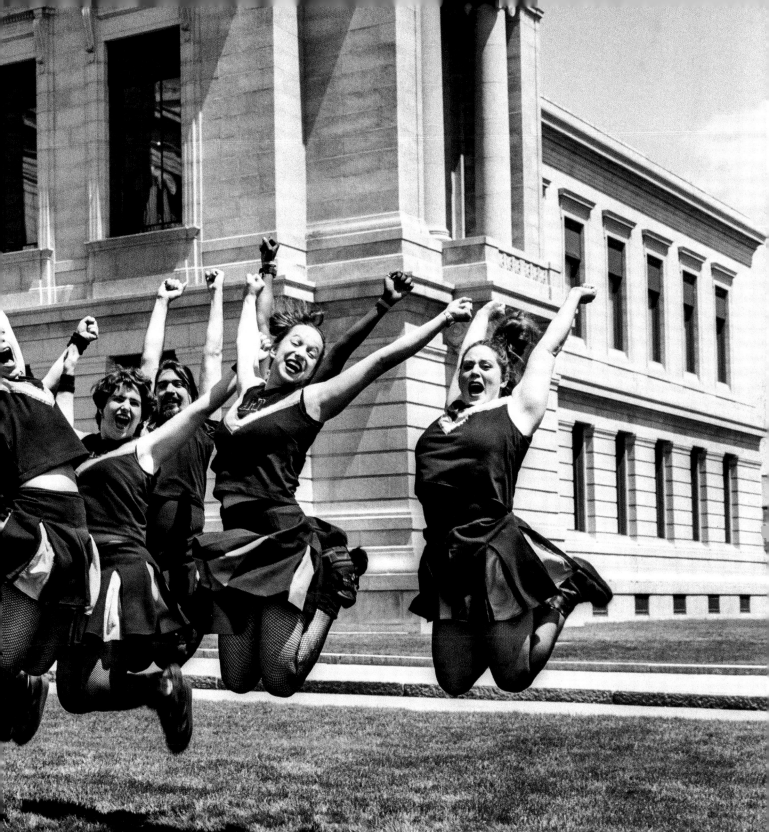

TIPS AND TALES FROM A WORKING PHOTOGRAPHER
HENRY HORENSTEIN

MONACELLI STUDIO

FOR ERNESTO APARICIO,
WITH THANKS

Copyright © 2016 Henry Horenstein and
THE MONACELLI PRESS

Photographs and illustrations copyright © 2016 Henry Horenstein,
unless otherwise noted
Text copyright © 2016 Henry Horenstein

Published in the United States by MONACELLI STUDIO,
an imprint of THE MONACELLI PRESS

Library of Congress Cataloging-in-Publication Data

Names: Horenstein, Henry, author.
Title: Shoot what you love : tips and tales from a working
photographer / Henry Horenstein.
Description: First American edition. | New York, NY :
Monacelli Press, [2016]
Identifiers: LCCN 2016025519 | ISBN 9781580934558
Subjects: LCSH: Photography.
Classification: LCC TR146 .H7933 2016 | DDC 770--dc23
LC record available at https://lccn.loc.gov/2016025519

ISBN 978-1-58093-455-8

Printed in Singapore

DESIGN BY JENNIFER K. BEAL DAVIS
COVER DESIGN BY JENNIFER K. BEAL DAVIS
COVER PHOTOGRAPHS BY HENRY HORENSTEIN

10 9 8 7 6 5 4 3 2 1

First Edition

MONACELLI STUDIO
THE MONACELLI PRESS
236 West 27th Street
New York, New York 10001

www.monacellipress.com

PAGE 1: *Bottlenose Dolphin,* Tursiops Truncatus, 2003

PAGES 2–3: *Art Cheerleaders, Museum of Fine Arts, Boston,* 2005

OPPOSITE: *Hillside Houses, Pikeville, Kentucky,* 1974

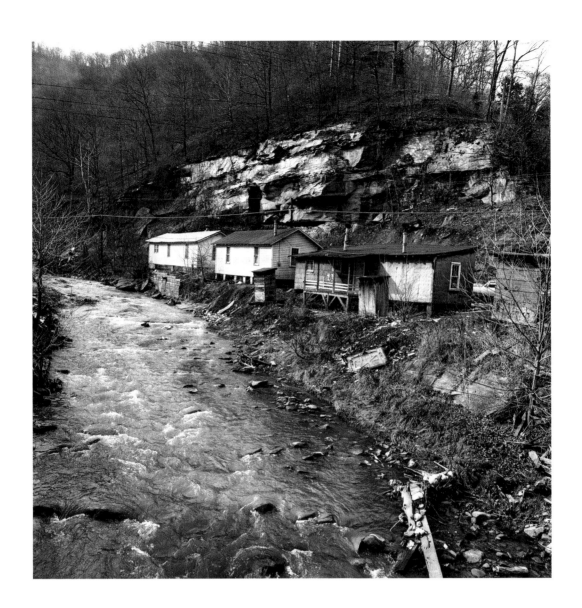

Life ain't easy getting through.

Everybody's gonna make things tough on you.

But I can tell you right now if you dig what you do,

they will never get you down.

TODD SNIDER, FOLK SINGER

* * *

Storytelling defined: a way of writing that is distinctly unmodern.

GRANTA 21

CONTENTS

OPPOSITE: *Helen Pontani and Peekaboo Pointe, This Was Burlesque, New York, 2008*

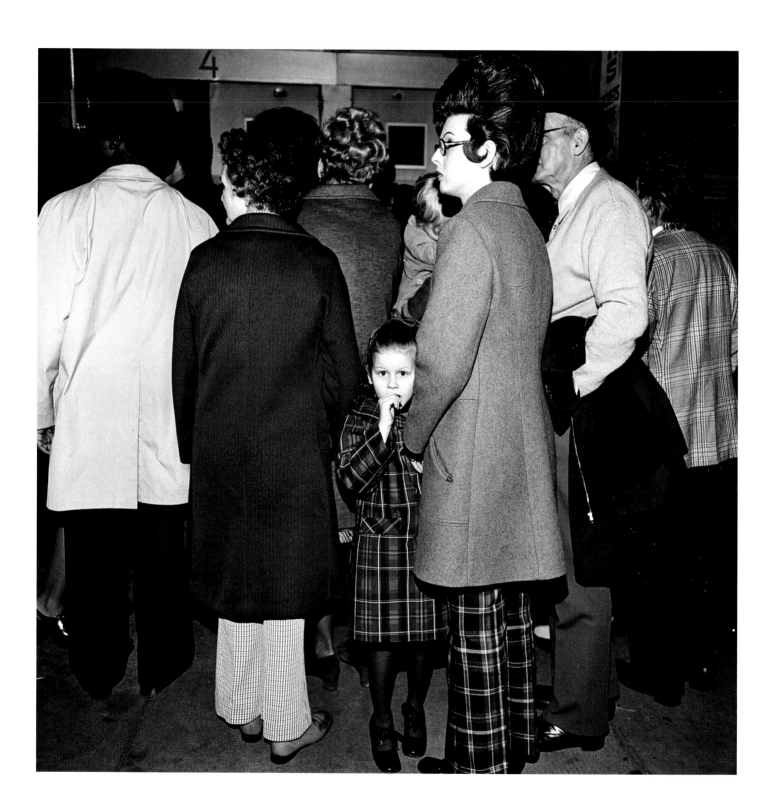

ARTIST STATEMENT

Over the years I've photographed many different types of subjects, even animals and the human form. But I've always returned to my roots as a documentary photographer. More than anything, I like a good story. And I try to tell one in a direct way, with humor and a punch line, if possible. With this in mind, I have photographed country musicians in Nashville, my family and friends in Massachusetts, horse racing at Saratoga Springs, nightlife in Caracas, old highways everywhere, everyone in Cajun Louisiana, South American baseball, tri-racial families in Maryland, and much, much more.

For subjects, I prefer older cultures and places, especially disappearing ones. That's what my history teachers, Jesse Lemisch (at University of Chicago) and E. P. Thompson (at University of Warwick), taught me. These cultures and places might vanish, but it is a historian's righteous duty to make sure that they leave a trace. I also was very influenced by another teacher in Chicago, John G. Cawelti, who taught me that popular culture should be taken seriously. One other great influence was my teacher at Rhode Island School of Design, Harry Callahan. Harry encouraged me to "shoot what you love," and to pay no attention to what others are doing. Thank you for that, Harry.

* * *

The above was written for a book I published called *Close Relations*. It was my first artist statement, and I wrote it reluctantly. When I was a student, even artists rarely had artist statements and photographers definitely didn't. Maybe that was because we weren't considered artists back then. That recognition came later, and it was good news and bad. Good that our status was heightened and bad that we had to come up with

OPPOSITE: *Waiting in Line, Grand Ole Opry at Ryman Auditorium, Nashville,* 1974

something insightful to say about the photographs. It was so much easier just to say "that works" or to look thoughtful and mumble something unintelligible, hoping that no one would press you on it.

Anyway, the first time I had to produce an artist statement was when I published my photographs in a book I called *Animalia*. The day had clearly passed when I could just say "I like animals and decided to take a few pictures. Here are some of my favorites."

So, I did the expedient thing and hired Tom Gearty, then a graduate student at Massachusetts College of Art, to write an artist statement. By then photography students were writing artist statements before they even had any art. Tom was an ace writer and made me look good. Turns out my work is a whole lot deeper and more meaningful than I ever thought it was.

I'm quite used to writing my own artist statements now. I even like doing it. It's a useful way to get clarity for yourself and explain to others what you've been up to. And people seem to want to hear this. In fact, you could view this entire book as an artist statement of sorts.

I think a good artist statement is straightforward and explains rather than confuses. Keep the Art Speak to a minimum. Let's say we sit down over a cup of coffee and I discover you're a photographer. I might say:

"What kind of work do you do and what's it about?"

And you might say:

"I take photographs of (blank) that try to show (blank). I'm interested in the subject because (blank). In making the work I was influenced by photographers who work in a similar style and whose interest in (blank) reverberates with me strongly. Namely (blank). I hope that the work will make viewers feel (blank). Fill in the blanks and provide details. Something like that.

OPPOSITE: *Abandoned Car, Highway 1, Marksville, Louisiana, 2008*

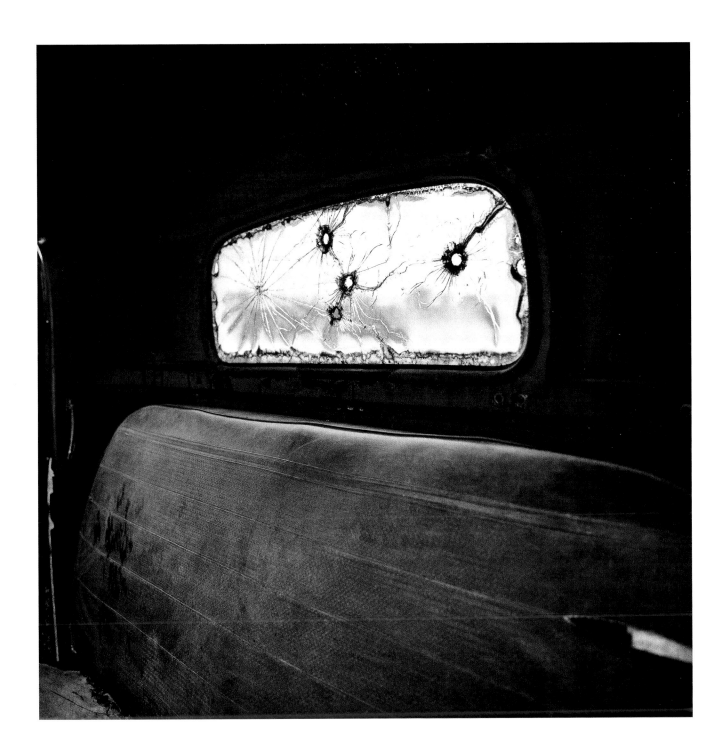

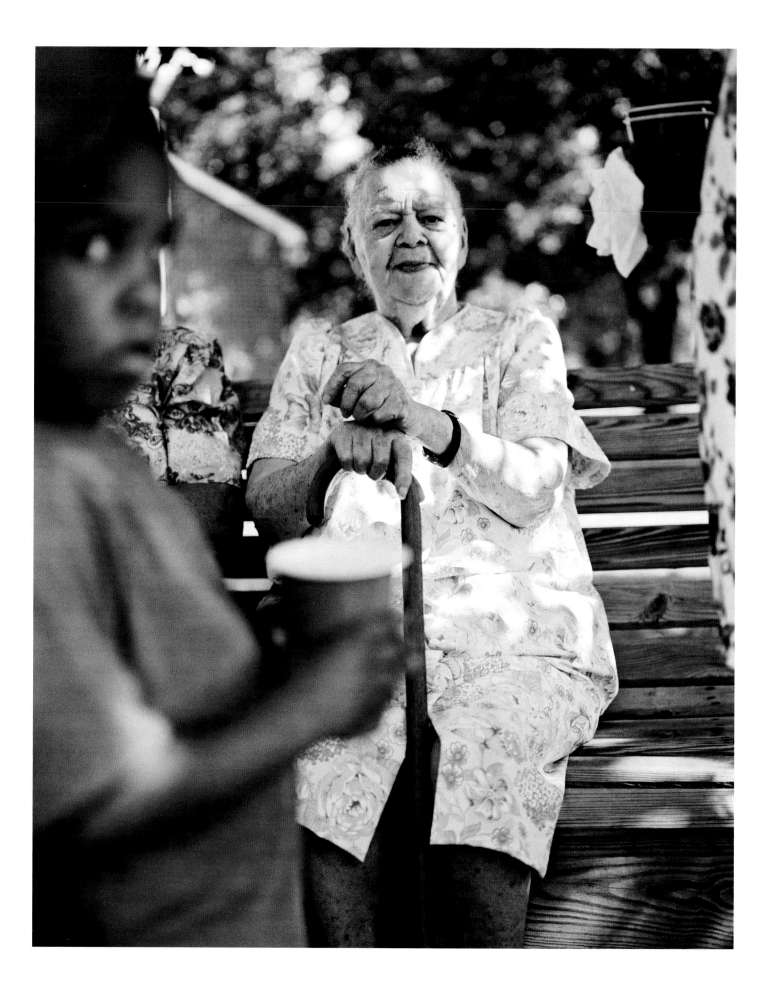

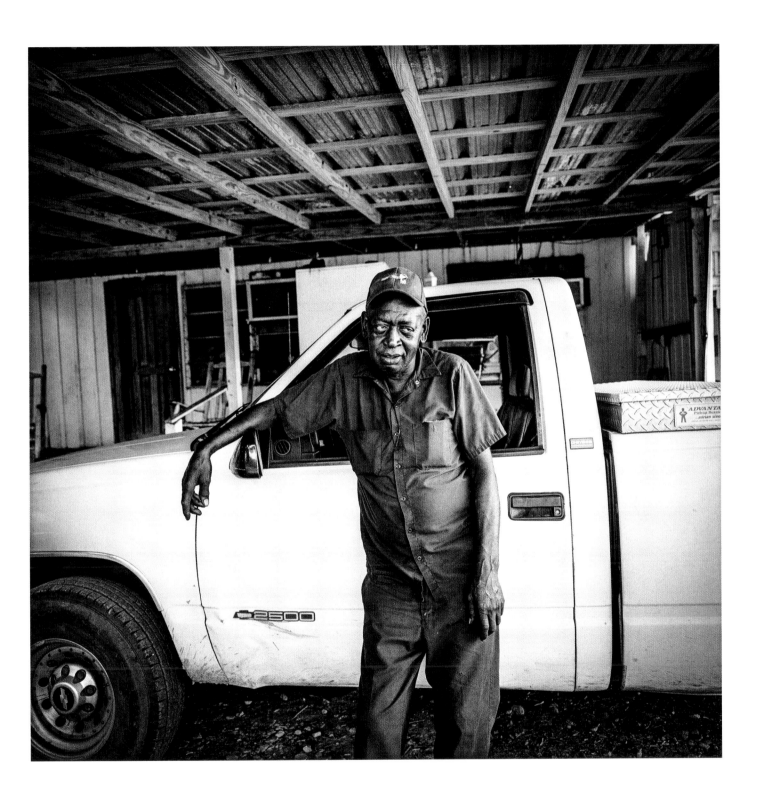

OPPOSITE: *Lonie at Church Picnic, St. Thomas Manor,
founded 1641, Port Tobacco, Maryland, 1998*

ABOVE: *Shade Tree Mechanic, Marksville, Louisiana, 2008*

OVERLEAF: *Photographer, Carol's Pub, Chicago, 2013*

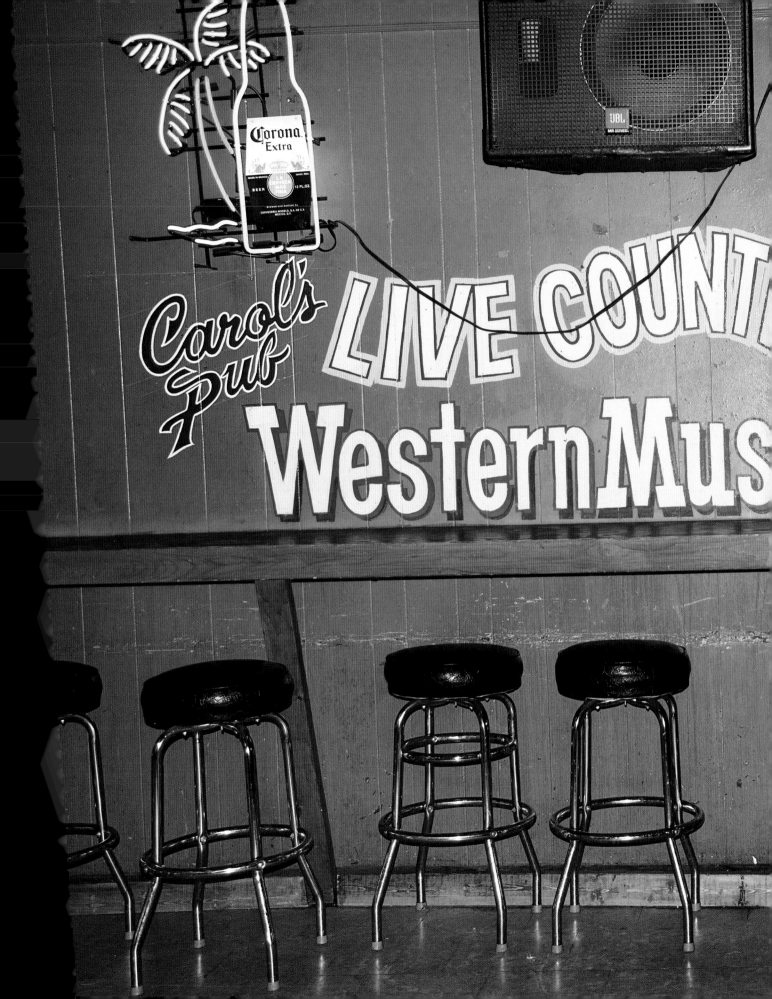

NEW BEDFORD

New Bedford, Massachusetts, is a little city with a lot of history. Herman Melville shipped out of there on the *Acushnet* in 1841, the one time he actually made a whaling voyage. And why not? New Bedford was the largest whaling port in the world, until oil was discovered underground. That was 1859 in Titusville, Pennsylvania—the beginning of the end for New Bedford as a world-class city. Whaling was the fifth-largest industry in the United States in 1850, and ten years later it was on its way out.

Later in the century, however, New Bedford made a comeback. The Industrial Revolution came full bore to the United States and found a home in many New England cities and towns, which offered somewhat-educated workers, banking services, and water to power the factories and ship the goods. Textiles. Shoes. And the like.

When I was born in 1947, New Bedford was doing all right—a bustling mill town with a blue-collar population numbering just under 100,000. The mills provided employment, tax money, and plenty of soot. Though it wasn't exactly prosperous, the town was getting by. But it was an illusion. In the 1930s Northern factories started moving their operations south to states that were less union friendly, and by the mid-1950s the deal was all but sealed. The city's fortunes began to slide downhill.

The New Bedford I grew up in was still an active factory town and far from a center of culture and the arts. The connection with photography was almost nonexistent. Lewis Hine, one of my early photo heroes, made a lot of great pictures of New Bedford mills and workers in the early twentieth century. Converse Photo Supply at 10 North Sixth Street opened in 1932 and closed its doors only recently—eighty-two years later. And one of the last large New Bedford factories to shut down was a Polaroid plant that made the negative for their instant materials until 2007. Kodak had formerly made the negative for Polaroid, but they stole the patent and made a copycat instant-film product for a while. The courts closed them down in 1990, awarding Polaroid close to one billion dollars. New Bedford got to host what must have been a toxic manufacturing process, until Polaroid declared bankruptcy and put their workers out of a job and out of a pension.

In New Bedford I got to know a good local folk singer. His name was Paul Clayton and he collected and sang the songs of the whalers; you can still find his music on Smithsonian/Folkways Records. When Paul wasn't in Greenwich Village, hanging with the likes of Bob Dylan, he could be found on Union Street at the Melody Shop, our local record store. There, he picked out an LP for me to buy with my first allowance at age nine. *Johnny Cash Sings Hank Williams* on Sun Records. I still play that LP. I mean vinyl.

Dad was a salesman, employed by Self-Service Shoe Store. Why they needed employees when they were self-service remains a mystery. Dad was a natural storyteller. His favorite was about selling a lady two leftover, left-foot shoes. That always got a howl. He started selling mutual funds at night, and he was very good at it.

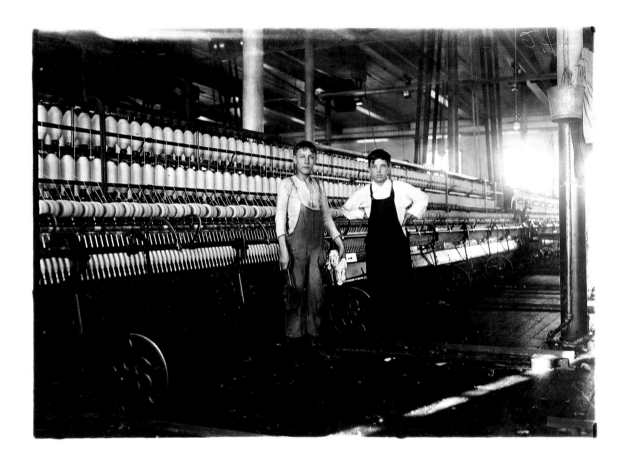

He began to make real money when I was about twelve, quitting his self-service job. Turns out he wasn't needed there after all.

Later in life, as his fortunes improved, his stories became grander. Once he sued Gulf Oil and won. Part of the settlement was that he could never sue them again. "But that doesn't mean Doris can't," I can still hear him saying. Over and over. Doris was my mom.

What I didn't learn about storytelling from my dad I learned at the racetrack, where good stories are easier to come by than good horses. The people I met and the tales they told could fill a book. In fact, they did—my first book of photographs, called *Racing Days.* My coauthor, Brendan Boyd, wrote the stories down, but I've chosen to make them my own moving forward. Hardly anyone bought the book anyway.

That's the other thing that I love about stories. They aren't really owned by anyone. That's where folktales, myths, and even the Bible come in. If you read or see anything you like here, feel free to borrow or adapt it. Steal it outright, if you like.

I learned a lot about life at the racetrack. For instance, that people like you far better when your stories turn out badly than when you succeed. There's the one about my horse and my date's horse fighting it out in the deep stretch, my horse in a close but comfortable lead. Whoa!

ABOVE: One of photographer Lewis Hine's shots of workers at Wamsutta Mills, New Bedford, Massachusetts, 1912

Here comes my date's horse in a rush, just catching my nag at the wire. That gets a good laugh whenever I tell it. But the punch line is even better. She cashed in her $2 bet and walked away clean with $5.40. Happy. My 30-1 shot and $200 win ticket would have netted me $6,000-plus had her horse not stuck his nose in front. The crowd goes wild for that one.

I remember hearing the late Larry Sultan speak some years ago, talking about how he jump-started his photography career. "There's one big advantage to having a dad who was a salesman," he said, or something close to that, explaining that a big part of what we do as artists is selling. Our work. Ourselves.

I didn't grow up with a lot of high culture, just the usual sports and TV. I loved the Red Sox, the Celtics, and the New York Giants. The Giants were on TV all the time; it was just before the Patriots started up. Maybe the most interesting thing I did in my youth was to go to basketball camp for five summers. Hall-of-Famer Bob Cousy co-owned the camp and worked it every day. The Cooz

was a thirteen-time all-star and, along with the Harlem Globetrotters, helped introduce the snazzy moves later popularized by Dr. J and so many marquee players who followed. Sadly, for him, he came along a little early. His salary for his final season (1962–63) was $25,000 or so. Real money in those days, but the ambitious Cooz still had to work summers. At Camp Graylag. And I got to be the butt of his jokes as he coached and refereed our games.

It wasn't that the Cooz was a bad guy. Not at all. It was that I was a bad player. A gunner. Which meant I was reluctant to give up the ball. I preferred to shoot it, regardless of the odds of its even reaching the hoop. Cooz was a passer. He led the NBA in assists a staggering eight times.

I should have figured out my basketball career would be short lived. After all, my entire family was short. My dad maxed out at five feet five inches and it was downhill from there. I was also slow afoot and not a team player—a curse that has haunted me over the years. It was time to reconsider my future plans.

Fortunately for me, I really liked school and I liked to read. I don't get it when people say that today's kids don't read. I think most kids didn't read back then. In my crowd, only Roz Tabachnick and I were readers. And if my sainted Aunt Marcia hadn't encouraged me, Roz would have been alone in the reading room at the New Bedford Library.

Anyway, I was a good student and, when my dad got a better job and the family moved to Boston, I was shipped off to a boarding school. The school was called Governor Dummer Academy (GDA). Insert joke here. They finally changed it to the Governor's Academy, to stem the hilarity. I doubt the good governor (actually lieutenant governor) would have minded the switch. He died a long time

ABOVE: Me with Bob Cousy at camp banquet, Chestnut Hill Country Club, Chestnut Hill, Massachusetts, 1958

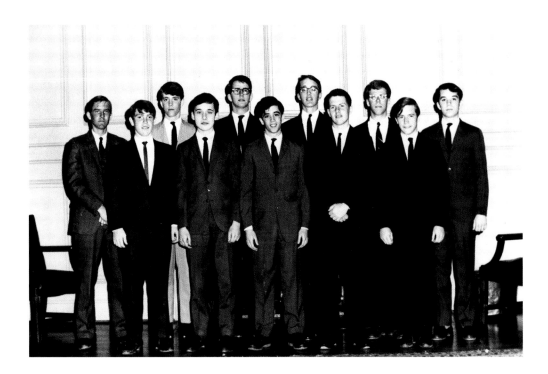

ago. The school was started in 1763 by bequest, making GDA the oldest boarding school in the nation. The Governor's Academy still is.

GDA in the mid-1960s wasn't Baltimore or Ferguson, Missouri, of recent times, but it had a racist and anti-Semitic tinge with strict racial and religious admission quotas. That's how most prep schools rolled in those days. My class of fifty or sixty had four Jews, four Catholics, and a lone black guy. Maybe there was an Asian guy, too. The class before mine had the same numbers, more or less. And the class after that, as well.

All guys. Coed prep schools were just being imagined.

I got called "Jew" and "kike" and bullied occasionally, but it wasn't so bad. I was better off than Timmy Rollins (fake name) who was discovered one evening with women's underwear, soiled with sperm. Timmy was known as "Panties" for the rest of his time at GDA.

My finest moments came, as always, when I stood up for liberty. I was chosen to represent Barry Goldwater in a debate against a Lyndon Johnson stand-in in front of the entire school in a mock 1964 presidential election. Friend Mark Starr, who went on to a fine career in journalism, represented L.B.J., and I kicked ass, despite what Mark says. I was president of the debate club, and Mark was vice president, and that says it all. I had the student body voting for Goldwater, and the faculty turned it around, kind of like W. in the 2000 Florida debacle. It was an outrage, and I'm sure the whole thing would have gone viral had it happened today.

Goldwater's slogan was "In Your Heart You Know He's Right," and I knew I was right. I swallowed right-wing politics whole, even reading *The Fountainhead* twice, subscribing to the *National Review,* and joining Young Americans for Freedom. If you don't know the book or the magazine or the organization, consider your ignorance bliss.

ABOVE: Front row center, Cum Laude Society, Governor Dummer Academy, Byfield, Massachusetts, 1965. Courtesy of The Governor's Academy

GOVERNOR
DUMMER
ACADEMY

THE MOODY KENT PRIZE

for the Highest Standing in History

to

Henry Horenstein

June 5, 1965

One other time I stood for religious freedom, and I'm not sure it was my finest moment. It started with mandatory church on Sunday. I went, one sheep among the flock, but I was not happy about it. I should have left well enough alone. After all, I got a lot of reading done in church, paperback hidden behind the prayer book. But no!!! I argued that I was Jewish, this was America, and we had religious freedom. Never mind that I was nonobservant and self-serving. I saw a chance to get out of church, and I seized it.

Headmaster Val Wilkie agreed, surprisingly. But he made Mr. Buster Navins, the only Jewish faculty at GDA, hold a weekly "seminar" to discuss religious issues. Buster must have been pissed to give up his Saturdays, as he was probably nonobservant as well. Plus, it was impossible to sneak a paperback into the mix.

Okay, so that didn't work out. But prep school wasn't a total bust. I heard a lot of folk music from a couple of student musicians and from Chris Martin, my English teacher. We even started a folk music club, and went to some concerts and coffee houses. Lame, I know, but it was really pushing boundaries for a prep school of the day, most of which made big efforts to shield their students from any kind of fun. We saw and heard Judy

Collins, Dave Van Ronk, and others at places like the King's Rook in the seacoast town of Marblehead. Getting to leave campus was great. The music was good, too.

I became a fan of folk music and ended up going to Cambridge's fabled Club 47 several nights a week when I went home on weekends and vacations. My folks had moved from New Bedford to suburban Boston and I had few friends there, so I would head over to the Tasty, a diner in Harvard Square, eat two hot dogs and an order of fries, wash them down with a Coke or two, and walk over to the club, where I started the admission line. I'd sit on the stairs and wait, reading my Ayn Rand or whatever, and eventually get the best seats in the house. Club manager Jim Rooney loved the blues (read his

ABOVE LEFT: Barry Goldwater for President button, 1964

ABOVE RIGHT: Best in History

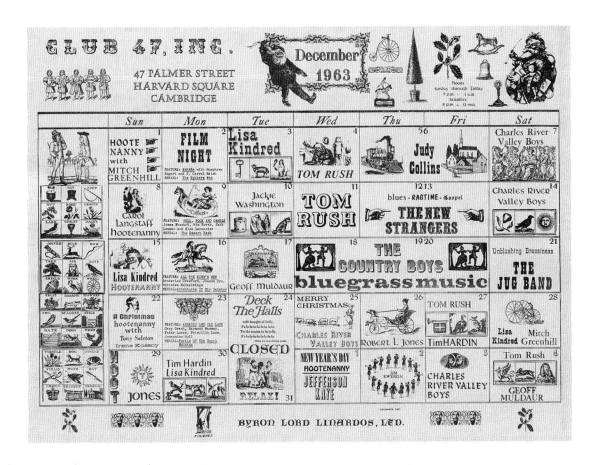

fine book *Bossmen*), and booked the likes of Howlin' Wolf and Muddy Waters. He also loved old-time and bluegrass music, so I saw and heard Doc Watson, Bill Monroe, Jim and Jesse, and so many others at the 47, some of whom I photographed years later.

Back at GDA, I was developing a strong interest in history, which I'm sure was related to my interest in folk music. The connection is stories. After all, history is nothing but stories, not all of them true, and a lot of folk music is much of the same. I also had two inspiring history teachers, David Williams and Bill Sperry, and I'm sure they made a difference. I worked hard for myself and also to please them, and I wonder if they were part of the reason I eventually went into teaching. Maybe. Probably.

Moving on, it was time for college. I wanted to go to either the University of Chicago (U of C) or Johns Hopkins, two schools our Northeastern-centric guidance counselor had never even heard of. Really. In a 1993 column, *Inside Edge*, a magazine published by college students, rated U of C and Johns Hopkins number 1 and number 4 among the least-fun colleges in the United States. I went with number 1. Safe bet.

At the time, I didn't know that U of C was where fun went to die. I chose it because it had a strong history department and lots of crazed right-wing economists (the Chicago School). Also, it was as far away as I could go and still get my parents to pony up tuition.

ABOVE: Calendar of events for Cambridge's Club 47, by Byron Linardos, courtesy of Catherine Linardos

CHICAGO BLUES

So, off I went to a big city to a serious university that actually admitted boys and girls. In the same classroom. Otherwise, my four years (more or less) in Chicago were uneventful, except for a semester in England and getting expelled my senior year. A highlight was going to the University of Chicago Folk Festival every year. Like everything at U of C, it was educational first and entertaining second. No fun, remember?

Actually, it was fun, if you liked country music and the blues, which I did. The New Lost City Ramblers (NLCR) were the organizers—today we might say curators. The Ramblers were citybillies, one of a few groups and individuals back then who brought rural music to urban dwellers. Kind of musicologists without a degree in musicology. These particular citybillies were one rotating guy plus Mike Seeger (half-brother to folk icon Pete) and John Cohen, who I later learned was a top photographer and filmmaker. The Grateful Dead dubbed NLCR "Uncle John's Band." Photo legend Robert Frank shot their early publicity photos.

Seeger and Cohen booked many obscure musicians who were at the foundations of white and black folk music, what's now sometimes called Americana Music. They weren't big stars as much as they were influential musicians from a previous, almost forgotten time. I saw banjo wizard Don Reno and mountain man Dillard Chandler and Martin, Bogan and Armstrong, whose music originally came from the medicine shows of the 1920s.

Then there were bluesmen Magic Sam, Junior Wells, and Freddie King. And, yes, even Pete Seeger and a rare survivor, Buddy Guy, who now has a fancy-ass club in downtown Chicago catering to the business/tourist trade.

Also, performing at the festival and all around Hyde Park (the school's neighborhood) was the Paul Butterfield Blues Band. A couple of the band members had a U of C connection, and they were as close as there was to a campus band until they went national, backed Bob Dylan at Newport (when he famously went electric), and landed in the Rock and Roll Hall of Fame.

The president of the Folk Society was Bruce Kaplan, a lifelong PhD candidate in Indian studies. India Indian, not Native American. Bruce helped start Rounder Records, then quickly moved on to start his own label, Flying Fish. More on the Rounder connection later.

As a good student from an East Coast prep school, I came with a bit of a chip on my shoulder. This fell off the first week of classes. As far as I can tell, there were two kinds of students at U of C in those days: valedictorians of small high schools throughout the Midwest and Jewish wise guys (and gals) from New York City. The Midwesterners were square socially and brilliant otherwise. The New Yorkers were beyond hip and also brainiacs, but of a different kind. Guess who felt somewhere in-between?

OPPOSITE, CLOCKWISE FROM TOP LEFT: Folkies all, 1968. Joan Baez at Boston Public Garden • John Cohen and Don Reno at the University of Chicago Folk Festival • Joni Mitchell and Buddy Guy at the Philadelphia Folk Festival

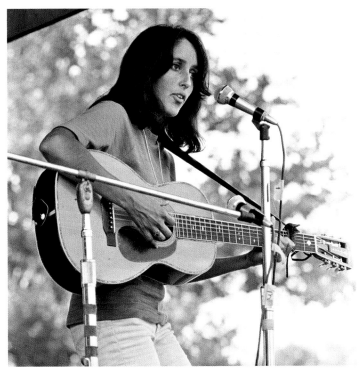
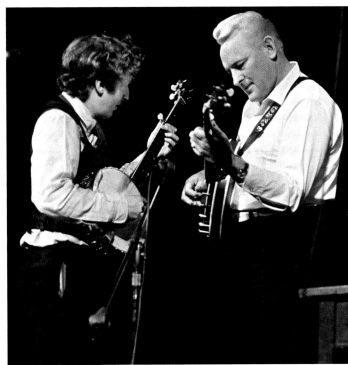
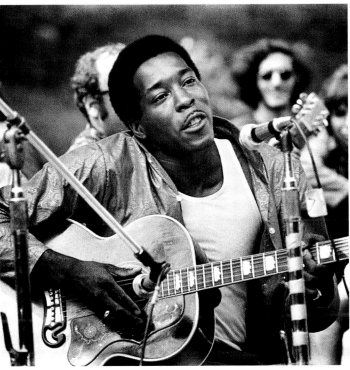
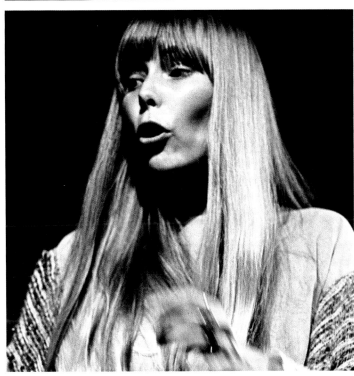

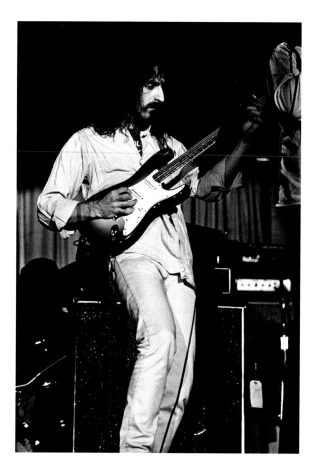

I made good grades, but I had to study all the time to keep up. At first, I fell in with the Midwesterners, as they were more familiar to me. There weren't too many New Yorkers or Jews at GDA. I was also shy and not used to being in school with females. The New Yorkers were another breed entirely. I had never met Jews like them. Everyone's grandfather had fought in the Spanish Civil War, and most of them had godfathers who were writers blackballed by McCarthy's House Un-American Activities Committee or union organizers who had been beat up multiple times by company thugs. My right-wing politics approved of company thuggery, so I was in a bind. I was beginning to become friends with some of the New Yorkers. What to do?

Simple. I changed my politics. The ex-valedictorians were far too busy being smart, and they kept to themselves.

The New Yorkers went to movies and concerts and talked politics and sex. Some even had sex. Besides, they were against the Vietnam War, and, now that I was draft age, I was coming around to their point of view. It took me a while, a few weeks at least, to realize that if there was any excitement to be had at this fun-challenged place, I better throw in with the New York crowd.

Besides, my right-wing attitude had a lot to do with libertarian thought. You know, freedom. Not mainstream. And what could be more liberating than smoking dope, free love, and listening to Frank Zappa? I had obviously been batting for the wrong team.

Furthermore, my favorite history teacher was Jesse Lemisch. He used to come to his class on the American Revolution dressed like George Washington—gone bad. Jesse was one of a generation of young historians who were having their day back then. They were sometimes branded the "New Left." Among them were such righteous historians and scholars as Stoughton Lynd, Howard Zinn, and C. Wright Mills.

Their movement was sometimes called the "bottom-up" school of history. It argued for studying and preserving the people on the bottom of the ladder—not the generals, kings, and industrialists, whose stories would be told regardless, but factory workers, farmers, and fishermen. After all, these historians were Marxists or close cousins.

Jesse taught me one of the most important lessons I ever learned, and not just about history, when he said, more or less, "If you want to understand the history, first understand the historian." Feel free to substitute "criticism/lesson" for history and critics/teachers for historian.

ABOVE: Frank Zappa with the Mothers of Invention at the Philadelphia Folk Festival, 1968

People usually reveal their own views when they tell a story—or give advice. I do. So, read with care.

Jesse also convinced me to go to England to study at the University of Warwick with the legendary labor historian E. P. Thompson, who wrote the classic *The Making of the English Working Class*. ListMuse.com has this book as number two of the one hundred best history books of all time. All time. The *Times Literary Supplement* said "no one interested in the history of the English people should fail to read (t)his book."

Hey, I'm interested in the history of the English people. So I read the book. Here's E. P.'s most famous quote:

"(I am) seeking to rescue the poor stockinger, the Luddite cropper, the 'obsolete' hand-loom weaver, the 'Utopian' artisan . . . , from the enormous condescension of posterity. Their crafts and traditions may have been dying. Their hostility to the new industrialism may have been backward-looking. Their communitarian ideals may have been fantasies. Their insurrectionary conspiracies may have been foolhardy. But they lived through these times of acute social disturbance, and we did not. Their aspirations were valid in terms of their own experience; and, if they were casualties of history, they remain, condemned in their own lives, as casualties."

Sorry for going on and on, but it's good. Right? He was writing about the workers during the Industrial Revolution, but he was singing my song. His words offered me an entry into photography. I had no art background, but I did know a thing or two about history. Maybe I could be a historian with a camera.

I think inspiration can come from anywhere. Read books all you like. Even books about critical theory, if you really must. But don't ignore lessons from life. For

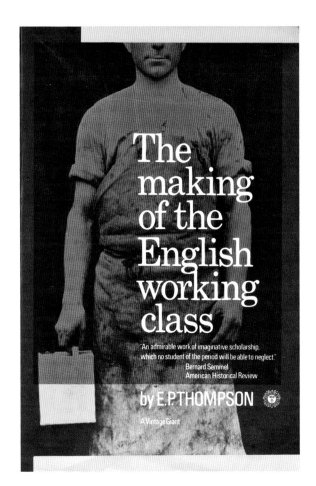

me, human concerns must always trump academic ones.

Anyway, Thompson didn't disappoint. He was a fantastic lecturer and made his arguments convincingly, with flair and humor. But I left England three months later determined to switch to photography. It was a bit of a stretch. Just listen to my ex-girlfriend from freshman year. I randomly ran into Norie Neumark at a peace rally in London. She said she was off to Australia to get a PhD in political science. Made sense. She was one smart cookie. I told her I was going to become a photographer.

"Sure you are."

Norie went on to be a sound/media artist and theorist of some renown. Go figure.

ABOVE: E.P. Thompson's classic book on workers during the Industrial Revolution

BYE-BYE HISTORY

High-school roommate Jeff Kane helped me buy my first camera, an entry-level Yashica TL-Super, when I went home for the summer after my sophomore year. I took it to the 1967 Newport Folk Festival and got some pretty good pictures there. But I didn't know how to expose film properly, so many of the pictures were underexposed and unprintable. I had no great dreams about becoming a photographer. It was more of a guilty pleasure—a tone-deaf guy's attempt to connect with the music world.

My technique was improving a little by the time I took my Yashica to England that fall. There I got to photograph the band Cream, with Eric Clapton, and Pentangle, which featured guitarist Bert Jansch, who opened a tour for Neil Young just before his death in 2011.

Once I got back to Chicago my resolve weakened. Could I really become a photographer? Hmmm. I wasn't thinking of a career in those days. These were the Hippy Times. I just thought I'd take pictures, meet girls, listen to music, smoke weed, and all that would somehow sustain me. If I thought at all.

I was trying to figure it all out when I heard about Danny Lyon. He published a book called *The Bikeriders* in 1968. It was about a motorcycle gang called "The Outlaws" and it had great photos and text, including interviews with gang members. It was a history and it was photographic. And Lyon had gone to the University of Chicago and studied history. Like someone else I knew. A historian with a camera? Maybe.

I figured, if Danny Lyon could do it, then I could do it. Not necessarily true, but at least I had a clear goal to shoot for. I was going to make books of my photographs, and they were going to be histories.

Years later, Brett MacFadden, who designed the first edition of my book Honky Tonk, also designed a new edition of The Bikeriders. He got Lyon to autograph a copy to me.

"To Henry. Glad I could help."

Then life interceded. I got involved in the political mess of the day. Forget about getting a date at U of C, if you weren't on the left. Unless maybe if you were studying economics.

Many of my friends were in SDS (Students for a Democratic Society) or worse—PL (Progressive Labor). The former stood for roaming free and spontaneity, and the latter stood for becoming one with the workers and educating them. Which do you think I preferred? Then, there were the demonstrations at the Chicago Democratic Convention. Weathermen. And don't leave out the Vietnam War.

It caught up with me in February of my senior year, when I was expelled from school, along with forty or so other fellow travelers. It's a long and surprisingly boring story, given that it is about my favorite things—photography and dogs.

Here's the long of it. During the summer of 1968, I decided to take a photography class. See if I was serious. So I took a class at Harvard Summer School. I loved the class and decided to move forward, but I had only one more year to finish my degree, so I went back to Chicago and applied for credit for the photo class.

I was turned down and decided to appeal the decision. I met with the dean of undergraduate students, George Playe. You'd think George had something better to do than to meet with an undergraduate about three credits. Apparently not.

"We don't consider photography a university-level class at Chicago."

"Hmm, Harvard does. That's where I took the class."

"This Harvard you mention. Is that an accredited school?"

Okay, he didn't say that, but I knew that was what he was thinking. Screw him.

"Is there a way I can appeal your decision?"

"Yes, but you'll lose, so why bother?"

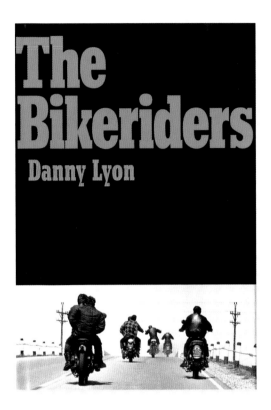

I bothered and won, and after a brief second meeting with Dean Playe, I could tell he was also bothered.

Still awake?

Fast forward a few months to February 1969. I was with a few hundred students occupying the school administration building. We were protesting the sociology department's failure to grant tenure to a popular Marxist teacher named Marlene Dixon. It was a political issue and a feminist cause. We were more or less at the beginning of the 1960s/1970s feminist movement and there weren't a helluva lot of female professors at U of C—or most schools. Add the military draft and the Vietnam War, and you had a potent mix. An imperfect storm.

OPPOSITE: Eric Clapton performing with Cream, somewhere in England, 1968

ABOVE: A historian with a camera? Courtesy of Danny Lyon, Magnum Photos, and Aperture

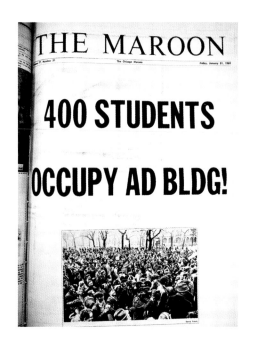

THE MAROON

400 STUDENTS OCCUPY AD BLDG!

Anyway, inside the building we had speeches and pledges and lectures and demands and on and on. It wasn't fun (wrong school for that), but the spirit was positive. Even New Left hero Staughton Lynd blew in from Connecticut to tell us what was what.

But I had a problem, and his name was Dobie, a heroic Doberman mix my girlfriend Sharon had found. He needed to be walked and scratched behind the ears periodically, and Marxists don't seem to like dogs walking around when there's revolution brewing. Dogs just aren't serious enough, I guess.

So, I left the building and the speeches two or three times a day to walk and scratch Dobie. This created a problem. The school decided to photograph and identify students going in and out of the building and summon them to a kangaroo court. If you admitted your sins, and repudiated them, then you got off with a hand slap. If not, you got the boot.

I was hardly a leader of the protest, just along for the ride. Still, when I saw who my accuser was, I decided not to play. Guess who he was? There's a hint in the previous sentence.

Oddly, my Republican dad took up my cause. He hired Harvey Silverglate, a young civil-liberties lawyer, to go to Chicago to meet with U of C President Edward Levi.

"That son-of-a-bitch German Jew talked down to me."

My father was a Russian Jew.

"Dad, Levi would talk down to God."

I was still kicked out, as I chose not to pursue it. I really didn't want my dad hijacking my life. Besides, I was going to be a photographer! As for Levi, he served for a brief spell as attorney general under President Gerald Ford. What do you want to bet that he talked down to Ford?

As for me, I was freed from taking a biology requirement I'd been ducking for three years, clearing a path for that other thing. Let me put it this way. Imagine you are dating a girl (or boy) and it's going well. Nice woman. Parents approve. Sex still. But taking a hard, cold look, it all felt a little boring.

Suddenly you meet this other girl. She is wild, funny, smart, and wisecracking, not to mention hot. And you waver. High upside, high downside. What if I make a play for her and she's crazy or hates me or . . . ? Then, out of the blue, your boring girlfriend dumps you and you're free to pursue the Wild Thing, for better or worse. Well, that's basically what happened to me. History dumped me and photography loomed ominously. I loved taking pictures. But I thought, "Maybe it's me who's crazy."

ABOVE: The *Maroon* front page, 1969. They probably underestimated. It was more like 1,000, if memory serves.

THOSE WHO TEACH (1968)

Teachers often learn their trade from their own teachers. I had some good ones, and some . . . I'd rather not say. One teacher I studied with early on was Minor White. Minor taught at MIT but he used to hold summer workshops at his home. He ruled Boston photography with a network that extended well beyond. A talented photographer, Minor was an influential editor (he co-started *Aperture*, one of the most important publications in photography ever), and a legendary teacher. His life's philosophy was based on the writings of Gurdjieff, a nineteenth-century spiritualist, and it smacked hard of the New Age. It was the late '60s, early '70s, after all. One of Gurdjieff's best-selling books was titled *Life is Real Only Then, When "I Am."*

I didn't make that up.

I'm more of a Western guy. I don't meditate or chant, and I even believe in inoculating kids against measles. Minor's workshop drove me crazy. I thought it was insincere, manipulative, controlling, and plain wrong. Otherwise, not so bad. After all, he was The Great Man and I was twenty-one years old and not so great. But I didn't buy his message. I understood it, I think, I just didn't agree with it. So I quit his workshop.

"I wouldn't do that if I were you."

"I'm just not getting much from it."

"Well, I'll give you two reasons to stay: One, you are not getting your money back, and two, you don't have to accept everything I say. Just take what you can use and toss out the rest."

Hmmm. So, maybe my worst teacher was actually one of my best. He taught me what not to do. Don't make my students parrot what I say or follow what I do. Don't try to be all things to all students. And remember that there are many ways to skin a cat. And that we should all carry our own skinning knives.

One thing Minor didn't teach me was to listen to students. He wasn't alone in this shortcoming. Many teachers come agenda-laden into the classroom and lay down the law. They think they have the only right path, and they are hell-bent for their students to obey. To me, this is an amazing, ego-driven, selfish attitude. Still, some students are drawn to it, either because they need to be led, maybe, or because in some odd way it works for them. Different strokes for different folks.

Here's how I see it. Students pay the money. Teachers get paid. It's our job to listen and to give what we can to make them more thoughtful and a little better at what they are doing. Simple. Guide and support. Don't shove anything down anyone's throat. Trust each student to figure out what works for him or her. One size doesn't fit all.

I favor the approach of Richard Merkin, a former colleague at Rhode Island School of Design (RISD). Richard was as quirky as they come and most definitely an original—a snazzy dresser and a triple-threat: writer,

teacher, and painter, whose work was often published in the *New Yorker*. He was even pictured on the cover of the Beatle's *Sgt. Pepper's Lonely Hearts Club Band* album.

Talking Heads drummer and RISD painting grad Tina Weymouth paid tribute: "(His) approach was not to reprogram you by breaking you down, but to inspire the exploration of everything around you." RIP Richard.

Over time, I studied with some amazing photographers, but one of my most important teachers was Rick Steadry. Rick was a teaching assistant for my very first photo class, VES 140 at Harvard Summer School. The head teacher was Arthur Siegel, a Bauhaus-influenced architectural photographer. Arthur was a smart guy—a confident photographer, a brilliant lecturer, and an erudite soul who had an especially deep knowledge of photography books. He was probably one of the main reasons I set out to publish my work in book form. But he was distant, except maybe to a couple of Ivy League waifs in the class. Note to future teachers: Make an effort to pay equal attention to every student, even when you don't feel so inclined and even when the waifs (or whatever male equivalents) are cute. Teaching is fun, but you're there to work.

When Arthur took off for God knows where, Rick picked up the slack. He stood by us as we printed, didn't belittle when we asked dumb questions, and stayed late and went for beers with us when class was over. Rick later went to work for the legendary design studio of Charles and Ray Eames and then had a long career running the huge photo program at Orange Coast Community College in Costa Mesa, California.

Years later during one of many mid-life crises, I helped produce a book by Walter Hriniak called *A Hitting Clinic*. Walter was a major-league hitting coach for the Boston Red Sox and Chicago White Sox baseball teams. In those days, and maybe today, many coaches were drinking buddies of the managers, who needed company on the road because they couldn't fraternize with the players. Walter was not a drinker. And he was a true coach—a teacher, if you will.

Anyway, in the course of putting the book together I interviewed Wade Boggs of the Red Sox, now a Hall of Famer.

ABOVE: Announcement for Minor White workshop, 1969. Note the last paragraph. Minor did an astrological chart on each applicant, before deciding who could take the class.

"So, did Walter teach you that chop-down, one-hand-on-the-bat release style you use?"

"No way. Walter didn't teach me anything about hitting. I was a great hitter when I came to the major leagues. I wouldn't have made it otherwise."

(Note: They said that Boggs changed up his swing according to the day's wind currents.)

"Really? So what makes Walter such a great coach?"

"If I need to talk about facing a pitcher or look at game tapes, he's there. Day or night. Extra batting practice when I feel rusty. Absolutely. Walter's always got my back."

Well, some teachers teach specific things—technique, theory, or history, for instance. Some teach confidence and others teach work ethic. I think we teach who we are. It's a creative act, much like making art or music or anything. And you can't expect to reach all students equally, and, maybe most of all, you have to know when to let go and let them find their own way. In the immortal words of country singer Kenny Rogers:

> *"You've got to know when to hold 'em*
> *Know when to fold 'em*
> *Know when to walk away*
> *And know when to run."*

I got my BFA ('71) and MFA ('73) from RISD where I had two legendary photographers as teachers. Aaron Siskind was a great photographer, a great guy, and for most students a great teacher. But for me, not so much. I already had an opinionated Jewish dad at home; I didn't need to study with one.

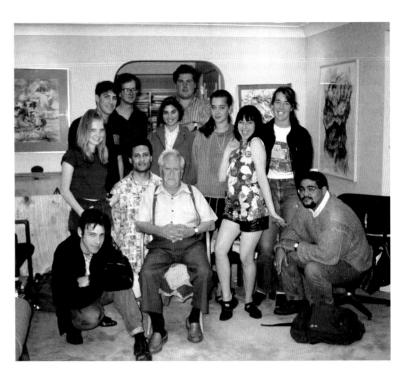

My photo teacher hero was Harry Callahan. Hands down. He was the opposite of Aaron (and my dad) and maybe that's why I fell for him. I know he had opinions, but he rarely expressed them strongly in class. It was more "Work hard. That's good. I'm not so sure about that. Going out for a cig now." If you made an effort and dedicated yourself, he was pretty much on your side.

One day I asked Harry what I could photograph.

"What do you like to do besides take pictures?"

"I like to go to the racetrack and bet horses, and I like to listen to country music."

"Why not photograph the races and the music? Even if you make lousy pictures, you'll have a good time."

Thanks, Harry. You meant it, didn't you? Hope so, because I've kind of built my professional life around your sage words.

ABOVE: Aaron Siskind with a class of my students at his home in Pawtucket, Rhode Island, 1988

PORTFOLIO: THE BLUES

Over the years I've shot a lot of musicians, sometimes for work but more often for myself. I do this for the simplest reasons: I like helping to preserve musicians who might some day be forgotten. A lot of these personal pictures were taken on stage, which represents a challenge in terms of framing and expression. Here are a few that seemed to work out.

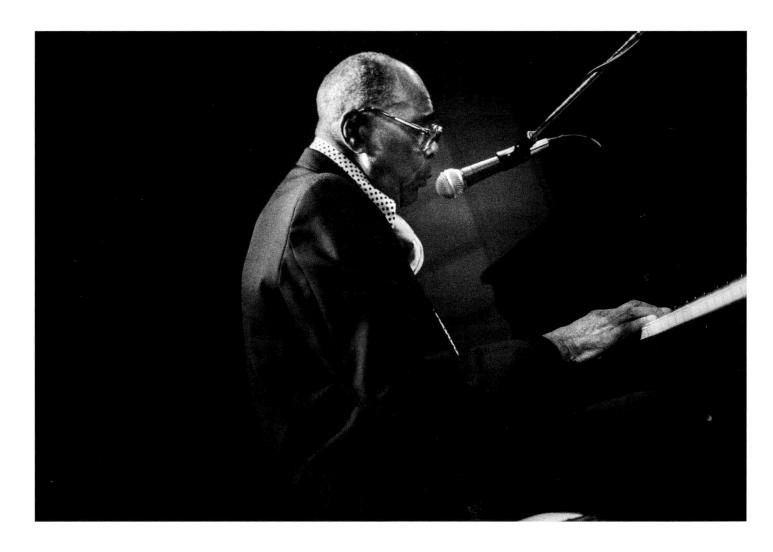

ABOVE: *Sunnyland Slim, Nightstage, Cambridge, Massachusetts, 1986*

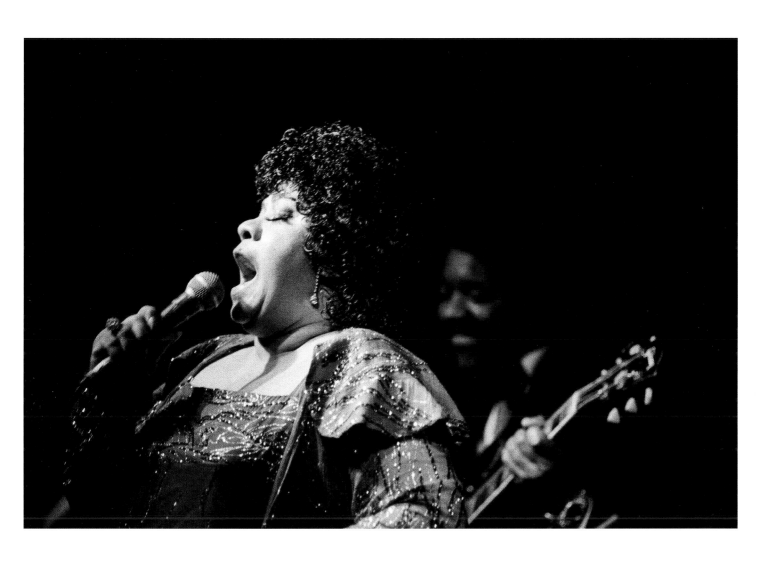

ABOVE: *Ruth Brown, Michael's Pub, New York City, 1985* OVERLEAF: *Boozoo Chavis, Rock 'n' Bowl, New Orleans, 1994*

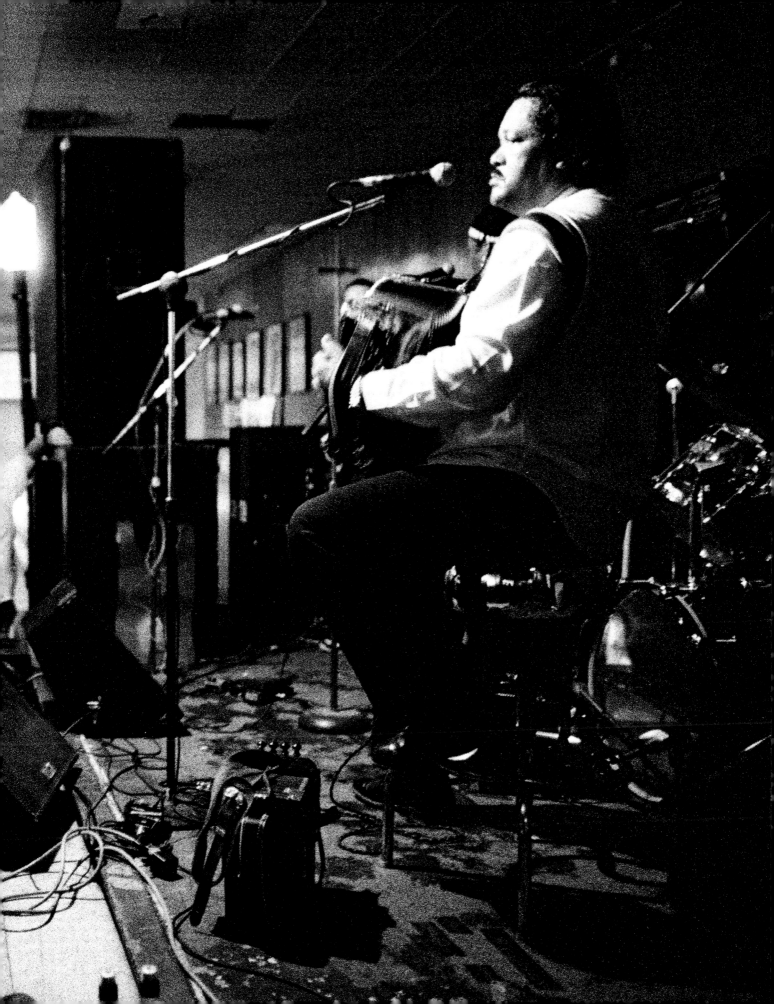

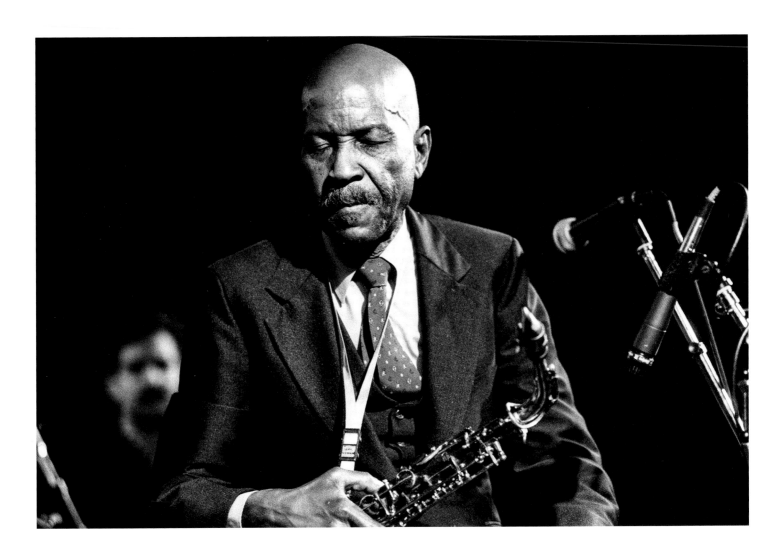

Eddie "Cleanhead" Vinson, Nightstage, Cambridge,
Massachusetts, 1986

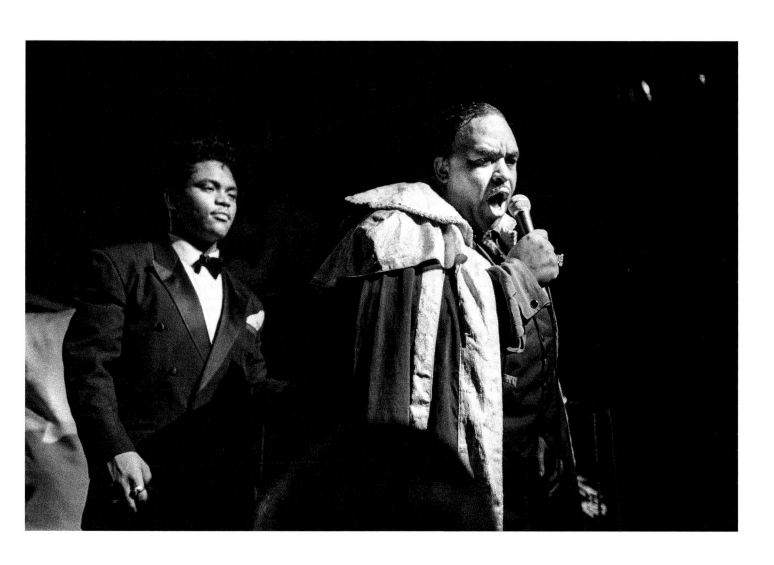

Solomon Burke, House of Blues, New Orleans, 1997

WHAT'S A CAREER?

ike any young photographer, I mimicked my he-
roes. Okay, I copied them blind. The elegant
August Sander. The formal Walker Evans. The
impish Brassaï. The crude Weegee. The dark Diane
Arbus. I was totally aware of these influences as I was
taking the pictures, but, looking back, I'm struck by how
much I absorbed from Harry Callahan, who was far and
away my most influential teacher. Tight composition.
Good light. Beautifully crafted print. Compelling subject.
Not that I achieved all this, but Lord knows I was trying.

Maybe the most important things Harry Callahan,
Aaron Siskind, and even Minor White taught me were
by inference. It was that this thing could actually be
a career—this thing being a combination of teaching,
freelancing, developing my own projects, or whatever. I
looked at my teachers, and I thought that's a very cool
way to live a life. After all, who wouldn't want this life?
A cozy gig with summers off and freedom to pursue a
creative life. Oh right, the students. They're fun, too.
Most of the time.

Speaking of unfun students, I think I qualified. I was
very serious and moody and egocentric. Today we would
say I had attitude. Not a positive one. The other kind.
Sometimes that works for you and sometimes . . . not so
much. I was in a huff one time in grad school and decided
I would skip class. Little did I know that my hero Diane
Arbus was coming to visit. She spoke in a room of 15 or
so grad students. I was missing in action. Fellow student
Steve Frank took a famous photo of her that day—the one
where she is showing her print of the boy holding a hand
grenade in each hand.

Arbus died a couple of months later and I never got
to meet her. There you go. I've turned it into my tragedy,
not hers or her family's. Anyway, best listen to Woody
Allen on this one:

"Eighty percent of life is showing up."

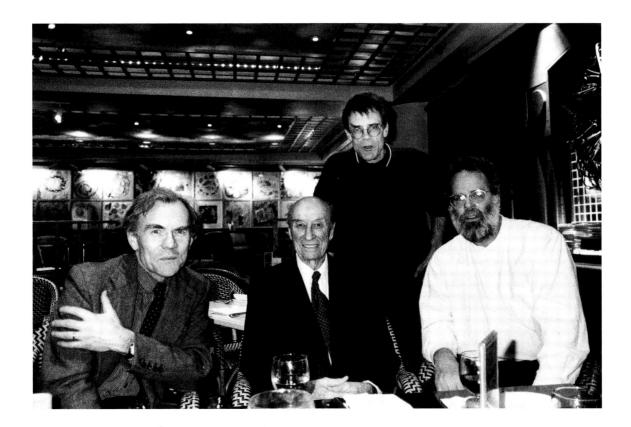

Today, teaching photography is an accepted career path. There are probably tens of thousands of BFA and MFA photo graduates trying to do just that. But back then it was a pretty radical idea.

I visited sainted Aunt Marcia, my childhood reading partner, in the nursing home some years later. She was very weak, but managed to say to me,

"Henry, imagine that. You became a photographer."

To this day, I don't know if she thought that was an awesome thing or a great disappointment.

For one thing, there weren't many photography teaching jobs when I was finishing school—in part, because there weren't many schools that taught photography until the mid- to late-1970s. As I was finishing grad school, I wrote inquiries to about 150 schools, searching for a teaching job.

I got two responses. No. No. So I began to put a life together—a little of this and a little of that. And I got by just fine.

I was painting houses, moving students and poor people, delivering the Yellow Pages door to door, writing some instructional books and articles for photo magazines, peddling silkscreened T-shirts, and selling blood on occasion.

I even wrote a master's thesis for a German graduate student in urban planning. Subject: Using mobile homes

OPPOSITE: What fine-art photography was worth in 1968. Until the late 1970s, the Witkin Gallery was one of just three or so galleries in New York City to exhibit photography.

ABOVE: Harry Callahan bred photographers and teachers. Surrounding Harry are (left to right) Emmet Gowin (Princeton University), Jim Dow (School of the Museum of Fine Arts Boston and Tufts University), and John McWilliams (Georgia State University), 1996.

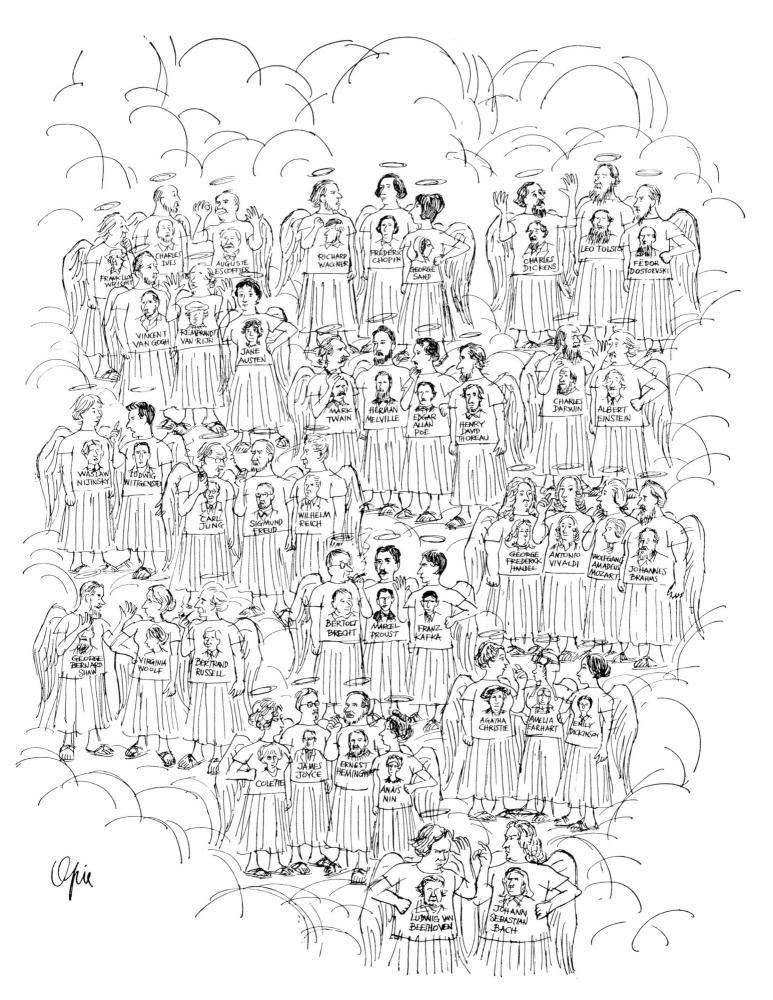

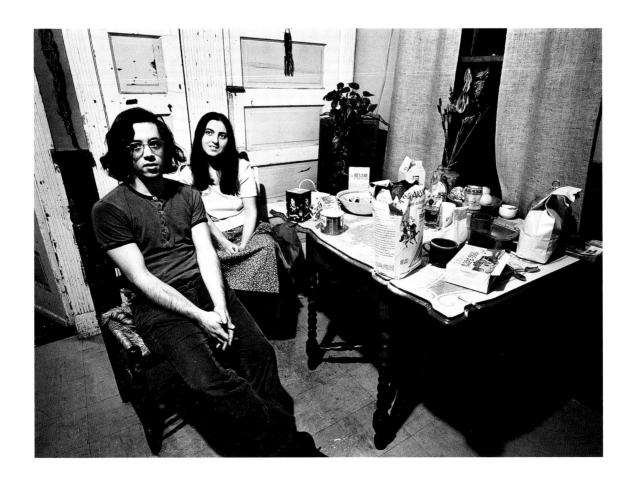

as a low-cost housing solution. Conclusion: Good idea! He fed me the research, and I turned it into English. And finally I was picking up some part-time teaching and free-lance photo gigs. I had no idea where this was leading, but I ate well enough, and the beers were cold. Boston had a kick-ass music scene, my dog Jenny walked off leash, and I was holding my own betting horses at the track. All in all, life was prime.

The '70s were a good time to be twenty-something. People were trying new things: for instance, drugs and sex. Fortunately, you didn't have to take one to get the other. Photography was getting popular, part of a growing visual culture, but the traditional schools were slow to get it. So, Project, Inc., later Project Arts Center, was started in Cambridge to teach a variety of arts classes, including photography. Minor White was on the board of directors and gave workshops to Project's teachers *gratis*. We met every other week and showed work, which Minor would proceed to dismiss. Most of us were semi-employed so we had time to make a few prints to show, tacking them up on Minor's Homasote-covered walls. Then, there was fellow teacher Kip Kumler (a Harvard MBA), who held down a serious business-consulting job. He'd come in every two weeks with maybe a dozen beautiful, matted prints from his 8x10-inch camera, many made

OPPOSITE: RISD artists and friends Lisa DeFrancis and Henry Isaacs and I started Historical T-Shirts in the late 1970s. *New Yorker* artist Everett Opie published this full-page cartoon of our subjects in 1980.

ABOVE: *Self-Portrait with Mary, Cambridge, Massachusetts, 1972*

with the ancient platinum process. (Note to non-photographers: That's a lot of work.) He also dressed a whole lot better than any of us.

New England School of Photography (NESOP) began in portrait photographer Yousuf Karsh's old studio, before moving a stone's throw away from Fenway Park, where it remains active. Its original business plan was to grab the generous tuition grants that the GI Bill handed servicemen, a bloated population due to the Vietnam War. Though billed as a professional school, NESOP attracted a lot of art students. Like me, many of the teachers had MFAs in photography.

Then there was Imageworks, probably the best of the bunch. It lasted only a few years, but they were rich and wild ones. Among the visiting lecturers and workshop givers were Lee Friedlander, Garry Winogrand, Diane Arbus, Lisette Model, and on and on. It was almost certainly one of the first schools anywhere to teach color printing, which was not yet in vogue. Thanks to Bob Hower for that. It also offered video and audio classes well before its time. Heady stuff. Exciting.

I taught at all of those schools and more—even at Harvard for a couple of adjunct years—a class here and a class there. It was at Project where I met the fine photographer and teacher Allen Frame, who remains one of my best friends. At NESOP I taught basic photography to Nancy Goldin, soon to become legendary photographer Nan Goldin. She was about 20 years old then, sort of a runaway, and dreamed of being a fashion photographer. She said the drag queens she lived with on the far side of Beacon Hill were far more beautiful than the models on the cover of *Vogue*, and she wanted to put them there.

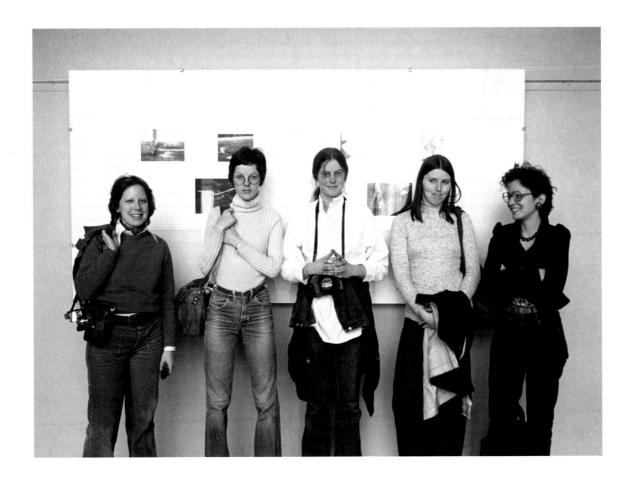

Nan came over to Imageworks with me, and took a class that included several other students who went on to stellar careers. Her fellow students included Jim Goldberg , currently a Magnum photographer and author of classic photo books *Rich and Poor* and *Raised by Wolves*. David Godlis was also in the class, before he left for New York and plied his trade at CBGBs, where he built a collection of punk pictures known worldwide. (See his book *History Is Made at Night*.) And then there was Stanley Greene, cofounder of the top photo agency Noor, a multiple World Press Award winner, and a courageous chronicler of deadly conflict zones, including Chechnya, as seen in his terrifying book *Open Wound*.

With a class like that, I'll understand if you see me as the world's greatest teacher. Or, you might just accept that there weren't many photography classes around, and on enrollment day I drew a stacked hand. You decide.

Me, I vote for the latter. And I'm not humble bragging. There are good and not-so-good teachers, for sure, but it's fairly easy to find a good one. There's so much teaching talent out there looking for work. But students are another matter. There are too few really good ones to go around. So, it's not that hard to look good when one or more land in your class. Just stay out of their way, help where you can, and let them do their thing.

OPPOSITE: Garry Winogrand at Imageworks, about 1972–1973. Photo © David Godlis

ABOVE: Photo 101 class, New England School of Photography, Nan Goldin on the right, 1972

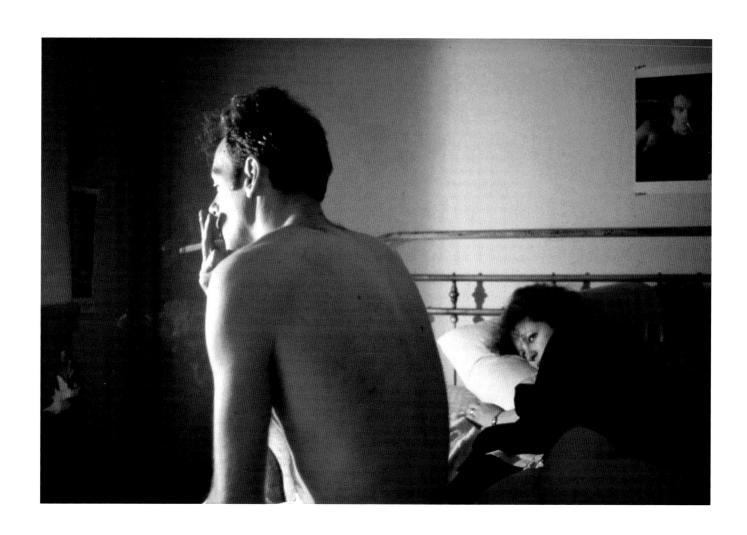

Nan and Brian in Bed, NYC, by Nan Goldin, 1983

One of Stanley Greene's images from his book *Black Passport*, 2009

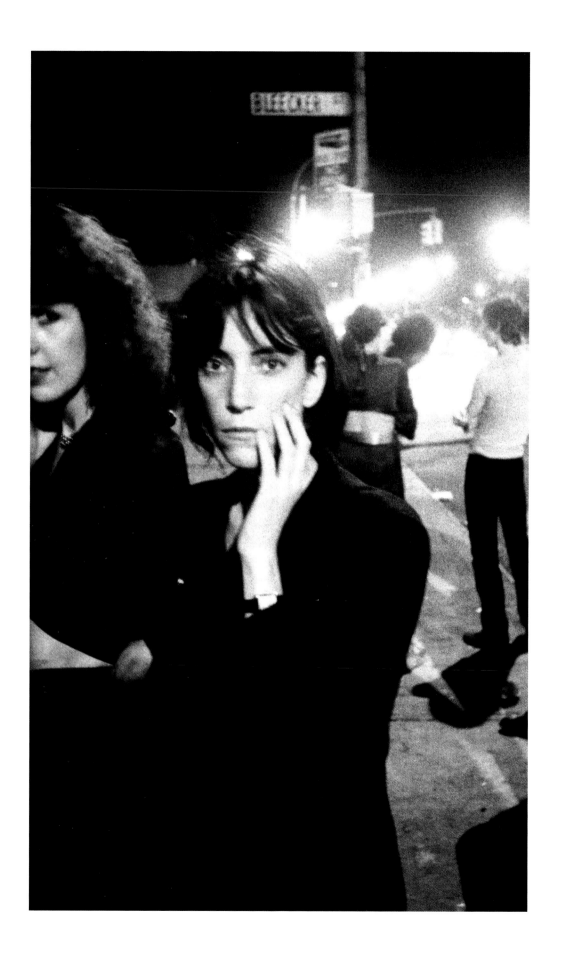

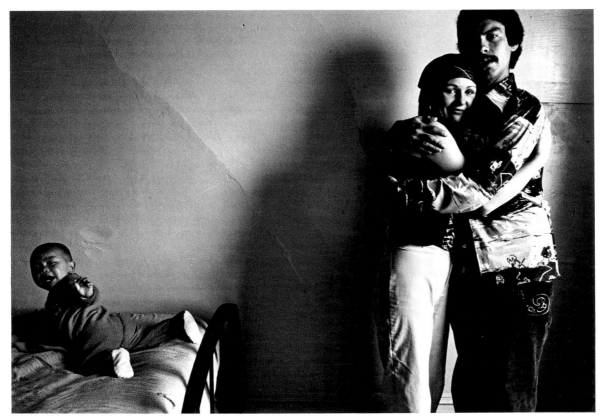

Me and Bobby been together for two weeks and we're still happy

Susie rm 54

OPPOSITE: David Godlis, *Patti Smith Outside CBGB, New York, New York,* 1976.

ABOVE: *Susie rm 54,* from Jim Goldberg's *Rich and Poor,* 1977

CLOSE RELATIONS
(1971–1976)

My very first "serious" photography project was not a project at all. It was a bunch of shots of random people in my life. A lot of photographers shoot family and friends, sometimes for personal, emotional, or even investigatory reasons. Some think that taking these pictures will get them closer to some sort of understanding or even healing.

No such thing was in my mind back when I took these pictures. I simply wanted to photograph strangers, but I was afraid to. So I shot family and friends because I knew they'd agree to be subjects, and I hoped this would maybe make me more confident. Maybe.

Students ask this question a lot: How do you approach and photograph strangers? It's less scary than you'd imagine. Ask ten people to pose and probably five will agree, two won't care, two will say no, and only one will become generally hostile or even violent. Not so bad.

Most important is to be direct and tell people what you want, I think. Most people will be flattered and willingly pose. Some will be embarrassed or indifferent—and some will simply turn you down. Their loss.

Ask ten times this week and ten the next, and after a while you'll end up with a lot of pictures. In time, it just piles up. And remember, don't take a "no" personally. It's your camera people are rejecting, not you.

Of course, not everyone wants to shoot posed subjects. Candids are a different matter. Shoot a lot and try to be anonymous, but not sneaky. If you're caught, smile and walk away. Or, go up to the accusers and chat with them. Tell them what you are doing. Hope for the best.

Years after I took those first photos I was cleaning up my studio and found a box of early photos. I had forgotten how many I had and how good they were. Maybe they weren't so great but I remember liking a lot of them back when I shot them. Turns out they aged well, as photographs often do. The hairstyles, the clothes, the cars, everything. Remember how bad Pabst Blue Ribbon tasted when you had your first beer, and how good it tastes now that it's vintage? Okay, it still doesn't taste that great, but…

So I edited through the work, went back to unprinted negatives, and made a book. I called it *Close Relations*, because it represents that time when you start to leave the family you were given for a new family—tight friends and community. Your posse.

These were my people. People I grew up with as a kid and friends I met along the way while making that awkward transition from adolescence to adulthood. Many of my subjects were close family, such as my parents Doris and Fred (Hot Dot and Fearless Fred), my sisters Ruth and Barbara, and any number of miniature poodles called Chammie (for Pink Champagne). My mother had a bad memory, so she decided to name all her dogs Chammie, figuring it would help her remember. Other subjects include

Henry Horenstein CLOSE RELATIONS

Introduction by Tom Magliozzi
Afterword by Shannon Thomas Perich

extended family, friends of my parents, and people whose names I never really knew at all.

I also included many of my first adult friends. These were my chosen family—roommates, girlfriends, drinking buddies. They all shared and shaped my life in some uncertain but important way. Unfortunately, I left a lot of people out for lack of a good picture. So forgive me Max, Eli, Abram, Hank, Dora, Frieda, Rhoda, Raymond, Morris, Allen, Lynn, Emily, Mark, Sharon, Jessica, Sue, Ingrid, Lewis, Joann, Margaret, Mary Lynn, Susan, Cat,

Bill, Lawson, Paul, Joe, Bob, Henry, Lisa, Jennifer, Mica, Peter, Jordan, and so many others.

You could view these pictures as a random collection of kooky shots from the early 1970s. It is that. But it also turns out to be a portrait of a unique place and time. A history, if you will.

ABOVE: Cover of *Close Relations,* published in 2007, more than thirty years after the pictures were taken

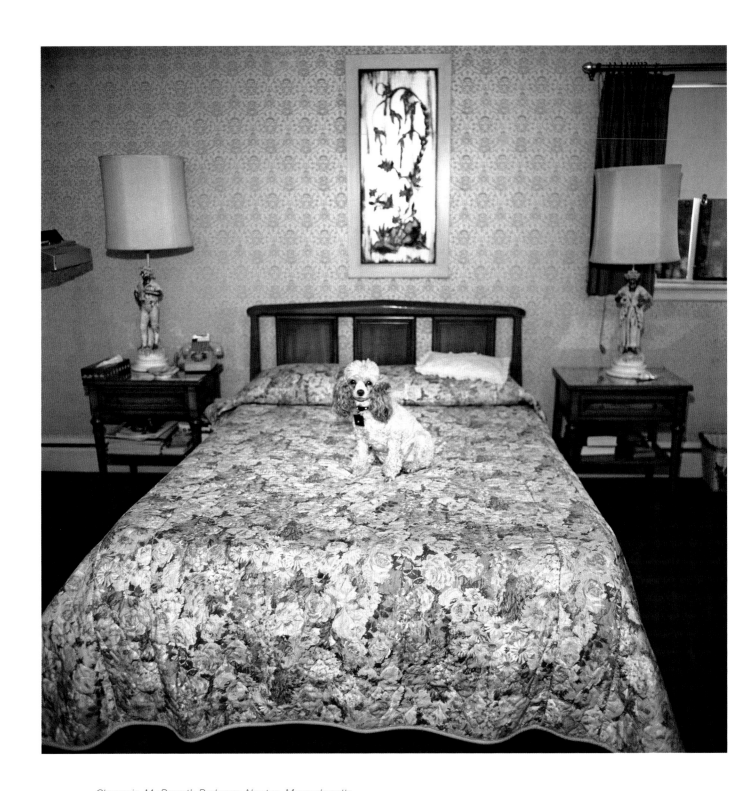

Chammie, My Parent's Bedroom, Newton, Massachusetts,
1972. One of my few color photos from this time

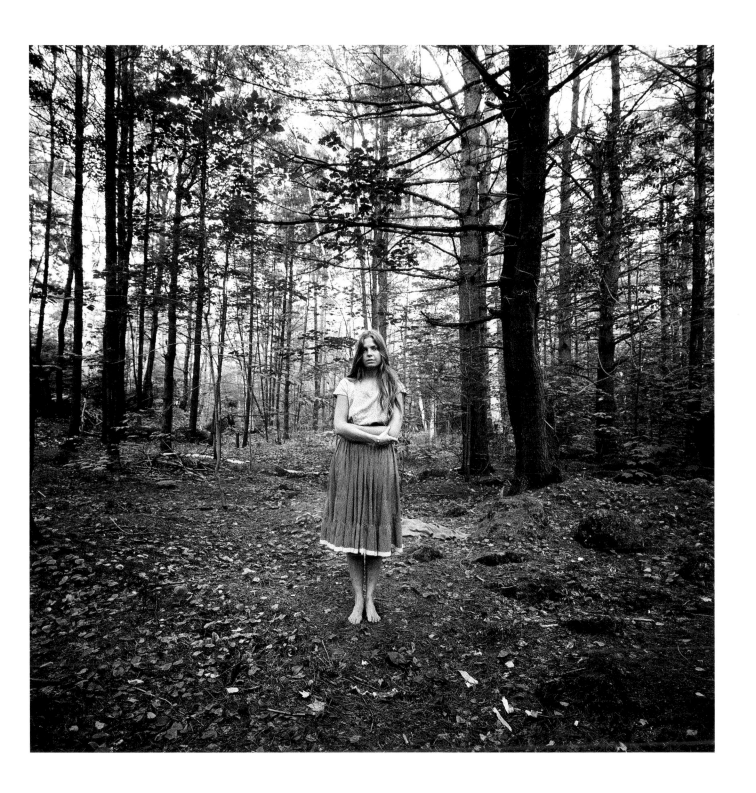

Roz, Hancock, New Hampshire, 1971

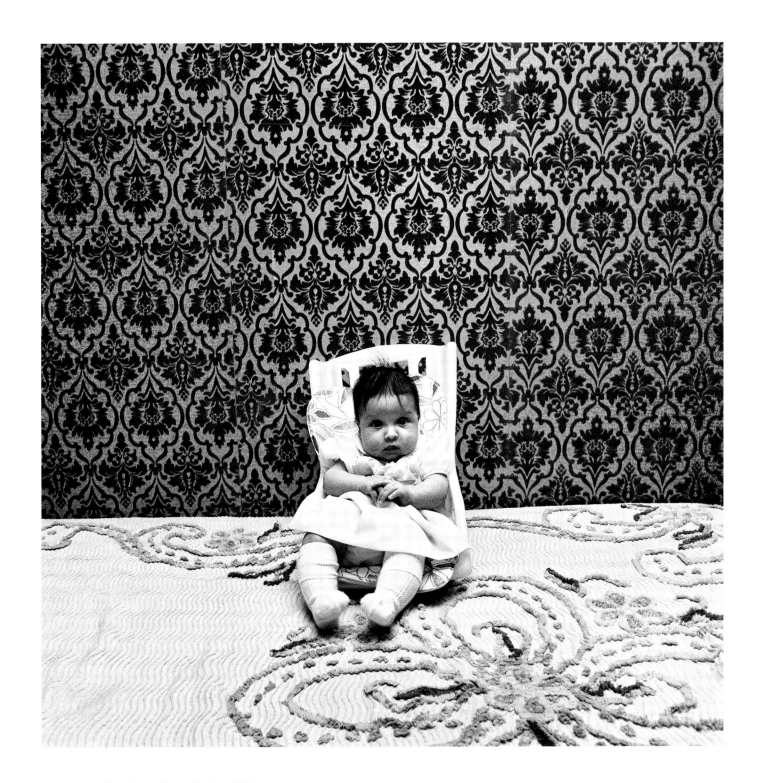

Christine at Home, Boston, 1972

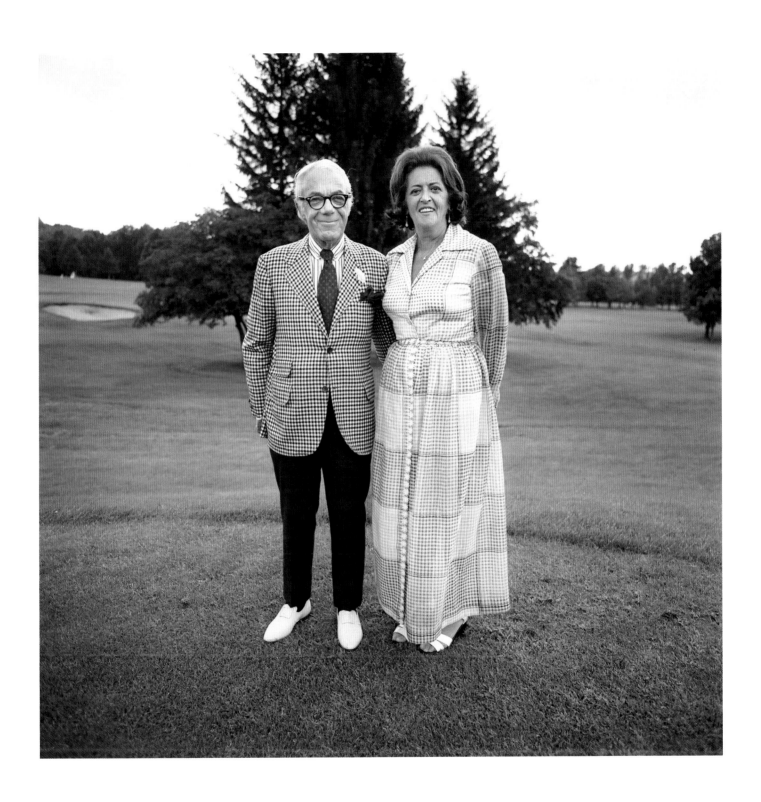

Mom and Dad, Golf Course, Brookline, Massachusetts, 1972.
More color!

PORTFOLIO: SPEEDWAY

In 1972 I worked as photographer for the weekly program of the Thompson Speedway, a stock-car track in north-central Connecticut. The track is still there, but the world has changed. You can see it in the styles of dress and hair and so much more. Here, my photographic heroes were the great chroniclers of urban life, Brassaï and Weegee. In *Speedway,* I wanted to do what they did—to show a slice now of what the world looked like then. Here, small-town New England 1972, dutifully recorded and preserved.

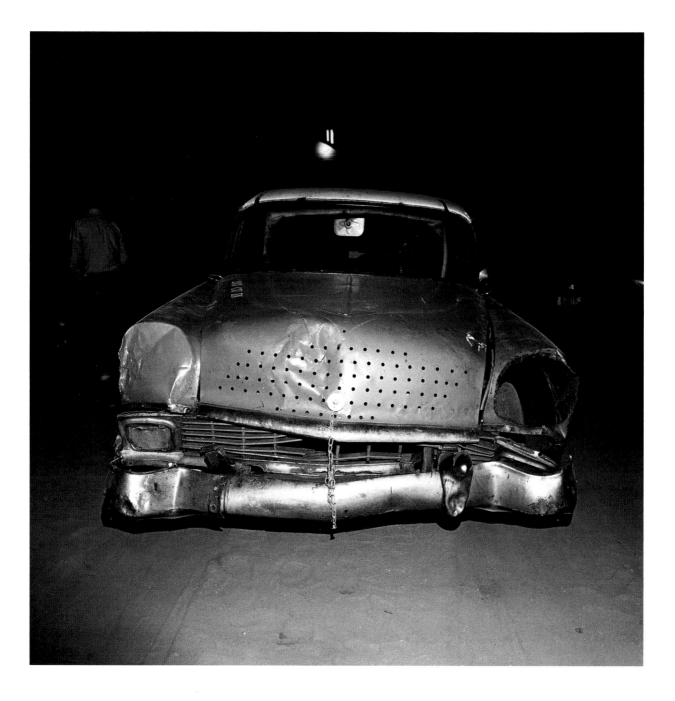

Stock Car, Thompson Speedway, Thompson, Connecticut,
1972

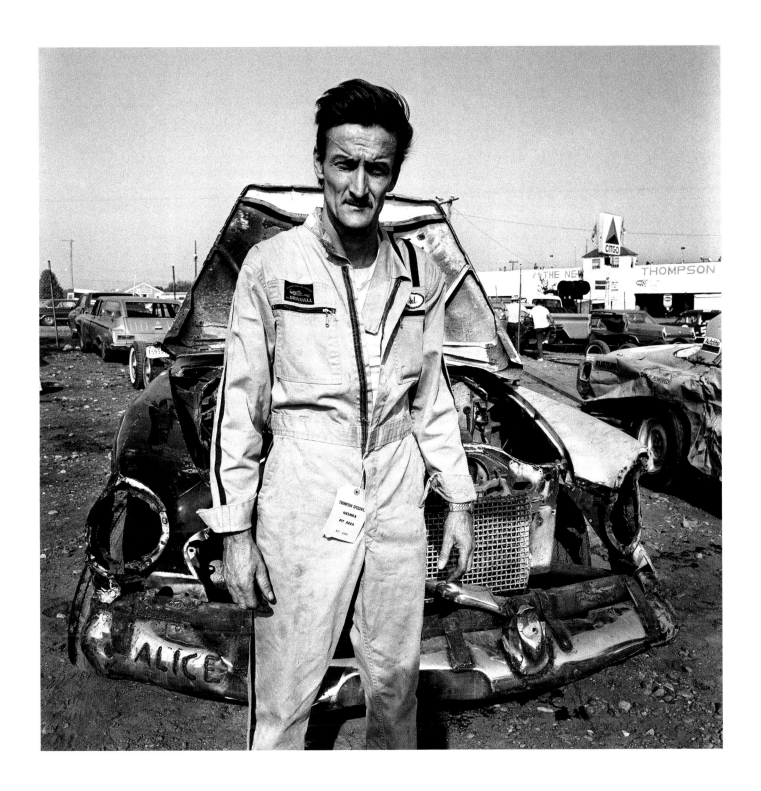

Del, Thompson Speedway, Thompson, Connecticut, 1972

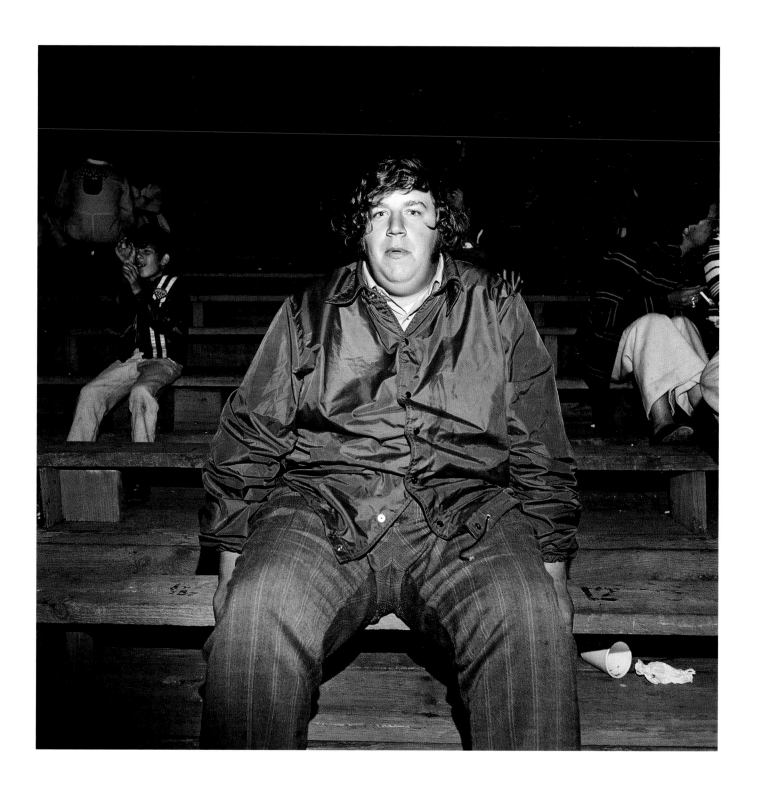

Solo Fan, Thompson Speedway, Thompson, Connecticut,
1972

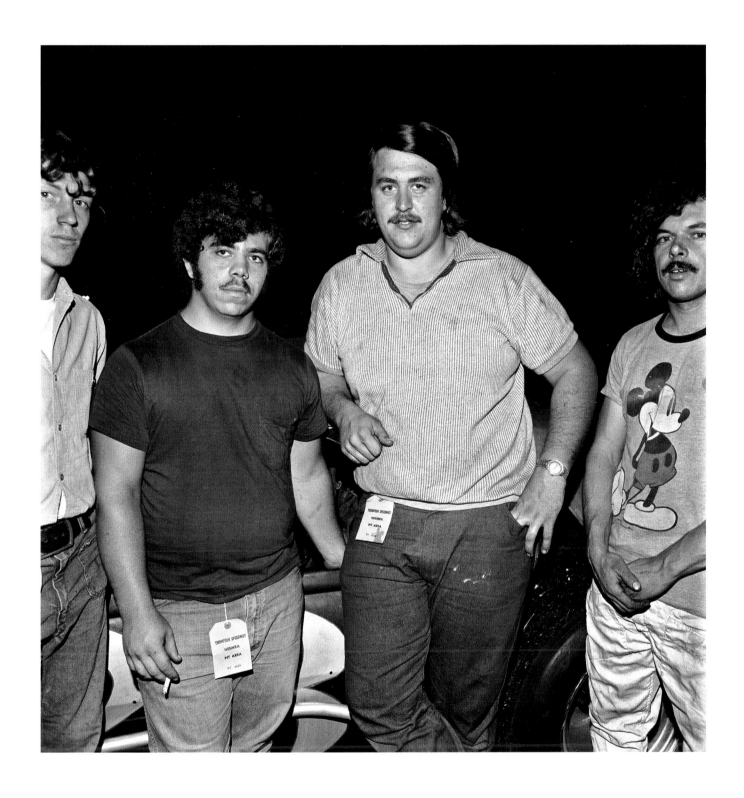

Four Boys, Speedway Fans, Thompson Speedway, Thompson, Connecticut, 1972

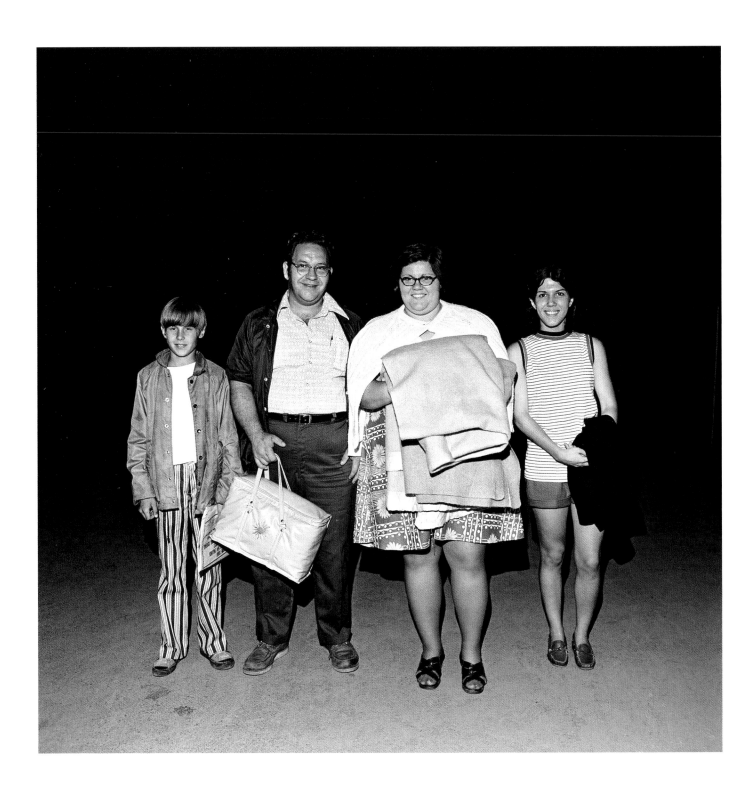

Speedway Family, Thompson Speedway, Thompson,
Connecticut, 1972

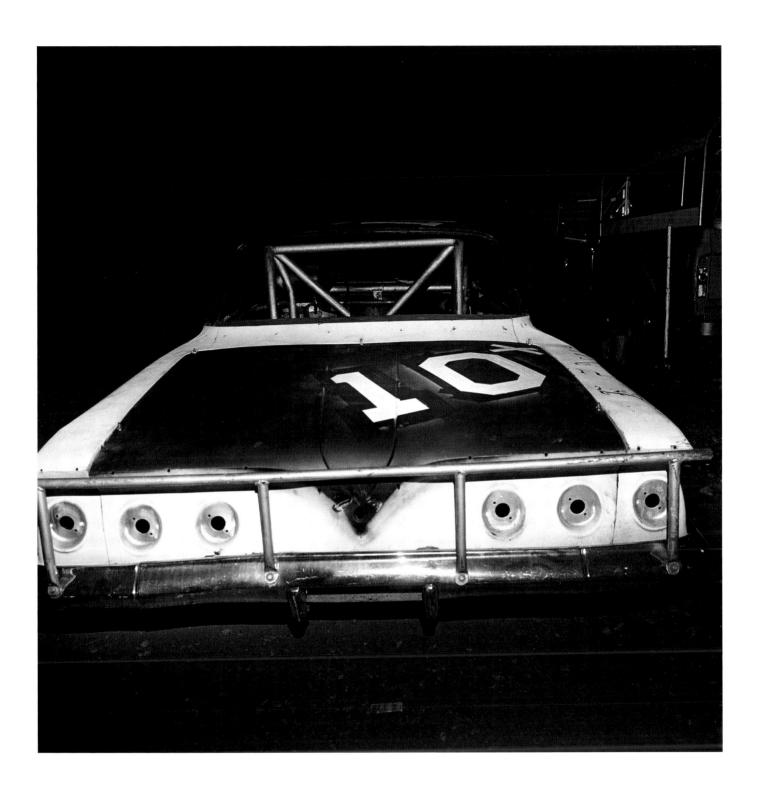

Car #10, Thompson Speedway, Thompson, Connecticut, 1972

THE BOOK (1974)

While teaching at Project, Inc. I received a series of phone calls, one after another.

"Hey Henry, I'm writing a book on how to weave. Can you take some pictures for it?"

"Guess what? I'm going to do a basic painting text-book and I need some pictures. Can you help?"

"Norman here. Someone asked me to write a basic ceramics manual, and I need photos. Can you do some for me?"

I agreed to take the photographs, but what I really wanted was to meet this "someone." Turns out his name was Dick McDonough, and he was an editor at Little, Brown, and Company, an old-line Boston publisher (now a part of the Hachette publishing behemoth). I called him up, and he actually answered the phone. These were simpler times. Today you would have trouble getting an editor's phone number, and it's a dead certainty that you would get a voicemail recording or, at best, an assistant would pick up and put you off—if they bothered at all.

I explained why I called. Dick said he was commissioning a series of craft manuals—how-to books. Did he have a book on photography?

"Hmmm, that's a thought. Send me a proposal."

Now I just had to figure out what a proposal meant. Can't recall how I found out, but here it is. One page explaining what the book was about and who would buy it. A table of contents detailing what the book would cover. And a bio or resume with a writing sample to prove that you're the one to write it. Forty-plus years later, this is still a pretty good prescription for a book, or even grant, proposal.

I sent the proposal a couple of weeks later and got a call from Dick asking me to lunch at Locke Ober, a Boston business institution, way above my pay grade. I wished he'd added that the publisher would pay for lunch, as I worried about that throughout the meal. Finally, he flashed his company AmEx card when the waiter dropped the check.

Dick made me an offer I couldn't refuse. Actually, I wouldn't have refused any offer, and I'm sure he knew that. They would pay me a $2,000 advance on royalties ($1,000 on signing and $1,000 on delivery), and I had to produce the book in nine months. Text and illustrations.

Now I had to do it. I think that most people who are fairly smart and well educated think they know how to write. This is simply not true, as I was about to discover. Maybe an email or a postcard or even a short paper, but a book is another kettle of fish. I was twenty-six and knew shit from Shinola about writing a book, not to mention book publishing. But I'm not too proud to beg, and I got a lot of help from friends, especially my ex, Margaret Harris. Even her father, Chauncy, a distinguished professor at the University of Chicago, weighed in. To this day I recall his simple but wise advice whenever I sit down to write almost anything. "Put the main point of each paragraph in the very first sentence, Henry."

Thanks, Dad.

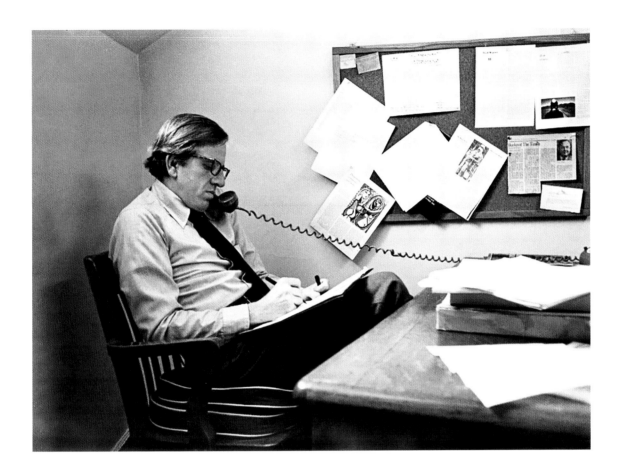

Actually, I had been thinking about writing this book for a while. In the early 1970s there were few, if any, basic instructional books on photography. Ansel Adams wrote some sophisticated ones, and top photojournalist Andreas Feininger wrote a best seller, as did an advertising guy named Aaron Sussman. These books were well known and mostly meant for hobbyists—camera clubbers. There weren't simple textbooks on basic photography meant for class use. That's mainly because there were hardly any classes.

Chuck Swedlund, a photographer/teacher from Southern Illinois University, had recently self-published a book called *A Guide to Photography*, and it was very good, really perfect for a basic photo class. But it was self-published and not especially well designed or printed. It also couldn't be found in bookstores. I thought I could do better. If I could find a way to publish it. In walked Dick McDonough.

Anyway, the book, *Black and White Photography: A Basic Manual*, got done and it was a hit. I wrote two more editions over the years and total sales have exceeded 700,000 copies. I thought, "This is easy." Note: I was wrong.

The book still sells a bit because film and darkroom use continues, mostly in schools, but sales have slowed considerably after forty years. Meanwhile, I have written several other instructional books—*Beyond*

ABOVE: My first editor, Dick McDonough, Little, Brown, 1976

BLACK AND WHITE PHOTO GRAPHY

A BASIC MANUAL

Henry Horenstein

A TECHNICAL MANUAL
BEYOND BASIC PHOTOGRAPHY

HENRY HORENSTEIN
DRAWINGS BY HENRY ISAACS

Color Photography

A WORKING MANUAL

Henry Horenstein

Author of the classic *Black & White Photography*

Digital Photography
A Basic Manual

Henry Horenstein
Author of the classic bestseller *Black and White Photography*

Basic Photography, *Color Photography*, and plain-old *Photography*, cowritten with friend and sometime collaborator Russell Hart. In 1983, I even wrote an introductory book with another friend, Eliot Tarlin, on computers, called *ComputerWise*.

Fast forward to 2011, when I wrote still another book, *Digital Photography: A Basic Manual*, with considerable help from my studio manager, Allison Carroll. It's the same book as *Black and White Photography*, except I substituted sensor for film and illustrated it with color images as well as black and white.

All these books have this thing in common: They are simply written and assume the reader knows nothing. I believe that's the best way to teach, whether in a classroom or in a book. But also I'm a bit of a technophobe—not so smart about deep technical matters, and not all that interested, either. I wrote the books for me, so I would better understand a subject I was destined to teach for decades to come. And also for the cash.

Back in 1974, when I had just finished my first book, I ran into a fellow RISD grad student (and a real-deal techie) in Harvard Square soon after graduation.

"I hear you just wrote a photography text book."

"I did."

"I should have written that book."

But, of course, he didn't.

When I turned in the manuscript, I thought I was out of the woods. But editor Dick said they needed a cover image, and, per contract, I had to provide it. My own pictures were about hillbilly singers, funny Jewish relatives with small poodles, and greasy-faced stock-car drivers. Even a publishing-challenged twenty-six-year-old knew

that these weren't the kinds of photographs that would help sell a basic instructional book.

I imagined a beautiful landscape or still life, but that was never my game. However, it was Harry Callahan's. I was in my second year of grad school, having never told anyone I was doing the book. I went up to Harry and confessed.

"So, I have been writing this basic book on how to make pictures, and it needs a cover picture. I thought of your *Chicago, c. 1950*, and wondered if there's any way I can use that."

"Sure. I'll bring a print tomorrow. Just make sure they give it back when they're through with it."

True to his word, Harry brought in a beautiful print and I delivered it to a relieved Dick McDonough. A few days later, Harry came up to me.

"I was thinking about that print and the book."

My stomach dropped.

"Don't worry, you can use it. But the publisher really should pay me something. It doesn't matter how much. Just something. It's the right thing."

I said I would ask, and we said good-bye. Then he turned back. He had read my mind.

"It's the publisher that should pay something. If it comes out of your pocket, I don't want it."

They paid $100, and Harry claimed to be happy with that. For the second edition, they wanted the same picture and paid $2,000, because the book was making money. For the third edition, they paid Harry's estate $5,000.

FOOTLOOSE AND FANCY FREE (1970s)

When I started out, I hoped to get editorial work, shooting for a newspaper or magazine or some such. Magazines ruled in those days, and most photographers shot for magazines, even photographers whose work is now in major museum collections. *National Geographic* was the top of the heap for editorial shooters. They had large staffs of photographers, and they spared no expense if the story was right and a half reasonable case could be made.

Helicopter for three days seeking out an endangered elephant herd in Central Africa? No problem. Six months in some obscure southwest Cambodian village to document an equally obscure religious ceremony? Go for it. Hiring six natives to crew a canoe down a toxic Latin American waterway? Absolutely. Hell, buy a few canoes while you're at it.

They say the Internet killed all that. Or, was it common sense? Magazines overspent like crazy. They were making a ton of money, so why not pass it on to the photographers and writers? No doubt they got better depth in their stories that way. You'd think.

The Internet was not the only factor in the demise of magazines, or for that matter newspapers, which were undergoing similar hard times. Crippling economic climates in the mid-1970s, early 1980s, early 1990s, and early 2000s forced publishers and other businesses to look hard at their budgets, and when they saw a bulge they sliced it off. Except maybe for those corporate jets and executive bonuses. There are precious few staff photographers for any magazines these days, and the staffs of all newspapers have taken a brutal hit.

So, off to the Internet they went. As we all have. The Internet is great at delivering news and all forms of content. What it isn't very great at is paying real money to its photographers and other content providers. So there goes editorial photography. Pretty much. Unless you undertake your own projects. Raise the money yourself, by begging or crowdsourcing, or raising the credit limit on your Master Card. Then, try to make hay of the work. Find a magazine, website, or other outlet willing to pay, maybe. Get a grant or sell a few prints. Convince a school to let you teach a class or workshop. Marry rich.

For this young photographer straight out of art school in the 1970s, editorial work looked pretty good. At one point, I really wanted to work as a photojournalist—go to wars and other conflict zones. Make the world a kinder place thorough photography, like some of my photo heroes, Robert Capa and W. Eugene Smith.

Then I had a reality check. My friend Mark Starr was headed to Nicaragua for the *Chicago Tribune* to cover the cruel revolution there. He called and told me to fly down. I could stay with him and feed on his expense account.

Since there weren't many photographers there, he was sure I could sell pictures.

I was excited. For about a day. And then I was scared. I could get hurt or killed down there. One top photojournalist, Olivier Rebbot, was killed and another, Susan Meiselas, was badly wounded. I didn't go down to Nicaragua, where Susan was the first journalist on the story and basically forced the world to deal with the crisis through her fine photographs and reporting. When Mark came back home, he told me he worked with Susan and that "he was relieved that she was willing to let us into her war."

Good for her. It was her story. And her possessive attitude was no doubt instrumental in getting her job done. The best photojournalists are like that, especially if they work in wars and other conflict areas. And that's when I knew I was destined for softer stories/projects.

The alternatives were bleak or worse. There was advertising work, but that would mean selling out. God forbid. Besides, I wasn't getting any offers. There were weddings and events. Not for me, though I have shot a few in my day. And there was fine-art photography. Ha! There were people like me who thought of themselves as artists, but we weren't fooling too many others. There was no market for what we produced. There are still not a lot of photographers making bank on print sales, but at least there are now galleries, collectors, curators, and the hope of good things down the road. It happens to a lucky and talented few.

* * *

So, I put together a portfolio, actually several portfolios, over the years. When I say portfolio, I mean a physical portfolio—usually a box or binder filled with real prints. Today, a good website and images for display are all you need to show your work, though some deciders still want real prints, especially for art projects, exhibits, and grants.

One nice thing about a website is that it acts as a filter. If people see your site and like it, maybe they will make an appointment to see you or at least communicate by phone, email, text, Facebook, Instagram. Whatever you got. If they don't like it, or it's just not going to work for them, they won't waste their time, or yours, with further communication. It's a cold, hard world out there. Just ask country singer Hank Williams, Jr.

"Pride's not hard to swallow when you've chewed it long enough."

It's best to not take rejection too personally; you aren't being rejected, your work is. And the reason isn't necessarily that the work is no good. Maybe it just doesn't fit what the decider had in mind. Or, maybe they have a regular business relationship with enough photographers that they don't need to add another one. Or, maybe they have a personal relationship with a photographer, if you know what I mean.

Or, maybe your work does suck.

So, what did I do in my freelance career? One of my first assignments ever was to illustrate a book for an educational consulting company. This was 1974. There were lots of such firms in Cambridge, where I lived, probably because of all the universities there. Graduates had to find some way to justify their advanced degrees.

The book was called *Drugs and You, Too*. And it was meant to educate kids about the evils of drugs. It went

deep into the options, from caffeine to more serious stuff. My pictures were in black and white and they were badly printed. I doubt they convinced anyone not to do anything except maybe never to become a photographer.

There was no budget to speak of, so I convinced my family and friends to model as drug abusers. Fortunately, it wasn't much of a stretch. I know a lot of narcissists and they love attention and notoriety at any cost. So, my mother took too many pills; my sister smoked weed. Whatever came naturally.

I did lots of other freelance things. I shot some for Rounder Records, which started as a tiny operation in an apartment in Somerville across the street from me, and grew into a major player in what became known as Americana music—country, blues, bluegrass, folk, and so forth. The main Rounders were Bill Nowlin, Ken Irwin, and Marian Leighton. I knew Bill from the history department at U of C and Ken from basketball camp. We were the two shortest guys in the annual camp picture. And I knew Marian from Bill and Ken.

For Rounder I usually shot album covers or publicity pictures, some of which landed years later in my book *Honky Tonk*. And speaking of low-to-no-paying jobs, I also shot for *Bluegrass Unlimited* magazine and *Muleskinner News*, where I was briefly listed as photo editor. Woohoo.

Then there were two years as staff photographer for *Boston After Dark* (later called the *Boston Phoenix*), an alternative weekly. "Staff" meant my name was on the masthead. I got paid only when my pictures were used. Ten dollars each time. Not so bad, when I think back. I made some pretty good photos for the *Phoenix*, including shots of Dolly Parton in 1972. I was star struck and a little in love when I met her, but managed to ask why she dressed and appeared as she did.

"Honey, people don't come out to see me looking like them."

Good advice for entertainers and good advice for photographers, too.

The *Phoenix* was a training ground for many good journalists of all kinds, including music writer Peter Guralnick, who wrote the definitive two-book biography of Elvis Presley; critic Stephen Schiff, who moved on to *Vanity Fair* and Hollywood screenwriting; cartoonist David Sipress, whose hilarious work is still featured in the *New Yorker*; best-selling author Anita Diamant; and many, many others. The alpha photographer on the *Phoenix* was the underrated Jerry Berndt, whose fine, gritty work has started to trickle out after his death in 2013.

What else? I was very briefly a stringer for *Time* and *Newsweek*. Stringers are freelancers hired as needed to work on local stories. I didn't do much of that, but I did get to shoot author John Updike and Senator Ted Kennedy, classmates, at Harvard's twenty-fifth reunion weekend. John was polite, charming, and cooperative. As for Ted, let's just say I prefer poets to politicians.

Then, there were photographs illustrating the book *Street Smart: The Guardian Angel Guide to Safe Living*. That was a hoot. The Guardian Angles still exist, but in the '70s and '80s they were quite popular and present—an extra-legal (okay, illegal) band of enforcers who patrolled New York and other cities, doing the work they said the police were unable or unwilling to do. From their website: The GA "remains a volunteer-based organization made up of dedicated individuals who generously donate

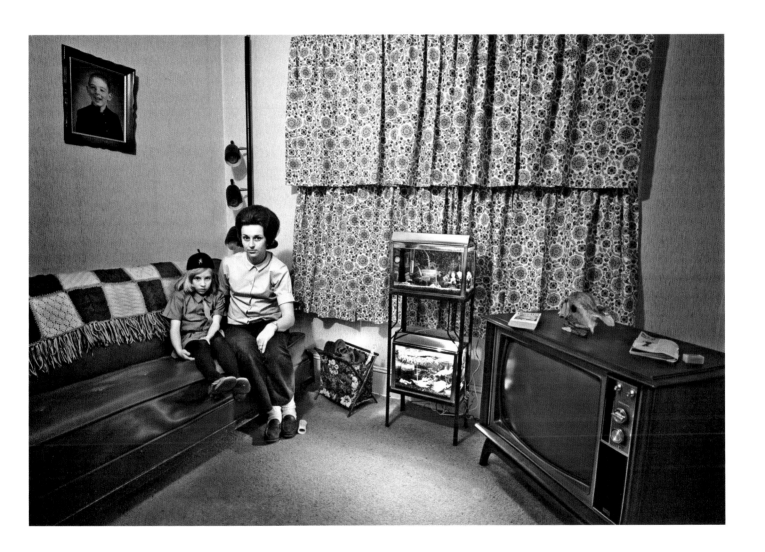

*Barbara's Friend with Daughter, New Bedford,
Massachusetts*, 1972

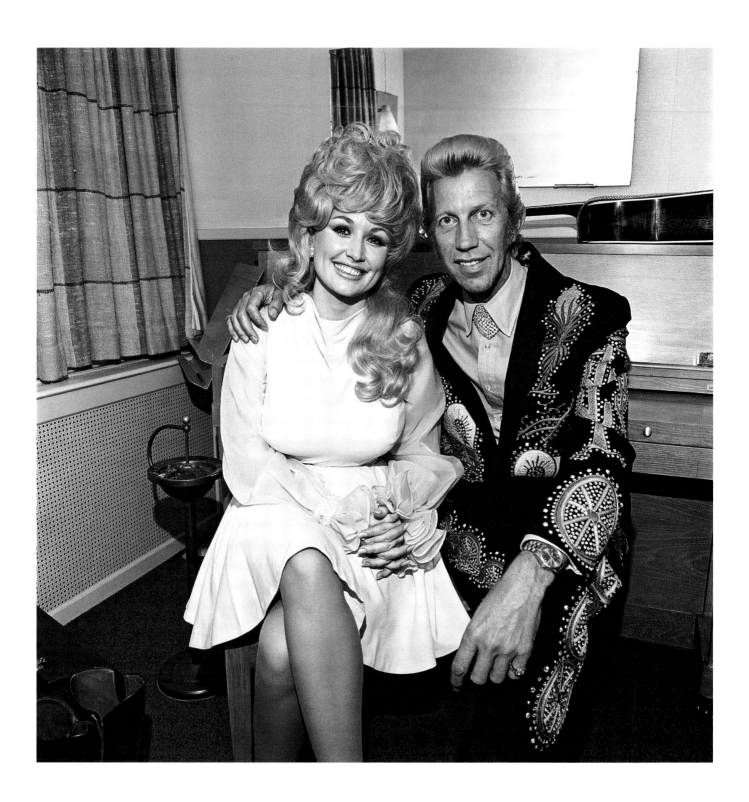

their time and energy to help protect communities around the world. A unique feature of The Guardian Angels approach is the group's inclusion of inner city youth in the safety patrols."

Sound safe to you?

In 1979, I spent six weeks working for the American Folklife Center at the Library of Congress. Folklife is basically folklore with a PhD. It's not practiced by the guy who collects Indian arrowheads, but rather by the guy who writes 200-page theses on the meaning of arrowheads.

This was a great gig. For what was called the *Rhode Island Project* I traveled the state with various folklifers, documenting French Canadian beach culture, the remains of the old textile mills, and a few African-American churches. Why was this important enough for the Library of Congress to spend our tax money on? The honorable Claiborne Pell of Rhode Island was on the U.S. Senate Committee on Appropriations. Follow the money.

I should cut Senator Pell some slack. He authored the bill that established the Pell Grants, scholarship money for disadvantaged kids to attend college—one of the few things your government does to help make higher education affordable and equitable. Oh, the other thing he did was to extend visas for foreign students so they could stay in the United States and pay full tuition to our overpriced schools. My school included. I love my foreign students and I think they've done a lot to broaden minds and human understanding, but schools often favor them not for the diversity they bring, but for the cash.

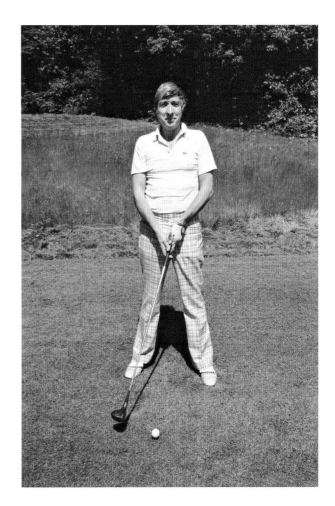

OPPOSITE: *Dolly Parton and Porter Wagoner, Symphony Hall, Boston,* 1972

ABOVE: John Updike, Harvard Class of 1954, for *Newsweek,* 1979

PAGES 70–75, LEFT TO RIGHT: My images for the Rhode Island Project, American Folklife Center, Library of Congress, 1979: *Camper • Preacher • Sand Horse • Counter Man, Diner • Running Home*

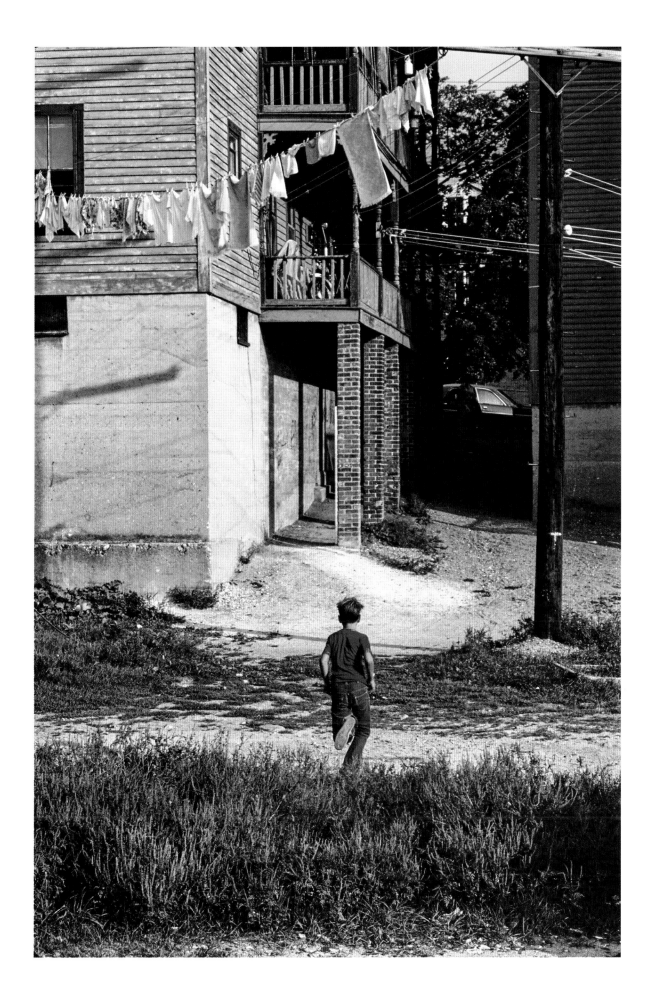

RACING DAYS (1976–1987)

Although he long denied it, Brendan Boyd was the first person to take me to the racetrack. I met Brendan through Dick McDonough, who was also his editor at Little, Brown, and Company. Brendan had just coauthored what became a pop-culture classic, the brilliant *The Great American Baseball Card Flipping, Trading and Bubble Gum Book*, which virtually started the entire baseball-card-collecting craze. Despite that, it's a really good book.

We went to Suffolk Downs, the now-defunct Boston racetrack, home of hard-nosed horse players and low-priced claimers, and Brendan showed me the ropes. I became addicted to the whole thing. The races, for sure, but also the betting. I knew I had to photograph there. It was such an obvious subject, and to me subject is always number one. If you have a good subject, you increase your chances of success exponentially. At the racetrack, I had horses, jockeys, crowds, and no end of characters. Moreover, it fit perfectly with my history lessons. This had the looks of a disappearing world that needed someone to preserve it. Move over Nathan Detroit.

I walked in with a bit of history with gambling, I'll admit. I like poker. Not the kind they have on TV. I'm far too good looking for that crowd. I think it goes back to when I was a kid. I used to play canasta with my sisters and usually won. We bet our allowance, short money for most but serious enough for young teenagers. One day my dad asked to sit in, and he took a year of my allowance in about thirty minutes. Dad was a card counter, but he didn't believe in gambling; with friends he played gin for matchsticks. The whole exercise was to teach me a lesson, and it did. Never ever gamble with someone you can't beat.

That's what you were getting at, right Dad?

Anyway, I really got interested in racing one cold January afternoon at Suffolk Downs. I met this old-timer between the first and second race.

"How's it going?"

"I got the first end of the double boxed with the 3, 7, and 8. So pretty good." (For the uninitiated, the number identifies a horse, so the 3 is wearing that number on his saddlecloth.)

"Well, I hope you have a big day."

"Son, I'm just hoping to break even. Lord knows I can use the money."

This was an oft-repeated lament of racetrackers everywhere. But it had a familiar ring. It works for artists, too. Some days break-even is cause for celebration.

So, I would go to the track with Brendan or other friends I could talk into it. But more often I went by myself. It's a great place for self-reflection. Twenty minutes between races leaves plenty of time for deep thinking. Thoughts like: Can the 3 horse handle a muddy track? Did the trainer work the 8 too hard in the week before the race? Did the favorite, the 6, have an excuse last race when he was carried wide on the turn for home? And did the jockey deliberately engineer the bad trip?

THE DEWITT CLINTON
PURSE $67,900
AQUEDUCT, NEW YORK MARCH 29, 1987
OLD EMPIRE STABLE OWNER OMAR KHAYYAM JEAN-LUC SAMYN UP
L.H.VEITCH TRAINER 7 FUR.TIME 1:23:1
HOT AMBER 2nd-PRESENTATION BY MR.BILL DREW-LONE QUADRANT 3rd

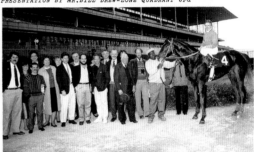

Like that.

Suffolk was an ugly track with broken-down horses and used-up jockeys, so I started traveling to other tracks, in particular Saratoga Springs in upstate New York, a mecca for horseplayers and a world apart with its strawberries-and-cream breakfasts and million-dollar thoroughbreds. I went for thirty-plus years straight, starting in 1974, the year after Secretariat won his Triple Crown. In my salad days at Polaroid, I even bought a house in Saratoga so I could spend the entire month of August at the races with my dog, Jenny. Off-season I rented it to kids from Skidmore College.

All along I brought my quiet and compact Leica M4. Some days I'd get so wrapped up in my betting that I didn't take a single picture. In fact, one sunny day at Monmouth Park in Oceanport, New Jersey, around the seventh race, I noticed that I didn't have my camera with me. I retraced my steps and found my little Leica on the bench where I had handicapped the second race. It had been sitting there undisturbed for more than three hours. It's not that racetrackers are honest so much as they are distracted.

Anyway, I met random people at the track over time, and in 1986 ten of us bought a two-year-old racehorse called Omar Khayyam for $5,000—five hundred bucks each plus a tenth of the maintenance. Our trainer was Leo Veitch, brother of Racing Hall of Fame trainer Sylvester Veitch and uncle of John Veitch, also in the Racing Hall of Fame. Leo was not in the Hall. Sylvester and John trained for the Vanderbilts and the Whitneys. Leo trained for ten guys with disposable income of just $5,000.

Leo was horse-wise, talented, and cranky. But little Omar didn't care. He had a lot of heart and won early and with conviction, piling up winnings in two years of more than $300,000. At the track, they say Omar outran his breeding.

Sadly, we took what was left of our winnings (think Hollywood accounting) and put them into four other not-so-cheap horses. Three had a variety of injuries and only raced a total of four times. Another named Del Viking broke his maiden (won his first race) at Saratoga after only three tries, and then dropped dead of a heart attack the next week while galloping in the early morning.

I continued to go to the track, but I went strictly for pleasure. Finally, around 1985, I convinced Brendan to join me in trying once again to publish a book. The idea of doing a truly collaborative book appealed to me. It's the very rare racetracker who knows racing and can write brilliantly. Also, we had been going to the track together for many years and shared a common perspective. A perfect storm.

ABOVE: Omar Khayyam in the Winner's Circle, the DeWitt Clinton Handicap at Aqueduct Race Track, Ozone Park, New York, 1987

For the next eighteen months, we pored over old photographs and discussed what we needed to shoot and write about. When I could find the time, and the money, I made several additional trips to a variety of racetracks to finish shooting. I got up early every morning to photograph horses working out and the activity on the backstretch, where the horses and often the track workers lived. Each afternoon, I would shoot the action at the track. Only occasionally would I take the afternoon off from shooting and study the *Daily Racing Form* (think the *Wall Street Journal* for the racing crowd) and place some bets.

While I was having fun, Brendan stayed home and wrote to the pictures. Well, actually, he wrote whatever he felt like. We decided early on that we would look at each other's work and make comments and then leave it alone. What Brendan wanted to write in the final analysis was his business; the same for what I wanted to shoot. No negotiation.

We had two models in mind for the book. One was August Sander, the graceful German photographer, who worked mostly between the two world wars. Sander set out to document the breadth of the German people, cataloguing them meticulously according to class, jobs, region, ethnicity, and so forth. Turns out not all Germans were blonde and mighty. Take that, Adolf.

We tried to do that for racing, a far less daunting and ambitious task. But we made lists of what we wanted to cover—to shoot and write about. Trainers, grooms, owners, and even the guys who catch urine for drug testing. We also wanted to cover moments, such as cooling down

a horse after a workout and horses breaking out of the gate and then turning for the home stretch. And also that delicate moment called jockey's excuse, where the jock explains to the trainer (and sometimes the owners) why their most excellent horse lost even though he (the jockey) gave a near-perfect ride.

The other model for the book was *Looking at Photographs* by legendary museum curator John Szarkowski. It's a brilliant book that any photographer should know. Simple, really. Open it and there's a photo from the Museum of Modern Art collection on one page of the spread and Szarkowski's thoughts about it on the opposite page. Sometimes he wrote about the photographer, sometimes about the moment or ideas that drove the image, and sometimes about whatever the hell he wanted to. The writing is wonderful and readable. No art speak. The way all histories and criticisms should read, and too few do.

There is a history of art and horses, by the way. Painting and sculpture with horseracing and other equine subjects have long been exhibited and collected privately and by museums. In my experience, however, the only real connection is Big Bob, a racetrack friend who surprised me between the fourth and fifth race at Saratoga by announcing he had a job.

"I'm chauffeur to Agnes Gund."

Agnes Gund was president of the Museum of Modern Art at the time.

"I thought you'd be interested. I pick up visiting artists at the airport and bring them to their hotel. Things like that."

"That sounds interesting."

"Got to tell you, Hank, artists are assholes."

ABOVE: Press pass from Santa Anita Park, Arcadia, California, 1985

OPPOSITE: *Seattle Slew, Winner Triple Crown 1977, Three Chimneys Farm, Midway, Kentucky,* 1989

OVERLEAF: *Secretariat Takes a Bath, Winner Triple Crown 1973, Claiborne Farms, Paris, Kentucky,* 1989

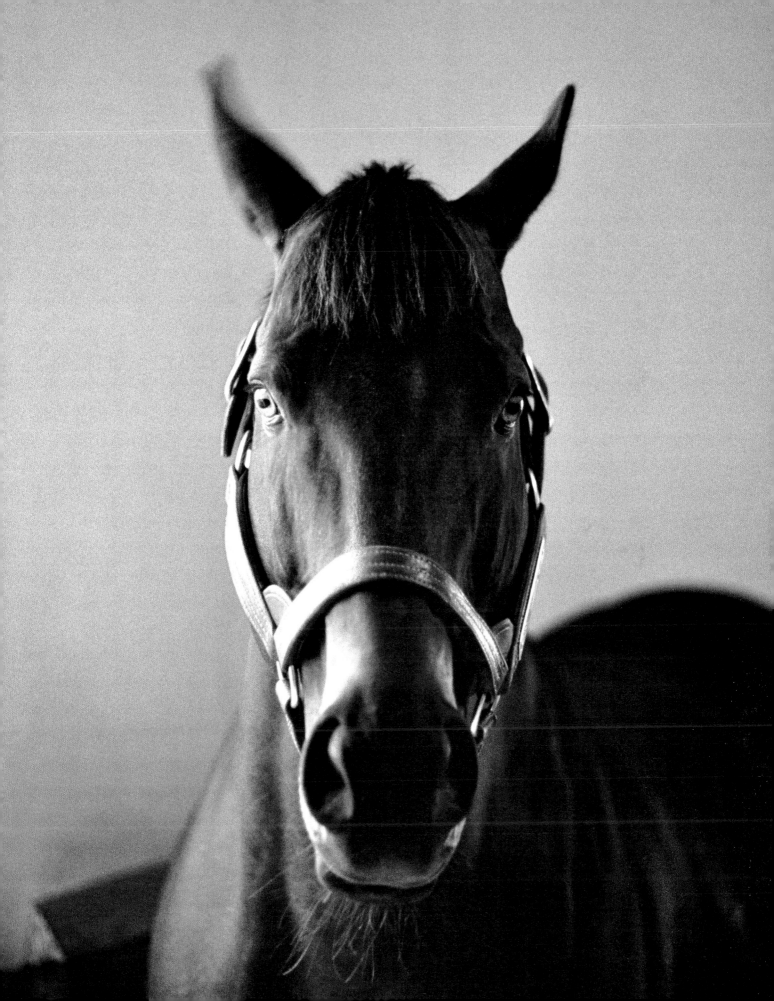

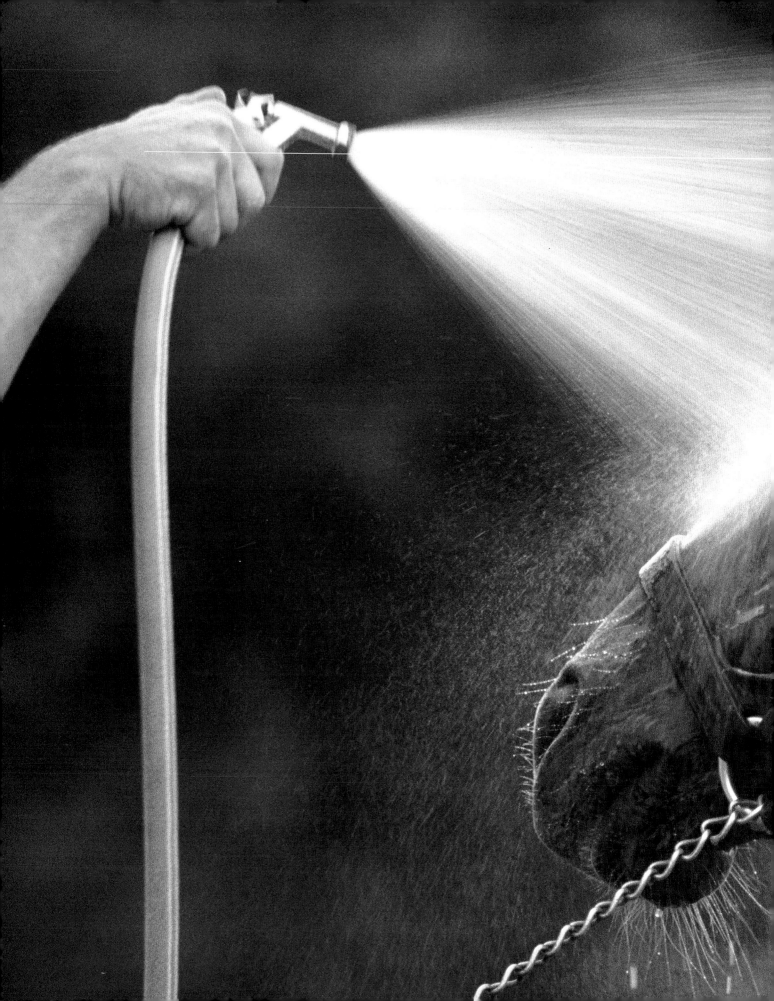

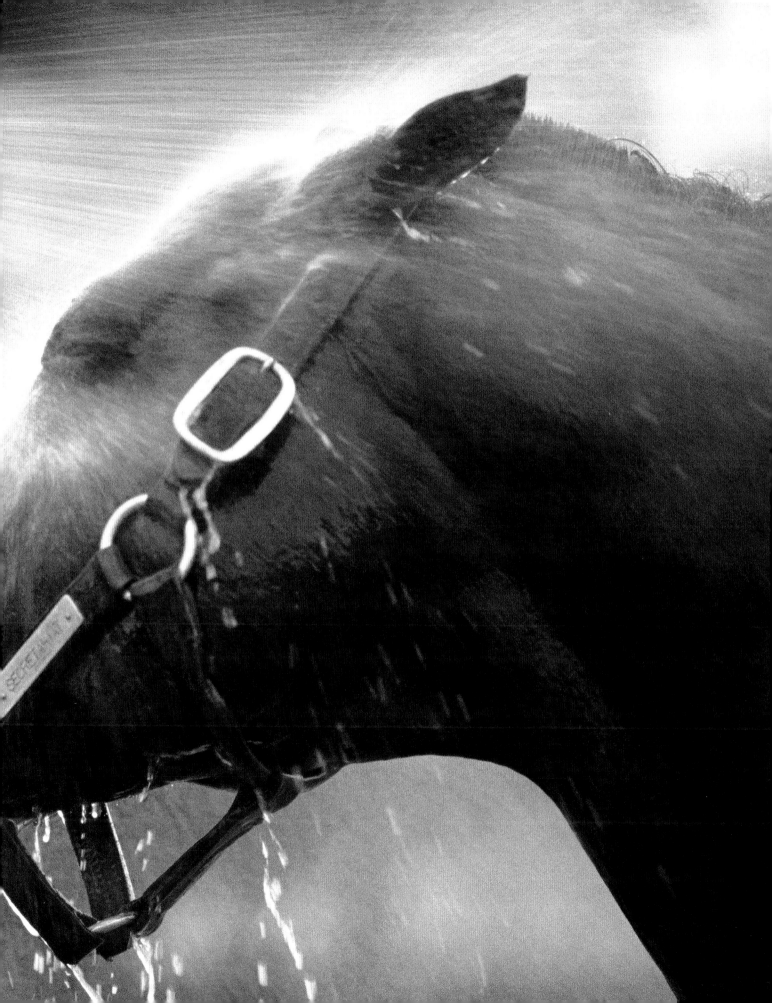

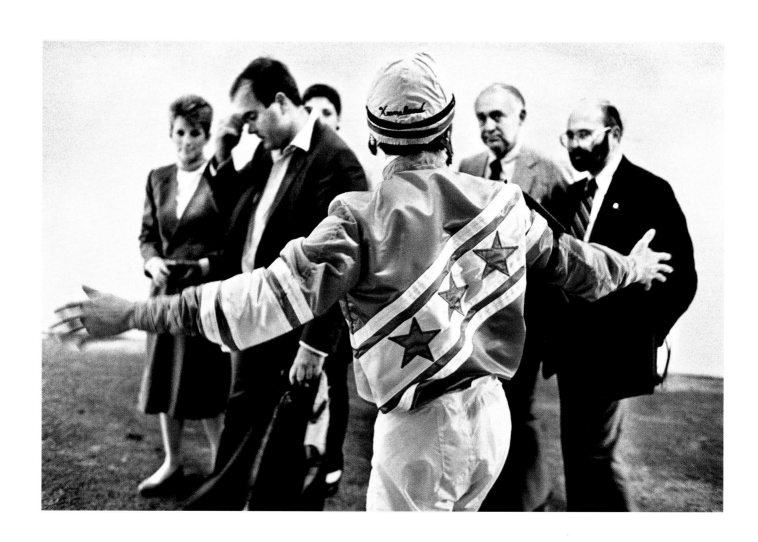

ABOVE: *Jockey's Excuse, Keeneland, Lexington, Kentucky,*
1985

OPPOSITE: *Maryland George, Northampton Fair,
Northampton, Massachusetts,* 1985

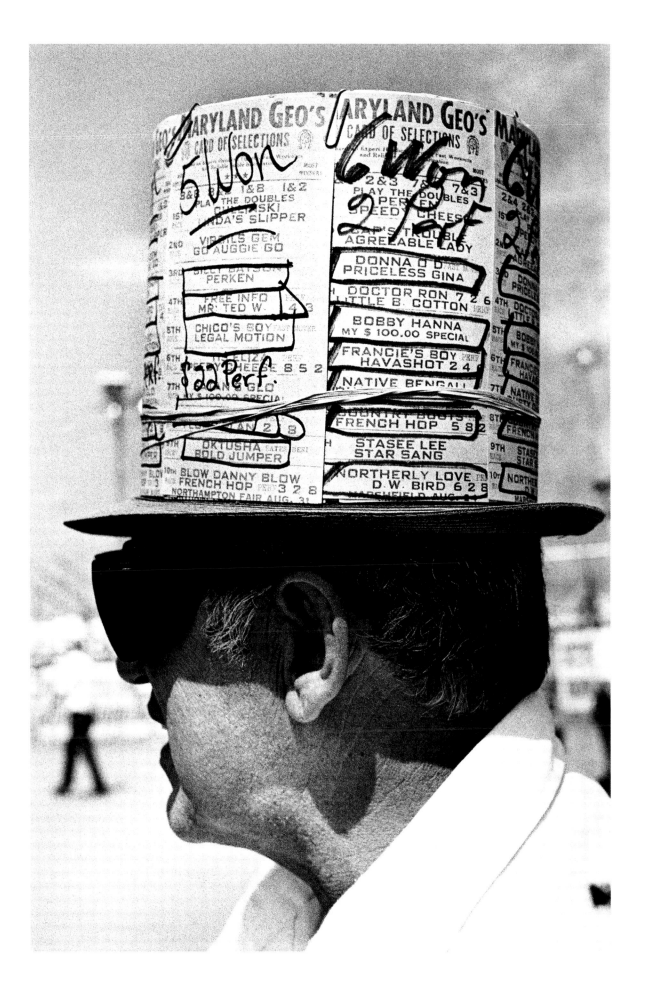

HONKY TONKIN'
(1972–1981 ONWARD)

My dad was a musician. He played tenor banjo in the Fred Harvey Orchestra ("Live from the Harvey Hotel"). He was called Fred Harvey and it was his band. Dad had retired from music by the time I came along. My only memory of my musical dad was finding his custom-made Vega 4-string in the attic and hacking off the neck. I wanted to play drums.

That left it to my older sisters, Ruth and Barbara, to provide the music of my young life. It was Elvis, of course, and any number of Elvis wannabes. Marty Robbins ("Big Iron"), Conway Twitty ("It's Only Make Believe"), Jerry Lee Lewis ("Great Balls of Fire"), Johnny Horton ("The Battle of New Orleans"). Turns out that most of the white guys on the radio were country singers in Elvis face. Flip the Johnny Horton 45 and you'll find "All for the Love of a Girl"—the corny side my sisters listened to when I was out of the room.

It's a common misconception that country music is a Southern thing. It kind of was. But it really was more of a rural thing when I was growing up (it's a suburban thing now). Back then you could hear it on the radio from Mexico to Canada. Even Boston and Chicago had 50,000-watt stations that featured a healthy diet of country music. And much of the country dialed in the Grand Ole Opry, a legendary radio show with a live audience on Saturday nights. From Nashville. WSM.

I didn't know all of this when I started photographing the obscure, long-forgotten beer joints and music parks, and the never-remembered people who patronized them. I just thought I was fulfilling my final history assignment from E. P. Thompson. I didn't want the music, and the people who made it, to disappear. And while that seems a tad pretentious, what can I say? I didn't know there'd be a plethora of scholars, formal and informal, to do what I set out to do—much better and more thoroughly, it turns out. I just wanted to do my bit. And have a little fun.

My approach, if you can call it that, was random. I shot what I could and when I could. For myself, mostly. And sometimes for low-paying magazines and clients. In a way, it mirrored the approach of many of the musicians. In those days, few of them had investors and marketing teams to direct their careers. They just went out, sang their songs, and hoped it would keep them from

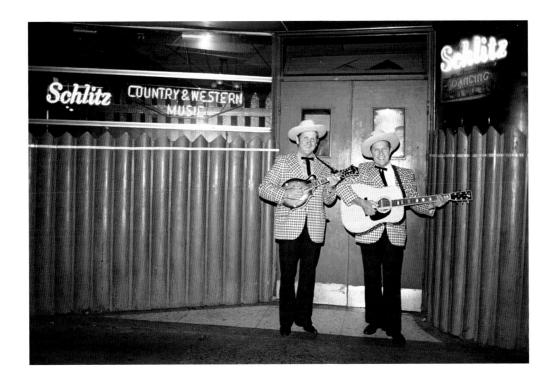

mining, farming, or factory work. Sometimes the music was great, sometimes not so great. But it usually came from the heart.

Since there was actually a lot of country music in Boston, I didn't have to travel all that much. The Hillbilly Ranch was an institution in Boston's Combat Zone in the 1970s. It was home away from home for workers at the Quincy Shipyard and the Charlestown Navy Yard and even the occasional college kid. One night my table of longhairs was being hassled by a few regulars. Banjo master Don Stover (now in the Bluegrass Music Hall of Fame) stepped off the stage, approached us, and called for a round. His treat.

"You boys are welcome here, whenever," he said loudly, staring at our tormentors at the adjoining tables, and then got back on stage to finish the set.

Later, I photographed Stover for his first two solo albums—*Rounder 0014* and *Rounder 0039*. One of the

photos landed on the cover of *Honky Tonk*, my book of country-music photos.

A fire destroyed the Hillbilly Ranch in 1980. The Combat Zone has been gussied up and rebranded the Theater District. No banjos or fiddles there. A disappearing world.

For years, I went to the Lone Star Ranch in Reeds Ferry, New Hampshire, or the Indian Ranch in Webster, Massachusetts, to listen to music and photograph the crowd and musicians. These country music parks were links in a chain of venues all over the Northeast and Canada that served as summer-weekend spots (think RVs and tents) for blue-collar families. Sundays featured country music—bands like Ernest Tubb and His Texas

OPPOSITE: *Backstage Pass, Grand Ole Opry, Nashville,* 1973

ABOVE: *Lilly Brothers, outside the Hillbilly Ranch, Boston,* 1978

Troubadours, Little Jimmy Dickens and the Country Boys, Hank Williams, Jr. and his dad's Drifting Cowboys, and even Porter Wagoner and his Wagonmasters, featuring Dolly Parton. Admission was usually a few bucks for the show, and performers hung around for hours, selling LPs and other merch, signing whatever, catching up with longtime fans, and maybe meeting a girl.

These days are over, mostly.

In recent years, I have photographed musicians and their fans in smoke-filled (and later smoke-free) bars in Bakersfield, California, Fais Do-Dos in Cajun Louisiana, gilded theaters in Branson, Missouri, Fan Fair in Nashville, Tennessee, and dance halls in Austin, Texas. I've included some of these pictures here because they reflect a continuation of the shrinking world I first covered in the 1970s.

Of course, what passes for contemporary country music has hardly disappeared, even if you wished it would. It's the most popular music category in the United States. Today's fans and musicians probably went to college, live in the suburbs, work in office parks, and drive SUVs. When I started photographing, a country music fan or musician maybe graduated high school, lived on a rural route, worked on a farm or in a factory, and drove a John Deere tractor or a forklift.

Except for me. I had a graduate degree in fine arts, lived in a triple decker, avoided straight jobs, and drove a '64 Chevy Nova. Blue.

I put my pictures of country music together in a book and called it *Honky Tonk*. A honky tonk is a slightly (or wholly) disreputable bar, usually featuring live music or a jukebox. Honky tonks are often located on the outskirts of town, and in any case nowhere near a church or school. Think dive bar. I tried several times over twenty-five or so years to sell the book. One editor told me:

"People who like this music don't buy books."

But in 2001, the soundtrack for the Coen brothers movie *O Brother, Where Art Thou?* sold almost 20 million copies ("units") with no commercial radio play. Only college stations and National Public Radio.

Anne Bunn, then a junior editor at Chronicle Books, got it. It helped that she loved country music and went to her publishing committee with a case of Budweiser longnecks and a boom box blasting Johnny Cash. She also went armed with plans for a 2005 show of the work at the Smithsonian Institution's National Museum of American History, courtesy of crack curator Shannon Perich. Publishers like shows and events and talks—anything that helps promote and sell books.

Lessons learned. You don't need everyone to like your work. Just a few who are passionate and able to make something happen. And usually that's someone who appreciates your story, message, whatever. Many thanks for that, Anne and Shannon.

LEFT: Dixie Chicks out of gray T-shirts

OPPOSITE: *Garth Brooks, Fan Fair, Nashville,* 1994

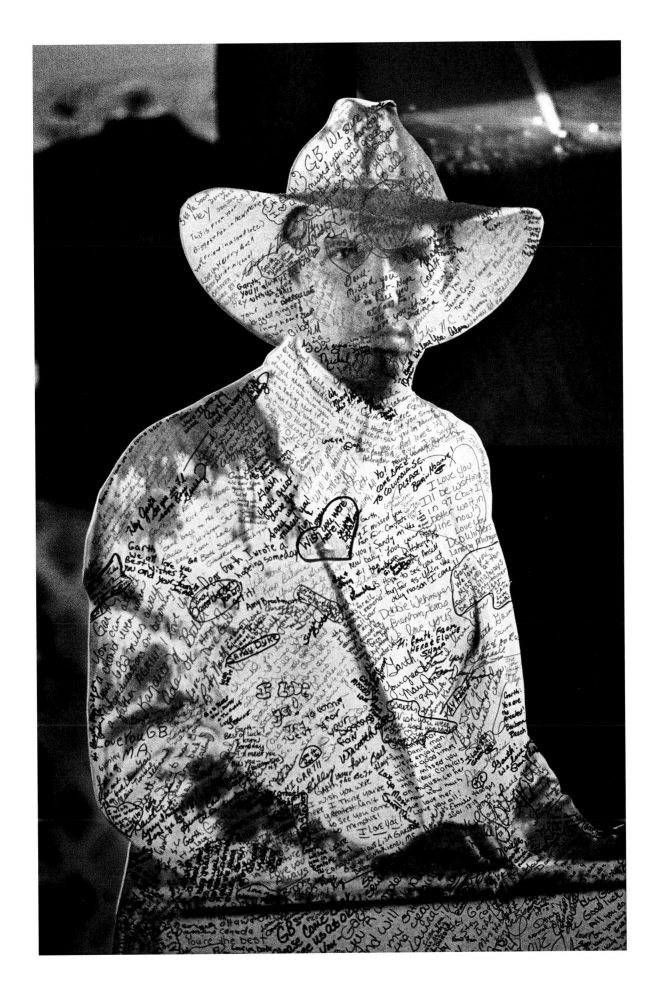

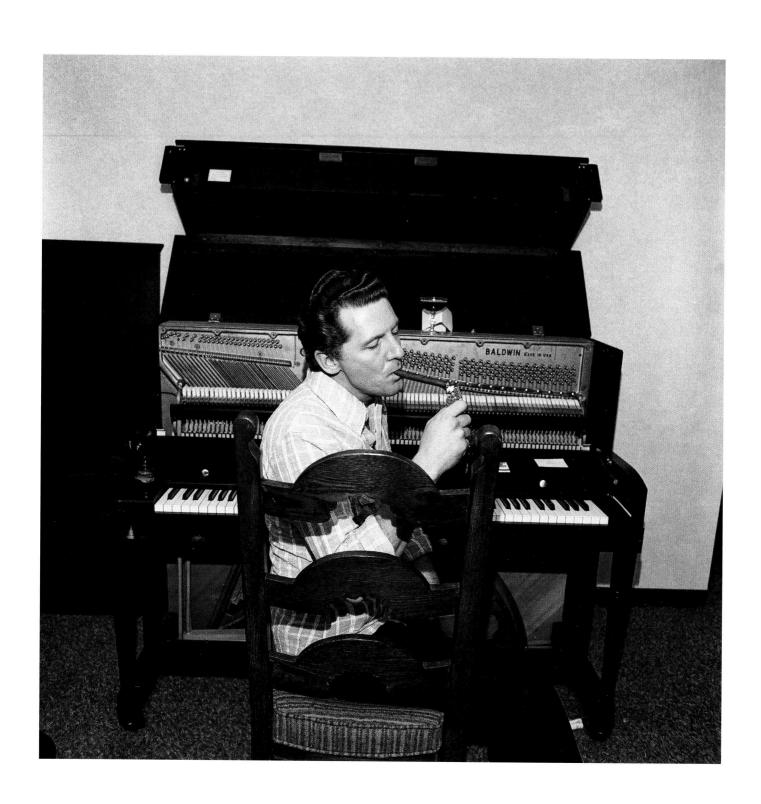

Jerry Lee Lewis, Ramada Inn, East Boston, 1975

TJ's Lounge, Marksville, Louisiana, 2008

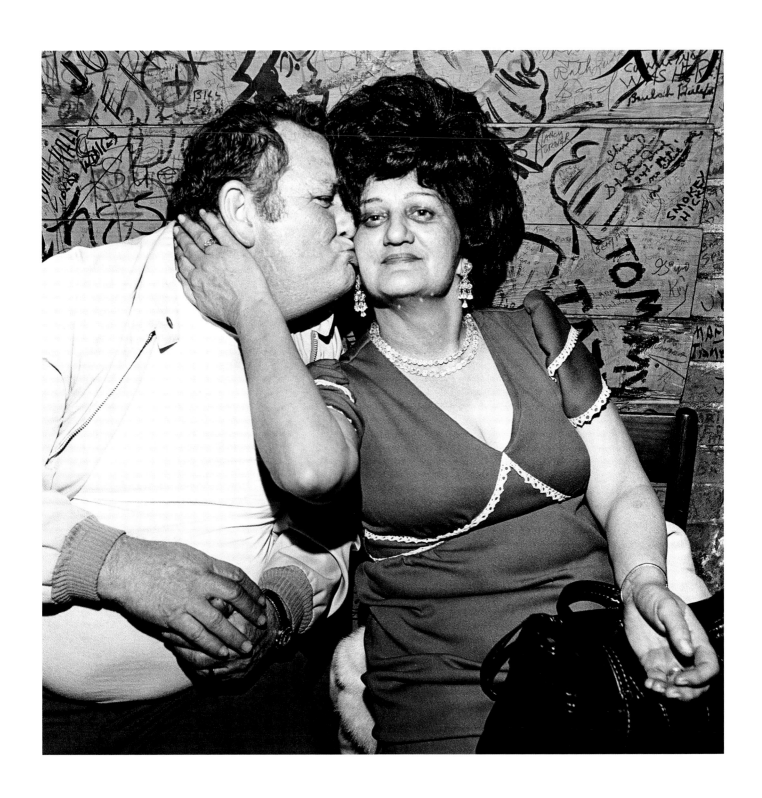

Lovers, Tootsie's Orchid Lounge, Nashville, 1975

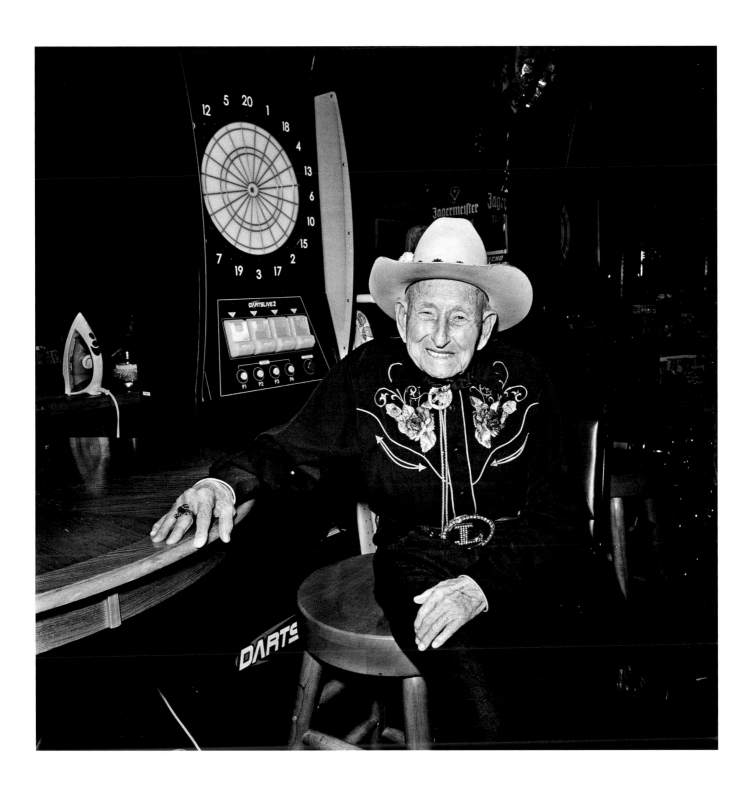

Early Bird, Trout's, Bakersfield, California, 2013

THE ART PART
(1970s ONWARD)

Until the 1970s and 1980s and beyond, most photographers worked as photojournalists or in fashion or advertising. Maybe they ran a portrait studio or did government work. They may have been artistic or creative in their approach, but they worked for pay. Very few identified as fine-art photographers. In those days fine-art photographs didn't bring in money. Even now, many fine-art photographers make their living as teachers.

But things were changing by the 1970s, as the broader art world embraced photography. It put down its stamp. Photographers no longer had to live in the "ghetto" of photography. They could now be artists, and maybe make money doing so. But this was a good-news, bad-news situation. The good news: We got respect. The bad news: We had to be respectful.

In my work, I try to make a good picture with some humor and some history. I also try to tell a story. This is how a lot of photographers work. But as the art world embraced photography, what was valued started to change. "Postmodernism" was the word in the art world in the 1970s/1980s, and also in photography. Now we hear "contemporary art," "contemporary photography."

All this starts with a rebellion against modernism. It's a bit complicated and encompasses a lot of art and cultural theory and discussion. Postmodernism rejects modernist ideas in cultural, politics, art, philosophy theory, architecture, and so forth. A lot of postmodern work is about irony and homage to the past—not reinventing the wheel so much as referring to it.

I never saw myself as a modernist or anything else particularly. As the song goes, "I'm just me." In my world, the picture is the thing, and what matters is the backstory or history, not the theory, the idea.

I think a lot of people still think the way I do. Even a lot of young people, like many of my students. By buying into any theory or movement, you give up some part of yourself. Art/photography used to celebrate the nonconformist—those who played outside the box. Now, you've got to play along to get along. In certain circles, at any rate.

If someone wants to be a postmodernist or a poststructuralist or whatever, best of luck to them. We make our own choices and that's the way it should be. Art by artists; not by committee. What I'm not crazy about is forcing others, including students, to think the way you do. There's a lot of that going around. I prefer students and artists who think for themselves.

And dress for themselves, too. In the late '80s, I was going to move from Boston to New York. I even found a place to live in tony Brooklyn Heights, and I was making

OPPOSITE: *Prince Poppycock, Los Angeles,* 2006

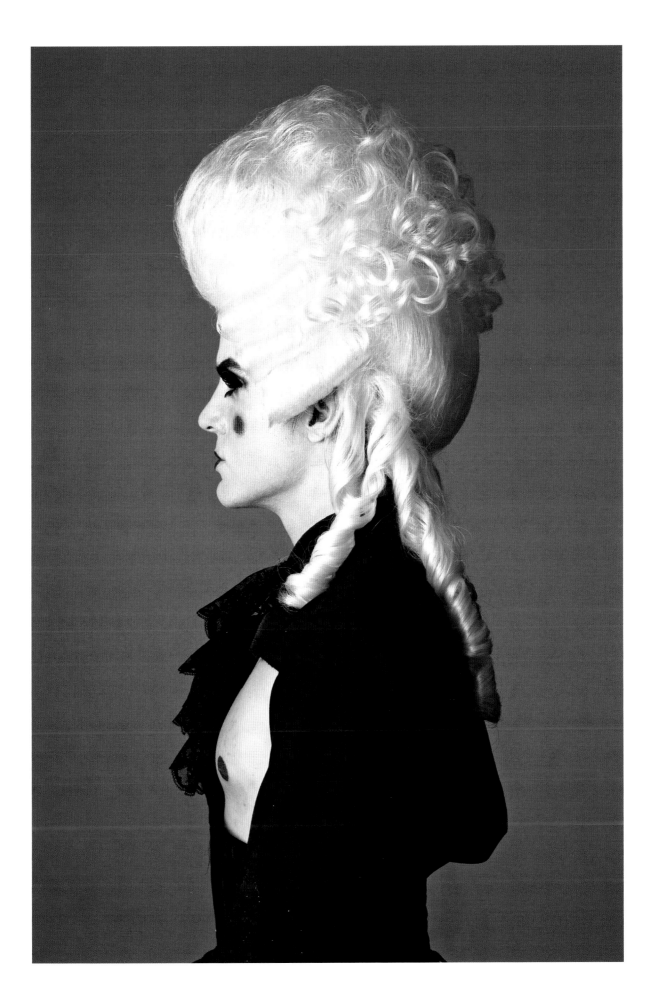

OVERLEAF: *Gatemouth Brown, New Orleans,* 1985

usual flannel/corduroy finery—very Boston casual, not SoHo chic. Anyway, I was chatting with a friend about my move and she said,

"First thing when you get here, I'm taking you clothes shopping."

And I said to myself, "I think I'll stay in Boston."

The '80s were all about color photography, as though color photography had been suddenly invented. It kind of had been, actually. Modern color photography dates to 1935, when Leopold Godowsky and Leopold Mannes, with Kodak's backing, launched Kodachrome. Called "God and Man" at Kodak, these two youngsters (they were under twenty-five when they took out their first patents) figured a path to color photography that Thomas Edison, Alexander Graham Bell, and some other pretty good inventors missed. Simply, everyone else was making materials with color dyes built in to form the color; God and Man made a black-and-white film and introduced the dyes in processing. See what I mean about playing out of the box?

Color photography had a slow road to acceptance from 1935. About forty years. Most films that followed were terrible. Kodachrome was awesome, but it was a positive film. Good prints were hard to make and expensive. This limited the use of color to advertising and other high-budget applications. Until the 1970s even most magazines were printed in black and white, except maybe the covers. Slowly, inside pages started appearing in color. Not so much for the sake of the readers, but because advertisers demanded it.

Then things changed. Color films and printing papers got much better, and much user-friendlier for individual photographers. At this point it was still *de rigueur* for photographers to make their own prints. With few exceptions, great photographers were generally great printmakers. It was part of the deal. Today, outsourcing printing is much more acceptable, even in the fine-art realm. Contemporary practice dictates that ideas and dialog trump production—the making of prints.

Digital technology provided methods of making large-size prints with relative ease. Now, photography could compete with painting and printmaking in terms of scale. Large images are impressive and impactful, for sure. And they can also command higher prices. Follow the money.

So we sometimes hear "make it big and make it color." That's fine when it works, but too often it's a strategic choice and not an artistic one. By entering the fine-art world and its conversations, you may also be entering the commercial side. For better and for worse.

Over the years, I've mostly shot in black and white. At first, I didn't think much about it. Black-and-white photography was the norm, except in advertising, fashion, and other commercial arenas. And printable color negative films were fussy, inaccurate, and unstable. Look at color prints from your family's shoeboxes and you'll see what I mean.

Kodachrome was the product of classic out-of-the-box thinking. And I think of that whenever someone asks me why I still shoot black and white. You have to do what you do, not what contemporary practice or others want you to do—whether they are friends, colleagues, or teachers. You may not end up inventing color photography, but you'll probably be a lot happier with your efforts and maybe more satisfied with your life's work.

Thanks, God. Thanks, Man.

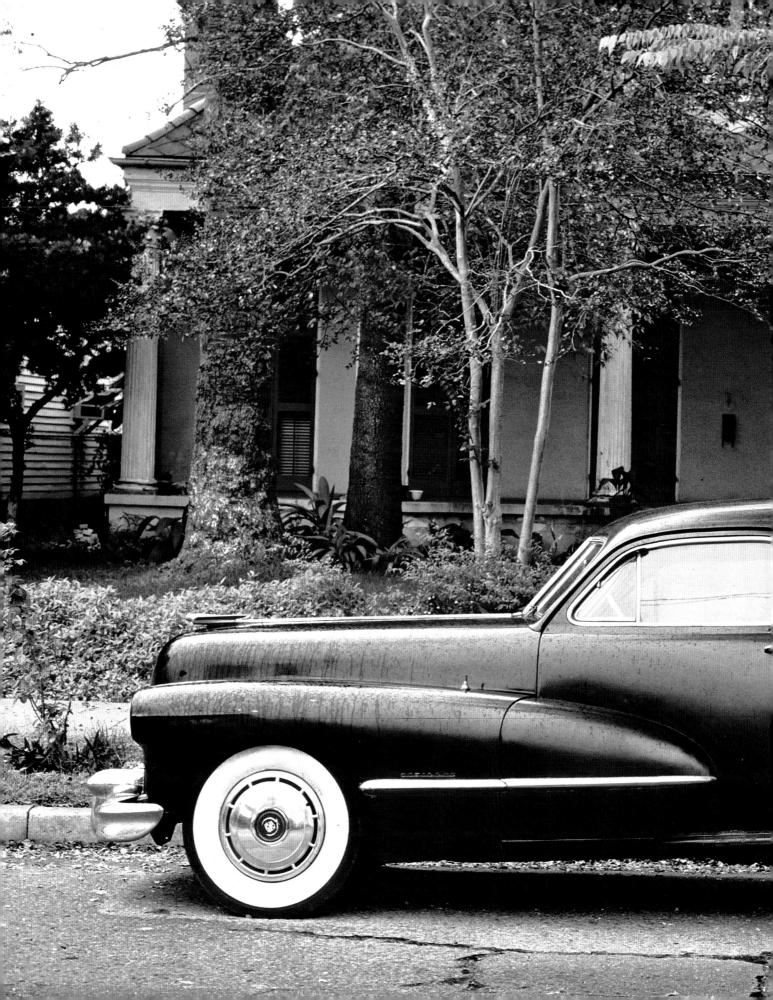

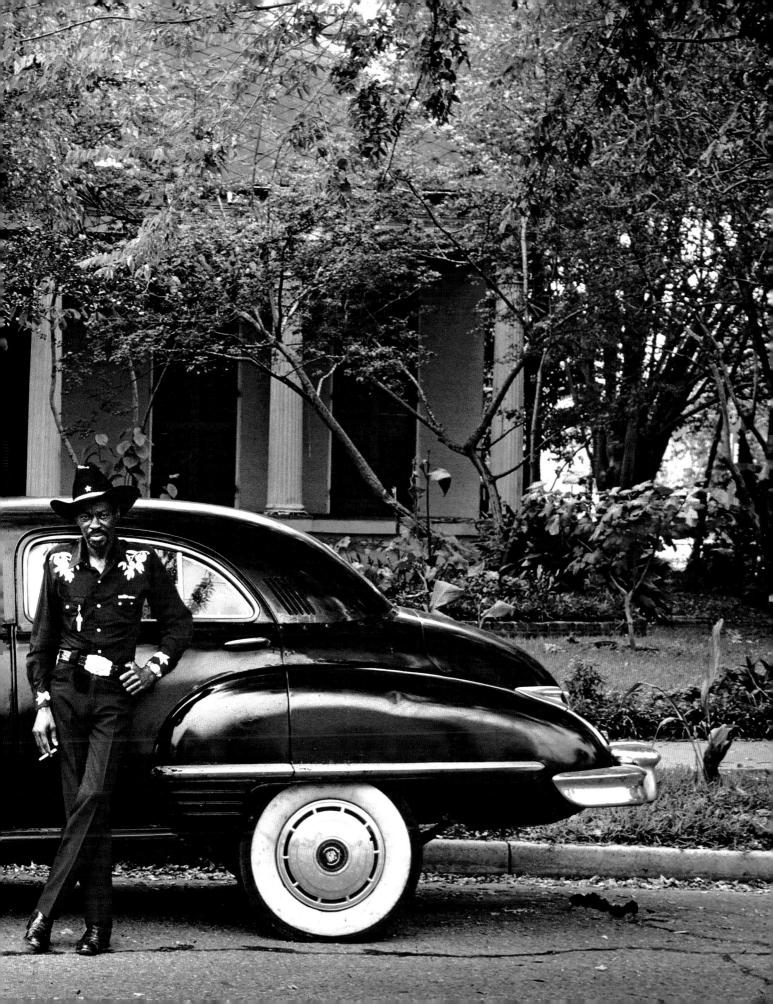

LOUISIANA (1977 ONWARD)

've spent a lot of time in Louisiana over the years. My trips have always revolved around music, horse racing, and photography. Go figure.

I took my first trip to New Orleans, and then Cajun country, in 1977, and photographed at the races for the first time on that trip, at Fair Grounds, the oldest still-running track in the country. The track is located in the Gentilly area of New Orleans, not the most upscale neighborhood. But then again, the track isn't too fancy, either.

Their media guy was called Black Cat. He greeted me and brought me up into the rafters and to the press box. Winding our way up, an older guy stopped him and took him by the lapels. Desperate.

"Give me a horse, Cat. I need a winner."

"How am I going to do that, Ginger? I don't know who's going to win."

"Come on, Cat. You owe me."

Silence.

"Okay, the 6 in the fourth race is ready."

"Thanks, Cat. He wins and we're good."

Ha. I was definitely not going to fall for that. Black Cat channeling Damon Runyon. An obvious dodge. So, when the 6 won for fun, by at least eight lengths, guess who hadn't bothered to bet him?

I like the Fair Grounds. Not so much the racing, which is common enough, but Jazz Fest, which is not.

The New Orleans Jazz & Heritage Festival takes place at the track the last weekend of April and first weekend of May. They clear out the horses and the punters and put up about a dozen stages that feature different kinds of music, but, oddly, relatively little jazz. No matter. Over the years I've seen the Rolling Stones, Linda Ronstadt, and Neil Young. And I've seen Boozoo Chavis, Irma Thomas, Professor Longhair, and Mighty Sparrow. Some think the best music is at the gospel tent, where you'll see black and white commercial gospel bands, followed by choirs from local churches, schools, and prisons. The music is hot and rocking. People weep loudly and faint in the aisle. It's all good fun.

I started going to Jazz Fest in the late '70s and, for a while, went every year. But inconvenient matters like work started getting in the way. My streak stopped just before Katrina, and I've been only an occasional festivalgoer since.

I still go to Louisiana to photograph when I can. Once, in Sunset, deep in Cajun country, I went to the cockfights. A state policeman took tickets.

"You can't bring that camera in here, son. Cockfighting is against the law in Louisiana."

I've shot at Linzay Downs, an informal (and also illegal) quarter-horse track in St. Landry Parish. The judges' camera was a beat-up Nikon, with the shutter attached to a string stretched across the finish line. A sign above read:

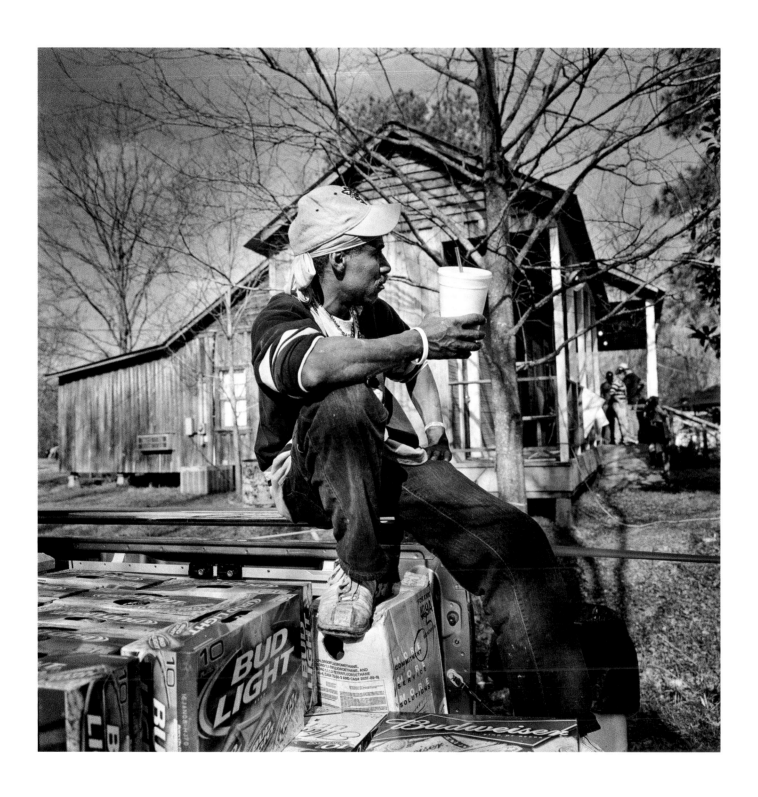

ABOVE: *Fais Do-Do, Avoyelles Parish Mardi Gras, Marksville, Louisiana,* 2008 OVERLEAF: *Irma Thomas Fans, Jazz Fest, New Orleans,* 1985

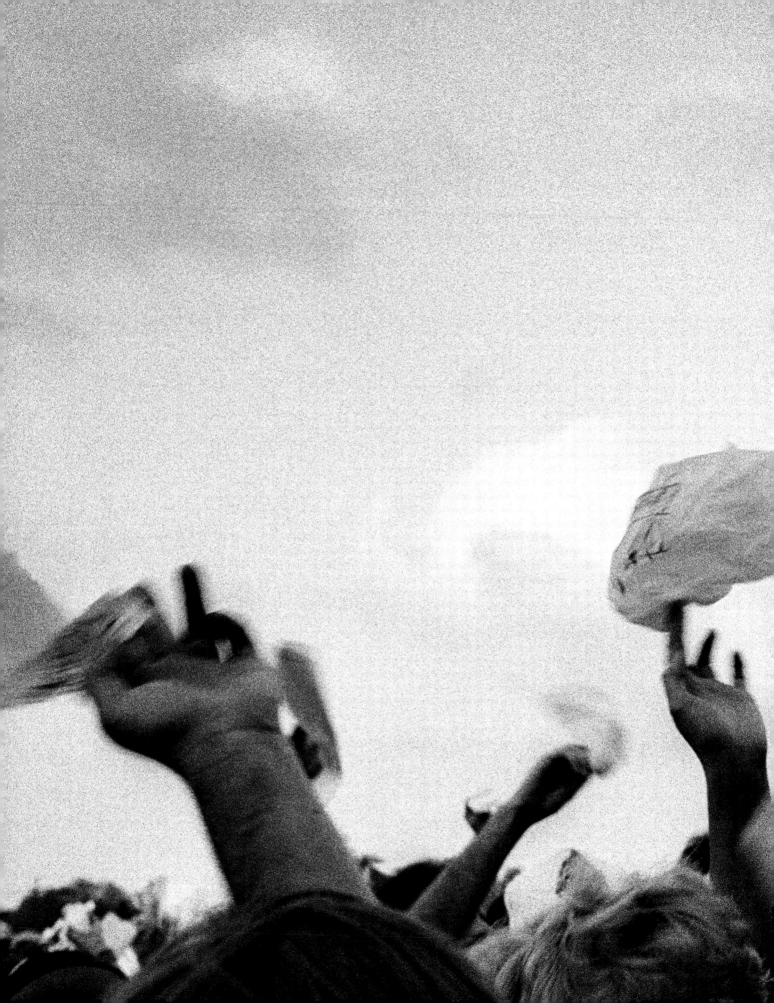

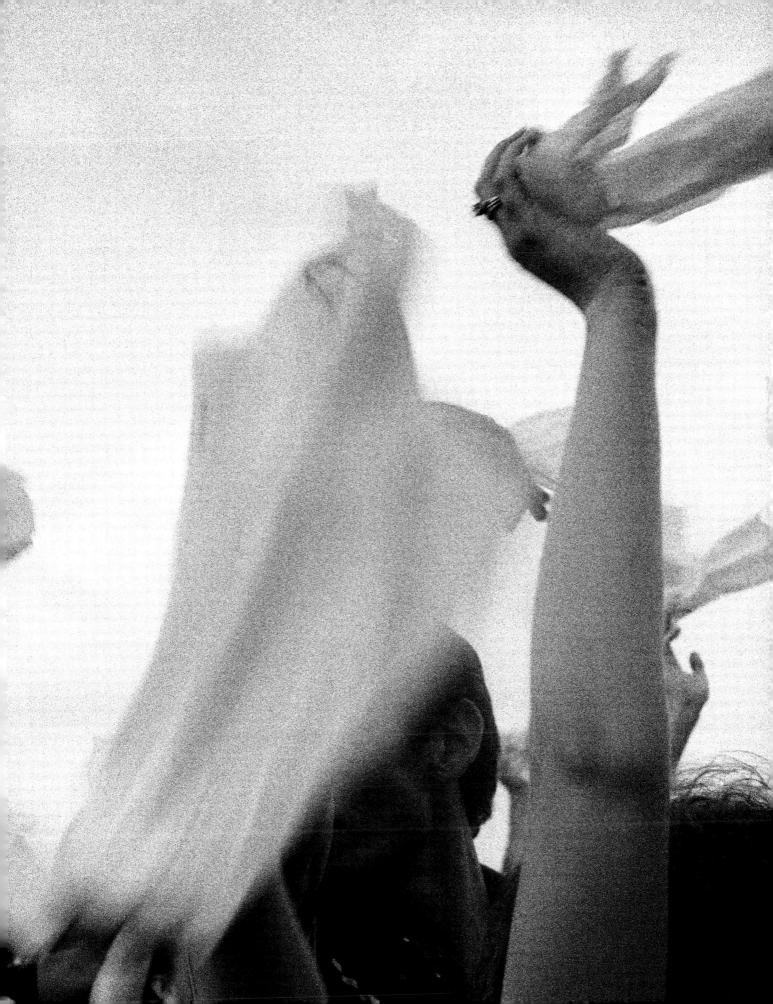

"Si l'appareil photo ne fonctionne pas, le gagnant sera déclaré par les juges."

"If the camera doesn't work, the winner will be declared by the judges."

"What time do the races start?"

"When Mr. Landry (the owner) gets here."

I also shot the legendary Balfa Brothers with Nathan Abshire on accordion at the Bearcat Lounge in Basile. I went for the first time to Fred's Lounge in Mamou, where Revon Reed hosted a radio show on a one-watt station, early Saturday mornings.

"I'd like a coffee with cream and sugar, please."

Hearty laughter all around.

"You ain't from around here, are you mister?"

It was several years later that I returned to Cajun country to go to Mardi Gras. There are many rural Mardi Gras celebrations, and they bear little resemblance to the much better-known New Orleans version. No tits for beads. My host was the unflappable Gerard Dupuy, fiddler and raconteur. Gerard's first cousin, Barré Bullard, worked in a Houston gallery where I showed my work. You never know when seemingly disconnected people will lead you to good photo opportunities.

People gathered at 8:00 a.m. for the Mardi Gras parade in Gerard's hometown of Marksville. Most were on horses, at least 500 of them. This was definitely not the backstretch of a racecourse, where hundreds of horses are typically housed in relative comfort and safety. This was a series of narrow roads deep in the country. Horses were packed tight along the parade route, and I started by walking with the horses and shooting as I went. People kept yelling to me to get on a float. I ignored them until one horse next to me bucked. I jumped on the nearest float and stayed put till the end of the parade.

Leading the parade were a few floats—really flatbed trailers with barrels of beer on ice, a portable toilet, cages of chickens, and maybe a few large costumed dogs and cats, human-sized. The horses followed, and parade workers threw cans of beer from the float to the riders on request. Endless cases of beer were consumed during the parade, thus the portable toilet.

Every so often, the floats and horses would stop for a chicken run—*raison d'etre* for the chickens. Here's how it goes. Someone releases a chicken, which runs for its life, and a horde of contestants try to run it down. The winner holds up the chicken, gets congratulated, and everyone returns to the parade. Including the chicken.

The fun ended early. A fourteen-year-old boy was accidentally killed when he fell off a float, which randomly backed up and crushed his head. His older brother was driving the float. Both brothers were drunk on beer. Earlier that day, a rider had suffered a heart attack and the road was too congested with horses for an ambulance to reach him. A medical helicopter finally arrived, but by then it was too late.

The police shut down the *fais do-do* (party) that followed the parade, and most people left, except for a small group of revelers on horses. They refused to leave for fear the police would arrest them for drunken riding.

OPPOSITE: *Winner, Chicken Run, Marksville, Louisiana, 2008*

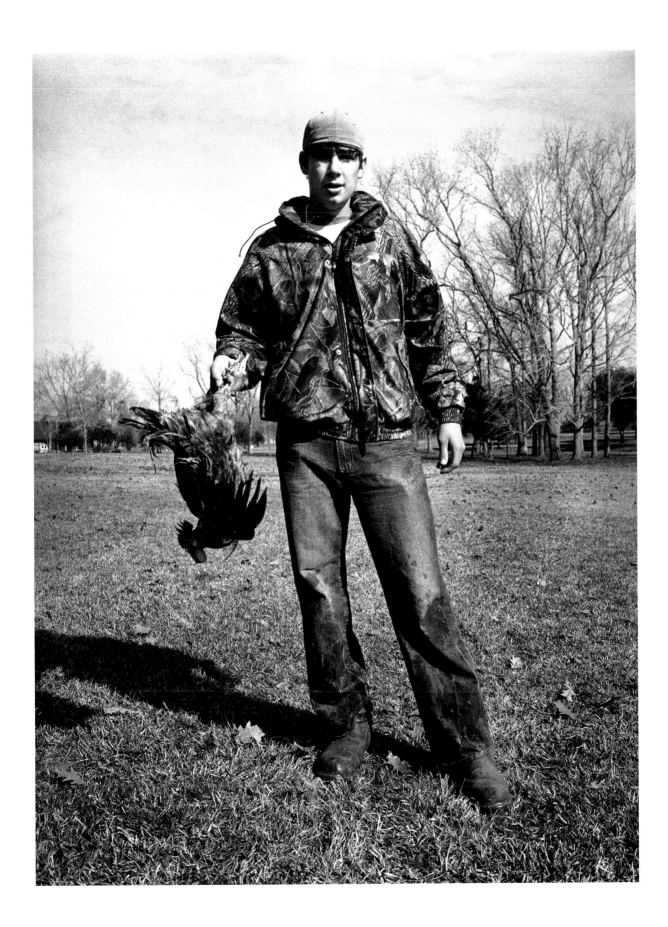

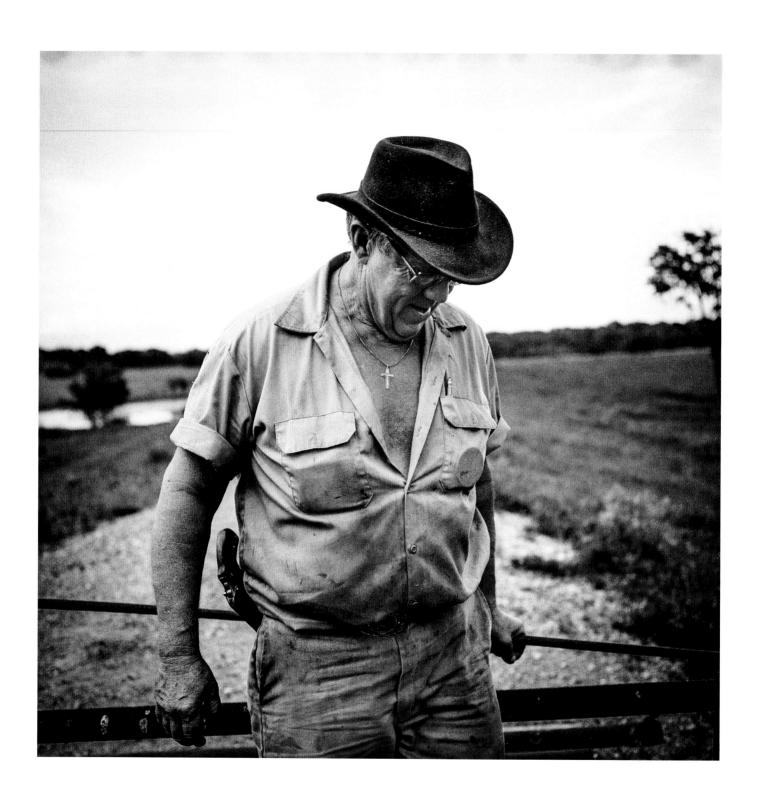

Gerald Walsh, on His Farm, Marksville, Louisiana, 2009

I've returned to Cajun country a few more times. In 2009, I drove around with my fiddler friend Gerard looking for subjects.

"I get it. You want characters, right?"

Right.

We met and photographed Gerard Walsh, who had once been an associate of Colonel Oliver North. Walsh had a gun on his hip and an airfield on his huge farm. Guards from the Angola State Prison delivered ten prisoners to him daily. They worked during the day, unchained, and returned to prison every night. How was he sure the prisoners would behave?

"I get to vet them, of course, but I only allow murderers to work here."

"Sounds dangerous."

"Hell, no. Thieves are the ones you have to worry about. They are always conniving. But murderers are usually poor guys who got drunk and made a fatal mistake. Not career criminals. They are in prison for life—no getting around it. Here, they have a good deal, working without bars and eating a good lunch. They aren't about to blow it by doing something stupid."

ABOVE: *Norman and Me at the Wolf Den, Marksville, Louisiana*, 2008

BYE-BYE BOHEMIA
(1979–1981)

You've heard the joke before. A guy walks into a bar and. . . . But that's how one of my biggest breaks ever happened. And it was no joke.

One night my dog, Jenny, and I headed to our local, Doyle's, for a few Harps and a cheeseburger. There I started chatting to Dave Mahaffey. Dave and I had never met, but I knew him as a good working photographer around town. As opposed to me, that is—an amateur, who took some pretty good pictures but made *nada* in return.

Dave was a friendly sort and generous with his suggestions. Maybe the beers helped. A lot of photographers never share information about clients or opportunities. But reciprocity is a good thing in our solitary worlds. Scratching each other's back. You help me and some day I'll help you. Sometimes you get screwed by the other photographer— no scratching, stolen information—but usually it works.

Anyway, I must have complained about my lame professional status to Dave, and he told me to call up a guy named Sam Yanes at Polaroid. Sam gave out paying work, apparently.

"Drop off your portfolio and see what happens."

Thanks for that, Dave. It was the last time I ever saw him, but this chance beer-infested encounter changed my life. Incidentally, a recent Google search found a Dave Mahaffey residing in Napa, making wine and still making photos. Very successfully, looks like. I hope so.

There was one thing Dave couldn't help me with. I didn't have a proper portfolio. I spent the next week assembling a loose collection of my favorite pictures, bought a fancy box, and brought it all to Polaroid. It's always best to see potential clients, gallerists, curators, whomever, in person, if at all possible. You're selling your work, but also yourself. All the better if you can make a personal connection. People like to work with people they have something in common with. Maybe you grew up nearby or drive the same model car or live down the street from one other. Or, maybe you're cute or have a good weed connection.

Anyway, I got a call and an appointment with Sam. We connected through stories about Chicago, where he grew up. We both had a somewhat hippy past, and he knew about the demonstration where I got expelled. That apparently endeared me to him. See what I mean about a personal connection?

I had walked into Sam's office hoping for a freelance assignment. What I got instead was a job offer.

"A job? I became a photographer so I wouldn't have to work a job."

OPPOSITE, CLOCKWISE FROM TOP LEFT: Working for Polaroid gave me a good salary and expense account and free unlimited film. I shot kids at Fenway Park • A peanut vendor there, too • Ellie in Mexico somewhere • Mary Lynn in Saratoga Springs

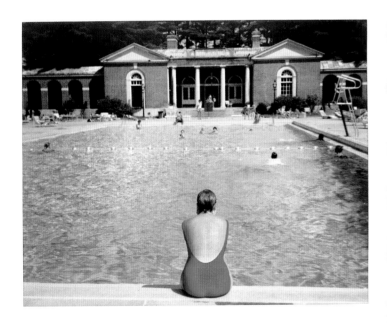

"You'll make good money, get to travel, stay in nice hotels, eat well. We're not talking Bun 'n Burger here."

"I don't know. A job just isn't my thing."

Fortunately for me, Sam understood and showed patience. He was the author of books on the free school movement in his youth—not free as in money but in spirit—and he was nostalgic about those times. More important, he really needed to fill an entry-level position with a photographer who could write. I fit that narrow bill and he didn't want to go looking. If only I could lose my holier-than-thou attitude.

My then-girlfriend, Mary Lynn, was the one who helped me do that.

"Take the job."

"Are you kidding? A corporate gig, no f***g way."

"It's not so bad, lots of people have one. You're broke, cranky, depressed, and doing poorly all around. You can always quit if you don't like it. Take the job."

"But I'll have to wear a suit."

"I'll buy you the suit. Take the job."

I took it and I headed down Satan's path. First stop: Brooks Brothers.

Sam assigned me to work for Maria Wilhelm. She was a no-nonsense public-relations pro who knew her stuff and tried hard to teach me. She was also the mother of a son who is the mayor of New York City as I write this. Bill de Blasio.

I worked it out so I had a job and I didn't. It was a fine line I walked. I was full-time, but on contract. This made me feel like I wasn't technically taking a real job. Fortunately, working for Polaroid in those days wasn't exactly a real job, either. Those were wild times for the company. And why not? They spent tens of millions a year on advertising the year I arrived.

One of my main jobs was to be Polaroid's go-to guy for the photo magazines—well known ones such as *Popular Photography* and lesser-known ones, such as *Industrial Photography*. My first assignment was to go to New York and take the editors of all "my" magazines to lunch, drinks, or dinner. In other words, go meet them in person and schmooze.

"What if they won't take my call?" After all, these were the guys who wouldn't call me back when I was freelance writing and looking for work.

"They will take your call *and* meet with you because you're from Polaroid and we advertise in their magazine." Duh.

There was one editor who would not take my call or my lunch offer, Sean Callahan. Sean founded and edited *American Photographer*, one of the best photography magazines ever. He came from serious journalism, where he had been the last editor of legendary photographer Margaret Bourke-White at *Life* magazine. His idea was to hire good reporters, like Owen Edwards, who also worked for real magazines like *GQ*, *Saturday Evening Post*, and *Town & Country*, and let them report on people, products, whatever. There was hardly any industry influence.

Sean finally did meet me, along with a Polaroid ad guy, succumbing to the pressure. Sort of. A ten-minute how-do-you-do in his office. No lunch, no drinks, no dinner. No schmooze.

"If you've got a story worth telling, send it along and I'll consider it. But I am not running anything that doesn't meet the magazine's standards."

OPPOSITE, CLOCKWISE FROM TOP LEFT: And there was a fan gear vendor outside Fenway Park • Brooke Shields at Hialeah Park Race Track in Florida • Some random guy near the Santa Monica Pier • Skating champion Caryn Kadavy in Colorado

Fortunately, Polaroid was a company with pretty high standards, and I was able to place some newsworthy stories with *American Photographer*. Later, Sean went on to help found AOL, and then run Time-Warner's Road Runner division. Owen started *Parenting* magazine and wrote his own column for *GQ*. Etc. Etc.

While I'm name-dropping, I should mention that Polaroid's marketing group included some people who went on to do noteworthy things. There was Belinda Rathbone, who authored the definitive biography of Walker Evans; JoAnn Verberg, who had one-person shows at New York's Museum of Modern Art and elsewhere; and Linda Benedict-Jones, who became curator of photography at the Carnegie Museum of Art in Pittsburgh. John Reuter also worked at Polaroid at the time. He enabled the likes of Andy Warhol, Chuck Close, Robert Rauschenberg, and so many more to make their large Polaroids, and he continued to run the company's highly praised 20x24 Studio long after Polaroid became an empty shell.

Aside from flaking, I did some cool things there, like assisting street-photography legend Garry Winogrand, as he shot thousands of exposures of Polaroid Time-Zero film in Venice Beach, California. Winogrand had a reputation for being a tough guy to love, but I found him charming.

He even took me to a Passover Seder with art-photo icon Robert Heinecken. I sat quietly the whole time wondering what those two were talking about—and why.

I assisted one of my photo heroes, Elliott Erwitt, as he shot country singer Emmylou Harris, using the obscure Polaroid 8x10-inch instant film. The picture landed on the cover of *Country Music* magazine. Guess who assigned Erwitt? I even got to sneak a few pictures of Emmylou myself. I later used one for my book *Honky Tonk*.

I also took a group that included another photo-hero of mine, Robert Frank, to the Suffolk Downs racetrack, where we bet the ponies staked by Polaroid cash. Along with my adopted boss, Marnie Samuelson, I edited *Close-up*, the corporate magazine, where we published Frank, Danny Lyon, William Wegman, and advertising-legend Hiro, among others. I was there when Hiro initiated his famous *Fighting Fish/Fighting Birds* series on Polaroid 20x24 black-and-white film, specially manufactured for the shoot. All on Polaroid's tab, of course.

These were my Zelig Years.

In the early '70s, I had spent two years getting an MFA in photography from the Rhode Island School of Design, one of the premier graduate schools of art in the world. That taught me something about how to make pictures. But I got my MBA in photography a decade later at Polaroid. And that was the degree that saved my career from oblivion. I learned how things worked, I met people, and I had a bigger view of my world than art school could ever teach me. Now, I had to figure out what to do with it.

ABOVE: Elliott Erwitt photographing Emmylou Harris in her backyard

OPPOSITE: *Emmylou Harris at Home, Los Angeles,* 1980

I QUIT (1981)

After two years on Polaroid Time, I was ready to move on—back to the not-so-real world, as I had known it. No coat, no tie, short money, and sleeping late whenever I wanted. Then, there was the photographer thing. I had rarely taken pictures for two years, except some goofing around with Polaroid materials, and I had a hankering to be a shooter again. Or, to move on. Maybe go to law school or become a hot walker at the track.

Fate interceded. My boss, Sam Yanes, offered me a promotion. He was climbing the corporate ladder and wanted me to take more responsibility. It meant more money, more corporatizing, and better suits. It also meant distancing myself from my original dream of being a photographer. It's hard to mix making meaningful pictures with meeting annual goals and fudging marketing budgets.

So, I went to a friend in Human Resources, a woman I'd known from the Hippy Days, and laid it out.

"So, if I take this promotion, I can't quit in a couple of months, right? I've got to commit or . . . ?"

"Henry, in five years do you want to be Sam Yanes?"

"Hell no. Nothing against Sam, but I want to be a photographer. I think."

"Well, if you take the promotion and all goes well, you'll become Sam."

So I quit.

Sort of. I was totally okay with losing the business suit and sleeping late, but I wasn't sure about the short-on-money part. Pre-Polaroid I had been used to living on the margins, but now I looked at things differently. I really liked making good money for all the greedy and unworthy reasons people do. But I also saw it as a way to fund my completely noncommercial personal projects. I reasoned: If I could still make good money from Polaroid, I could afford to make whatever pictures I wanted without relying on grants (almost impossible),

LEFT: *Polaroid Newsletter for Photographic Education*

editorial assignments (tough but not impossible) or print sales (ha).

I didn't take the promotion. Instead, I let people know I was available to freelance. I became the "creative consultant" for Polaroid's professional advertising group, dealing with famed ad agency Doyle Dane Bernbach, the mad men who produced such iconic campaigns as "Think Small" and "You don't have to be Jewish to love Levy's." I photographed for a book on making better real-estate photos and for a catalogue for the Jewish Museum in New York. (A Polaroid exec was on the museum's board.) I took twenty Soviet industrialists to the racetrack (my specialty). Some manager at Polaroid had invited these guys to visit the company and ran out of things for them to do. He asked me for an invoice describing my work as a "writing project." I also started and edited *The Polaroid Newsletter for Photographic Education*, a slick marketing tool targeting photo educators. And I edited and helped write *Instant Projects*, a book on using Polaroid materials in school assignments.

The education gigs came from Eelco Wolf, who headed up public relations international, and was a poet in his past life. I did a lot of other work for Eelco over time, as he became my main client at Polaroid. He also became a good friend. We still enjoy the occasional lunch at Foley's, my current local. Eelco went on to be executive director of Magnum, arguably the world's most famous photo agency.

Working on *Instant Projects* was a dream gig. My coauthors were Ansel Adams's staff writer Robert Baker and Barbara London, whose best-selling textbooks competed with mine. For several weeks, we stayed and worked in Carmel, California, in a historic Spanish hotel

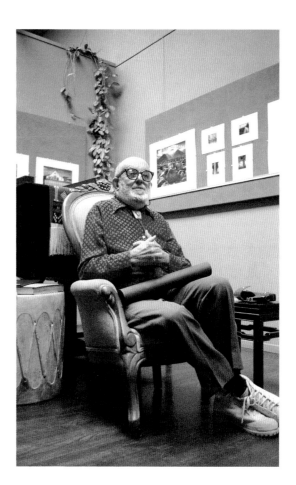

overlooking the Pacific. We ate amazing meals of fresh fish and fruit and vegetables and fine wine. We even got paid.

An added perk was meeting the legend. Adams was a good friend of Edwin Land, Polaroid's founder, and also a consultant for the company. Polaroid paid him a tidy sum, rumor says about $50,000 at the end, to be available to test and comment on new films, make pictures, or whatever the company wanted to use him for. By the time I met Ansel, Land was on his way out of the company, and no one at

ABOVE: Ansel Adams in Carmel, California, 1980

Polaroid was using him for anything. I think collecting his fee without working made him feel guilty. Definitely old school.

In the evenings Ansel hosted a happy hour at his home, inviting whoever was in town to stop by for snacks and cocktails. One thing I noted about Ansel was that he listened more than he spoke. He was very curious about people and what they did, to the point of making a youngish nobody like me feel like I had something to say. Of course, I represented Polaroid, his client, and that might have factored into the equation.

I even got to have dinner with Ansel, his wife Virginia, and a few other assorted visitors. In fact, when my friend April came to visit, I was invited for dinner several nights running. April, too. Of course. She was a pretty, flirty Texan, and Ansel made sure he sat next to her at the dinner table.

The freelancing had its moments, and its perks, for sure. But I was still a suit. I wanted skin in the game, a return to being an artist, and I was afraid if I waited too long I would become addicted to the high life forever.

Just in the nick of time I got a call from Paul Krot, my crazy, talented, and generous ex-teacher at RISD. Paul invented Sprint Systems, darkroom-based chemistry products that were meant to compete against those produced by the mighty Kodak. He also changed his hair color daily, drank his own chemicals, and led parades of kazoo players to cheer up cardiac patients at Miriam Hospital. RIP Paul, who died of a heart attack in 1993 at age fifty-three.

Anyway, Paul asked if I wanted to teach a basic class at RISD. Hell yes, I did. It was a way back in—teacher and artist. Like Harry Callahan, Aaron Siskind, Arthur

Siegel, and even Minor White! That's what I'd set out to do, and now I could come back and give it a second shot. With a few more bullets in my chamber and some shekels in my bank account.

Good thing for that. During my Polaroid years, I was making good money. I even paid for my own suits. I also stayed in top hotels and ate fine food. That life was gone and I would be lying if I said I didn't miss it. I got used to the high life and now… if I was a racehorse, handicappers would say I was dropping in class. The way I looked at it: I was back to running my race.

* * *

I like it when my pictures are used. It makes me feel like a real photographer, a pro, and that the photos have practical as well as creative value. Moreover, if you can say you are working for, perhaps, *National Geographic,* doors will open.

I was not getting a call from *Geographic,* but I did pitch some freelance pieces to the *Boston Globe Sunday*

ABOVE: Paul Krot

Magazine. Dropping the *Globe* name would help get me access, and I could make extended essays on subjects that interested me. I wasn't paid for the time I really spent on them—just the usual freelance rate. But that was no problem, as I was doing it for the pictures. I was doing Polaroid freelance for the money.

My *Globe* article "You Can Still Get Your Kicks on Route 6" was a stroll down memory lane. Also known as the Grand Army of the Republic Highway, Route 6 ran through my hometown of New Bedford. A lot of my youth was wasted along that highway—failed make-out sessions at Dartmouth Drive-In, coffee milk and English muffins at the Orchid Diner, bumper cars at Lincoln Park.

At the Lincoln Park Ballroom I even caught Alan Freed's rock-and-roll show, featuring Danny & the Juniors, who topped the charts in 1958 with "At the Hop." Years later, ace jazz trumpeter and friend Jordan Sandke told me this story. He was a Junior, backing Danny at a local gig. Between sets, Danny explained it was great to be a rock-and-roll star. The girls went wild for it.

"See those girls over there? Watch me."

"Hmm."

"Hey, girls, can I sit down? I'm Danny. You know, Danny & the Juniors."

"Who?"

Anyway, while visiting my family one day, I was amazed to find that these Route 6 places were still around. A poor economy had kept them from devolving into malls and box stores. The area was depressed, but I was in luck. Here was a dying culture, about to disappear, and I was all over it.

Today, Route 6 officially runs cross-country from Bishop, California, to Provincetown, Massachusetts, though the routing has changed over the years. It's part of the National Highway System, built by the Roosevelt administration in the 1930s to accommodate the boom in traffic caused by the rapid spread of automobile ownership. It soon proved inadequate, as our post-World War II economy was booming, and the auto industry along with it, so a new Interstate Highway system was built during the Eisenhower era in the 1950s. That was the point of my story—the original highways passed through towns and the Interstates passed towns by. This made traveling faster, but meant fewer stops at local businesses for hot dogs and ice cream. Old-time businesses suffered accordingly.

For my essay, I chose to cover the portion of Route 6 that runs from Wareham, Massachusetts, to East Providence, Rhode Island, a distance of about forty miles. I drove up and down that road dozens of times searching for a past that was still present. I shot about eight hundred rolls of 35mm film, maybe 29,000 frames, and I handed in about twelve pictures, along with a heartfelt 5,000-word essay. The *Globe* ran the story, but the words dwarfed the pictures, which were run postage-stamp size. Lesson learned: Shut up and just take pictures.

A lesson I unlearned in writing this book.

"The Death of Connolly's Gym" was a peon to my dad's love of boxing. For me, it was also a way to continue my work on a failed boxing book started years before with *Racing Days* coauthor Brendan Boyd. Connolly's was owned and operated by brothers Billy and Jimmy Connolly. The gym had moved recently from South Boston, which was heavily Irish and white, to Dorchester, which used to be. Word was that they got in trouble for letting black fighters train in South Boston. It wasn't that

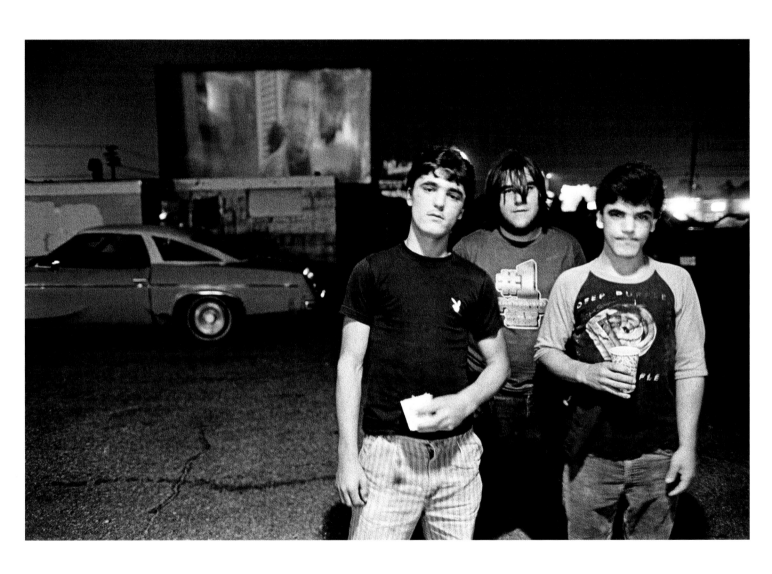

At the Dartmouth Drive-In, Route 6, Dartmouth,
Massachusetts, 1985

Counter, Al Mac's Diner, Route 6, Fall River, Massachusetts,
1985

the Connollys were civil-rights workers; they were boxers. And not all boxers were white. Therefore. . . .

I hung around the gym for a few months. During that time, Billy Connolly disappeared for a while because he had pissed off someone. It was the Whitey Bulger era. I'm not saying he pissed off Whitey, but this is the sort of thing that might happen in those days. No end of characters. Or noir.

I loved boxing as a kid because my dad loved boxing. Before I was born, he and his best friend Sidney actually backed a boxer. Kept him fed and housed so he had time to train. Nice guy, Dad said, but he had a glass jaw. Sidney died young, and my father got out of the backing-boxers business.

I soon realized that I wasn't very successful as a freelance photographer. Which is to say, I couldn't make my living that way. Maybe I was doing too many other things to get enough work, or maybe I don't take direction well, or maybe I was just no good at it. Whatever. It just wasn't working. And then I discovered stock photography.

Stock refers to licensing existing pictures for use. You don't sell your photos per se. Instead, you license them for an agreed-upon purpose and period of time. Most professional photographers are involved in stock licensing to one degree or another—even fine-art photographers, who are generally dismissive. For instance, if a website or magazine wants to use your image and actually pays for the use (or even if they don't), you have licensed it. Technically, it's a stock image.

Anyway, stock had a bad reputation for a long time. Still does to some degree. The imagery was considered generic—not original. Too slick. Too commercial. And lots of other unarty things.

In fact, it was all these things and worse. Then a Japanese company called Photonica came to town and changed things up. Under successive creative directors Gregg Lhotsky, Jane Yeomans, and Stephen Mayes, they started using more unique imagery, which began appearing on book jackets and LP covers. Photonica upped the game for the existing players, and also helped spawn other boutique, arty companies, such as Swanstock, owned by Mary Virginia Swanson, who had started her venerable career working with Ansel Adams.

Anyway, I joined Photonica, and it worked for me. I assigned myself to take the pictures that I wanted, and Photonica licensed them to all kinds of clients. Successfully, for a while. It helped me creatively and financially to produce two bodies of work that eventually became books, *Animalia* and *Humans.*

Inevitably, Photonica was swallowed by Getty Images, one of the two big fishes of stock photography, and it all ended. Getty and Corbis, which was privately owned by Bill Gates, were massive companies that became huge in part by buying small companies and then lowering their prices and standards. It would all benefit the photographers, they said. But it didn't. Consolidation typically helps the bosses, not the workers. Note that Getty recently swallowed Corbis in a slick move that seemed designed to circumvent the anti-monopoly folks.

Shooting stock meant that I wasn't dependent on someone else's deadline, so I could make my own schedule. And I was getting more and more interested in book

OPPOSITE: *Boxer Stretching, Connolly Gym, Dorchester, Massachusetts,* 1985

OVERLEAF: *Boxing at the Harvard Club, Boston,* 1976

publishing. So I decided to become a book packager. This is someone who comes up with ideas, sells them to a publisher, and then makes the book happen—hiring the writer, photographer, designer, and so forth.

Sometimes a publisher hires a book packager to complete a book that's already been signed up. That happened with me and *Eyes on the Prize,* the companion book to an award-winning PBS series on the Civil Rights Movement. Basically I managed the book's publication. I was also hired to package an IBM project, *The Joy of Computing.* The title was not my fault. Honest. But maybe the result was. The marketing director who backed it left, and the new guy, Buck Rodgers (honest), killed it.

Most of the time, I worked on my own ideas. They were quirky and seemingly unrelated, except that they were all illustrated, either with photographs or drawings.

I packaged two books by top fashion photographer Patrick Demarchelier. I had little experience with fashion of any sort (check out the way I dress on Facebook) and I'm sure Patrick noticed. For both books, he hired his own art director, choosing two legendary fashion designers, Fabien Baron and Mary Shanahan. Smart guy—investing in his own project to make sure he could control the results. Of course, Patrick's day rate was likely north of $50,000 in those days, so money was probably not his first concern.

I also packaged *A Dog's Life* and *A Cat's Life*, two baby journals for owners of new dogs or cats. I love these books because of the amazing illustrations by Pierre Le-Tan. Very fun. I figured these silly books would make

ABOVE: Popular stock photographs, originally shot for my *Animalia* work and a children's book. The elephant was licensed by banks and nonprofits and the burning man for an album cover for the hard-rock band Bullet Boys.

me a ton of money, but they turned out to be the only dog or cat books ever published not to sell a lick.

And there was *ComputerWise*, an introduction to personal computing, which I wrote in 1983 with friend Eliot Tarlin, an ex-filmmaker turned computer scientist. Well, someone had to know something about the subject. He provided information and I edited and wrote it down. Another artistic success and financial flop.

One odd freelance gig was as media spokesperson for Canon cameras during the 1994 World Cup. I know almost nothing about soccer, but the money was good and the hours easy, so I jumped on it. Besides, I was going to travel for a month, eat well, stay in prime hotels. Fond memories of Polaroid.

Basically, Canon booked me on television and radio shows in the ten World Cup cities to give advice about photographing sports and to mention Canon as often as

I could. I was on the *Today Show*, interviewed by Matt Lauer. John Waters preceded me and two baby leopards followed. In Los Angeles I followed Shari Lewis and Lamb Chop, an oddly popular ventriloquist and her sock puppet. Following me was a potbelly pig with a perm. On his head.

Leaving Los Angeles in a limo, my PR handler had a fit about a television station we were passing.

"Why wouldn't they book you? You were perfect for that show, damn them."

I think she was getting paid a commission for each booking. I was getting a flat fee for the month so I couldn't care less. Until . . . I looked over at the station just in time to see the potbelly pig waddling in.

Sometimes I say that I took up photography so I wouldn't have to take a job. That's a bit of an exaggeration,

ABOVE: My RISD class visits fashion photographer Patrick Demarchelier's studio, 1992. Photo © Patrick Demarchelier

available on the Internet for free or short money that clients are not used to paying much, or really anything.

* * *

Even before the Internet was a gleam in Al Gore's eyes, people were trying to figure out how to make money off it. Corporations, especially. Some of the biggest players in American business thought they had it figured out and started a company called Prodigy. The players were IBM, the largest computer company in the United States; Sears, then the largest retailer; and CBS, a huge media company. These smart cookies had the answers: technology, commerce, and news.

but not a stretch. I like being on my own, making my own schedule, picking and choosing what I do and don't do.

Too bad freelancing doesn't allow much of this. If you're working, you're working all the time. As in, what's a weekend? I blame it on my dad. Before he wrote me off as hopeless, he tried to teach me about money. He told me to take a portfolio approach to investing. Put a little here and a little there, so I'd be protected from downturns in one industry or another.

I had no money to invest, but I took it as career advice—mixing part-time gigs like teaching, writing, work, shooting assignments and stock, packaging books, and consulting. I figured if I had several streams of income, however trickling, I was protected. Best not to put all my eggs in one basket, especially in the highly vulnerable worlds of art, photography, and freelancing. I needed protection.

This isn't a bad strategy. Proof is that today's freelance shooters have had a rough go over the past few years—partly because of difficult economic times but also due to digital technology and the Internet. Everyone has a digital camera, or smartphone, and a lot of the routine assignments are going to amateurs, who can get the job done for far less than a pro. Also, so many photos are

They weren't far off, actually. Though they should have added pornography to the mix. Poor call on their part.

Still, they soldiered on, spending about a billion dollars along the way before giving up the ghost. In Prodigy, they established one of the first Internet service and content providers ever. At the time, the biggest was CompuServe, which had a subscription base that reached more than 600,000 at its peak. That was how it worked in those days. You paid a monthly subscription fee, and you got the services they provided. Prodigy was nipping at CompuServe's heels, and then it all went away.

Part of Prodigy's offerings was access to forty or so "experts" in various specialties. These specialties just happened to be areas of interest to advertisers. There were

ABOVE: With Matt Lauer on the *Today Show* talking baseball and photography, 1994

OPPOSITE: Ray Tomlinson, credited with inventing email, shot for *Forbes* magazine, 1996

experts in food and wine, home improvement, technology, gardening, and . . . photography. That was where I came in, as Prodigy's photography expert. Really, columnist is all.

My job was simple and remunerative. I posted three original columns a week, about 750 words per column—that's maybe three printed pages (double spaced), and answered thirty-five questions from subscribers via a primitive, and proprietary, email client. Some of the columns were actually written by my frequent collaborator Russell Hart, who worked for *Popular Photography* at the time, and Sean Callahan, who I mentioned earlier. The company Sean helped start, AOL, was smart and nimble enough to put down Prodigy, which was born into three stodgy, pre-Internet corporate cultures.

CompuServe is still a content and service provider, though way reduced in size and influence. Type in www.prodigy.com these days, and best of luck to you. Netscape, Yahoo, Microsoft, and now Google have taken their place. And along the way, I lost my gig (and a tidy income) as a photography expert. Collateral damage.

<center>* * *</center>

Out of the blue one day, I got a call from painter Lee DeJasu, head of the RISD part-time faculty union.

"How would you like to be converted from part-time to full-time faculty?

Lee was offering me better pay, good benefits, and job security. It was like winning the lottery. Traditionally, full-time teachers at the university level get tenure or the equivalent—guaranteed employment, barring bad health, or committing a felony.

A slam dunk, right? Of course not. I made an appointment with Bob Rindler, a former RISD administrator,

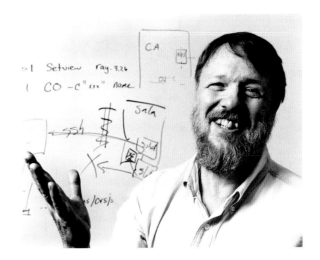

then Dean of the School of Art at The Cooper Union, and a Wise Man. When I walked in, he said, "So, they offered you full time and you're not sure you want to take it? You like your freedom, right?"

Good guess, Bob. We talked for an hour or so and, as I left, I thanked him profusely for his time and generosity.

"I should be thanking you, Henry. Usually when someone walks in here, they are yelling at me, crying uncontrollably, or giving me three days of extra work to do. You walked in and we had a pleasant chat. You were very gracious throughout and left me with no extra work to do. I should be thanking you."

Why not take the job? It was a little more work, committees and meetings and such, but well enough compensated for. It also guaranteed me a good teaching gig. I didn't get along very well with my department head, which meant he could ax me most any time. In fact, he once tried and an older colleague, painter Tom Sgouros, talked him down.

Naturally, I took the deal. Had to. There was a time limit to the offer, and I figured I could always quit if I was unhappy. Thanks, Mary Lynn. RIP, Tom.

PORTFOLIO: KIDS' BOOKS

Though I authored several children's books, I didn't do it for the love of kids. I did it for an excuse to shoot subjects I was interested in. And for the money. Some of the books worked out well; others, not so. One of the former was *Baseball in the Barrios* (1997), a look at Venezuelan culture through the filter of baseball. It continues to sell, especially in the Spanish language edition. One of the latter was *Go, Team, Go* (1988), about high school football. Maybe not my best book, but I think I got some good photos—a couple I get to show here.

ABOVE: *Venezuelan Kids Play Ball, Caracas,* 1996 OPPOSITE: *Huvaldo at Practice, Caracas,* 1996

Natick Redhawks Take a Break, Natick, Massachusetts, 1987

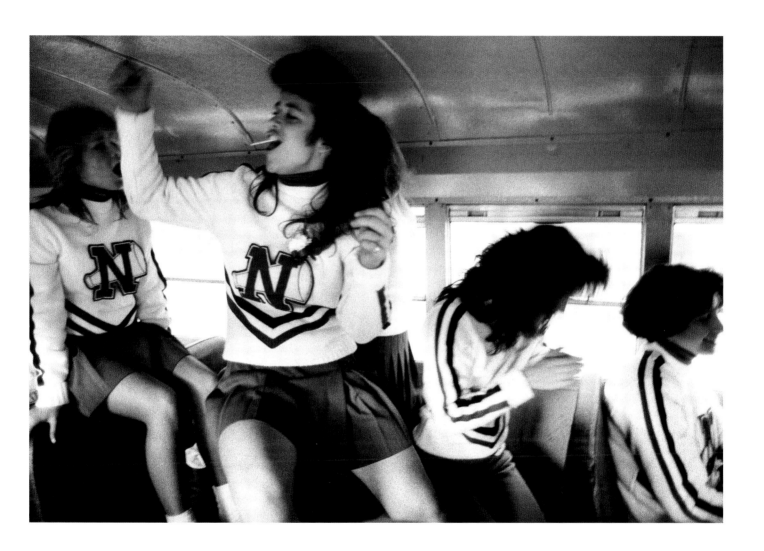

Cheerleaders on the Bus, Natick, Massachusetts, 1987

ANIMALIA (1995–2001)

There was still this thing nagging at me. It was boredom with my personal work. I was doing projects I liked well enough, but I was dispassionate. Hardly a tragic problem. I was getting older, but I wasn't quite near death, so I maybe had time to make some changes. By taking a full-time teaching job, I was afraid I was only putting off the inevitable.

Still, there's something to be said for procrastination, or why would so many people do it? I liked my students and I had one of the best teaching gigs ever. So . . . what's the problem?

Relief came in the form of a children's book. I was assigned to do photos for a series of books by Candlewick Press, a first-rate children's publisher in Cambridge. These books, however, were second rate at best. But sometimes a bad thing can lead to good. One of the books involved photographing animals at the zoo—four-legged moms and babies.

I took the pictures I was meant to, and then hung around for a while after. I always liked zoos. I know that's not a popular view in some circles, but a lot of zoos treat their animals well and some do good things in terms of preservation and research. Also, I think it's good to be able to see real animals and not just 3-D simulations—good for kids and for adults. Besides, I dig animals.

While at the zoo I started shooting pictures for myself. They had just kicked me out of the New York Aquarium in Coney Island for shooting fish without permission. It's

okay if you're a tourist using a cell phone, a simple DSLR, or just walking around with a GoPro on your head. But if you look professional, you need to get permission, pay a venue fee, and carry, say, a one- or two-million-dollar liability insurance. That wasn't going to happen.

I vowed that next time I would go light and lean. No tripods, no assistant, no lights. Like when I went to Mystic Aquarium soon after Coney Island.

ABOVE: Me with Astrolabe, pet monkey at University of Chicago, 1968

"Hey mister, here to take some pictures?"

"Yes, well, umm, just snapshots. Photography is my hobby."

"Wait till you meet Willie. That's what I call him. He's one of the beautiful belugas they just shipped us from the Coney Island aquarium."

Willie was beautiful. Not to mention graceful and elegant. And ready for his close-up.

I was fed up with documentary photography. Or, maybe just bored with myself. The phone calls, explaining myself, harried air travel, suspicious subjects, cheap hotels, and cheap fast-food restaurants. Bad hotels and food really hurt. Polaroid was in the rear-view mirror.

Perhaps it was simply a midlife crisis. I couldn't take a mistress because I wasn't married. I couldn't buy a Porsche, because I couldn't afford one. Shooting animals seemed like a reasonable option.

As subjects, animals are close to perfect, especially if they live in zoos and aquariums. If it rains, or if the light is against you, you can come back the next day. Your subjects can't go far. Not close enough? Wait until they run out of grass in the far pasture and come to you. Miss the shot? They will swim back your way if you're patient.

Animals give no attitude, and they also require no model releases. Actually, strictly speaking, animals (even domestic pets) do need to be released if you are using their image commercially, because the law considers them property. Strictly speaking. . . .

But the likelihood of someone suing you over an animal's model release is slim. Legal help and court time are expensive and only worth it if the other side has deep pockets to tap into. Just take my lawyer Mark Fischer's advice.

"To keep from being sued, Henry, stay broke."

Anyway, I took the path of least resistance and shot only in zoos and aquariums. For a while I billed myself as the Jewish Wildlife Photographer. I never shot in a jungle or underwater. Only where it was safe and there was a food court, bathroom, ATM, and WiFi.

When I started this series, I was more than a bit unsure about it. So many great (and not so great) artists had tackled similar subjects since the beginning of time. How could I presume to add to this daunting history? One thing I did not want to do was simply document my animals. I just wanted to make great pictures. So I chose not to shoot in color and not to show their environment. Rather, I looked closely and abstractly—to see my subjects for their inherent beauty, oddness, mystery. For this, I shot often with macro lenses and sometimes multiple close-up filters, so I could get close, and worked with grainy, over-processed film, printed in sepia to give them an old-school, timeless feel.

Actually, I tried to shoot as though I was in a studio. Like Irving Penn or Richard Avedon—simple backgrounds that make you really look at the subject, not its surroundings. And Willy wasn't my only animal subject worth looking at. Get close and you see the hair on an elephant's legs, an octopus's penetrating eye, a cownose ray with what looks like a necklace. I admire photographers who can style or stage a subject to make their pictures. But for me, what exists in nature trumps anything I can imagine. You can't make this shit up.

Photographing animals is very different from photographing people. You can't tell an elephant where to stand, and you can't ask a skate to smile or a lizard to say cheese. Instead, you must be very patient and wait, hoping your

subject will do what you want it to do or maybe something else unexpected that might make a good picture. When animals do cooperate, you have to be ready, because most won't stay in one position long. You have only a few seconds, and often less, to get your shot.

This was a perfect project to snap me out of my midlife crisis. It was not demanding or stressful shooting. It was calming and quieting. It required patience, not chutzpah. Unlike documentary work, I didn't have to con anyone into allowing me to shoot them. Animals couldn't care less.

I worked simply and alone, flying into cities with good zoos and aquariums—Chicago, San Francisco, San Diego, even Lisbon, London, and Berlin. After covering these places, I would drive to every zoo and aquarium I could find within three or four hours. In zoos, I rented a stroller meant for hauling kids to carry my tripod, 35mm cameras, and several lenses. In aquariums I was more discreet and took a camera bag with a single camera and a couple of lenses.

I shot Agfa Scala film, tons of it, and sent my day's take, usually about twenty to twenty-five rolls, to the lab for processing via FedEx every evening. I figured I was less likely to lose a huge amount of film, and days of work, if I sent small batches daily. I was always anxious about losing film. Of course, now I'm anxious about losing memory cards.

Another plus: Processed film would be waiting for me when I got home, and I loved seeing what I shot as soon as possible. This was analog photography, not digital. Also waiting for me after one trip was my girlfriend. I told her I was glad to be home and happy to see her.

"Actually, I've been meaning to talk to you about that."

Her parting words.

So, I decided to add a side project. Shooting what I truly love—above country music, horse racing, and even other animals. Dogs. Pat their belly and they groan. Feed them and they stick around.

At this point you might be wondering how I paid for all of these trips, the film, breakups, and equipment, now that Polaroid was out of the picture. Easy. The same way I pay for all my personal projects. Visa, MasterCard, and American Express. Still. Usually.

But after twenty-plus years, this was the first time I was able to see some cash back from my personal work. I was selling prints for the first time in my life through galleries and private dealers. I wasn't putting away retirement money, for sure, but I was making enough to feed the engine and keep it going—always recalling the sage words of racetrack gamblers. My mantra. Worth repeating. "I hope I break even. I can use the money."

I had to be a little less flip when dealing with the gallery world, I soon discovered. One gallerist who turned me down said in no uncertain terms:

RIGHT: My photo of a frog's legs, used as a postage stamp in the UK

"When you describe them, say they are your images of marine life, Henry. Don't say they're your fish pictures."

Jane Yeomans, then creative director of Photonica, liked the work and licensed it often enough to help finance my first book of the work, called *Creatures*. There would be three more books, including a "greatest hits" compilation called *Animalia*. And, of course, notecards, calendars, magazine stories, and even a stamp in the UK. Turns out animals were more sellable than anything else I had ever done. Makes sense. Who wouldn't want a tiny print of a large elephant in their child's room or a large print of an octopus in their dining room?

Crass commercialism? You bet. I think photographs are made to be seen and to be used. And I think artists/photographers have the right to be paid, just like any working professional. Some people don't see it that way and that's their business, of course. But some of these people have inheritances or working spouses.

Back to the work. Pleased as I was to get paid, I didn't do it for the money. I did it because I loved the animals, the pictures, and also the process of making them. It was quiet and contemplative and cheaper than psychotherapy. And as a wiseass student pointed out years later, it was a kind of nod to my teachers Harry Callahan, Aaron Siskind, Arthur Siegel, and even Minor White.

"So, why do you trash White all the time and then turn around and make pictures like him?"

Good point. While my animal pictures weren't exactly like my teachers' work, they reflected what they all taught me—the righteous value of traditional artistic concerns, such as good composition, interesting light, and compelling subject matter.

With *Animalia*, I was walking the thin line between art and commerce. As a student in the '70s, I was taught that working commercially was selling out. Finally, I was getting some offers and I liked the way that felt.

A final word from my high horse. Art is commerce. Always has been. Commerce may not be the motivation, because art is supposed to be personal. We do it for ourselves, not for a client, although there are some artists who may have a more strategic purpose. Regardless, as soon as work goes to a gallery or an art fair or an auction and a price tag is put on it, that's commerce. Even Wikipedia says so:

"Commerce is the activity of buying and selling of goods and services. . . ."

So there.

I mentioned that I photographed *Animalia* with Agfa Scala, an awesome black-and-white positive film. I shot the film, sent it off for processing, and it came back as black-and-white slides. Positives. Beautiful quality, but a product that hardly anyone used.

Except me! I might have been the number one consumer of the film worldwide. I loved the quality, and I loved not having to make a print to get a positive result. But I also liked prints, so I started making Ilfochromes (né Cibachromes), a print material that allowed you to take a positive film image and produce a positive print, the exact opposite of the usual negative-to-positive process.

OVERLEAF, LEFT TO RIGHT: *Lookdown Fish,* Selene vomer, 1998 • *Cownose Ray,* Rhinoptera bonasus, 1997

PAGES 136–137: *Brown Sea Nettles,* Chrysaora fuscescens, 2000

PAGES 138–139, LEFT TO RIGHT: *Hippopotamus,* Hippopotamus amphibious, 1995 • *Smoky Giraffe,* Giraffa camelopardalis angolensis, 2001

Here's the rub. Ilfochrome is a color material, and Scala images were black and white. So in the printing there would likely be a bit of a color tint from the Ilfochrome. There was some control of the nature of the color, but it was limited. You pretty much got a monochromatic brown or green or magenta, and that's about it. The brown looked good to me, reminding me of old-school sepia-toned prints, so I printed the Scala pictures that way.

I took some of the early prints to the Bonni Benrubi Gallery, a quality gallery then on New York's Upper East Side. I showed Bonni the work, and I could see she was ambivalent. She liked them okay, but I'm sure she was wondering if she could possibly sell them, so she stalled.

"So what do you do besides teaching?"

"Lots of things. Assignments, Polaroid consulting, publishing. Many types. Books of my works, textbooks, even children's books."

From a hidden office behind us:

"This is Sam. He's sitting in his dad's Mack truck, model R-600. Today Sam and his dad are going trucking together."

That was Bonni's husband, Dennis, quoting the opening lines from my best-selling kid's book, *Sam Goes Trucking*, which happened to be their son's favorite book. Dennis read it so often that he knew it by heart. Their son's name? Sam.

Anyway, that book got my work into the Bonni Benrubi Gallery, but not for long. Bonni put it up in a group show one summer. No one bought, and that was that. It's a cold world when even a beloved son can't save the author of his favorite book. Fortunately, the work was picked up by the incomparable Sarah Morthland, who was the first photo gallerist to open in Chelsea in New York City. A wonderful salon-style space on Tenth Avenue.

Anyway, I am a big fan of illustrated children's books and especially the artists who make them. One of my very favorites is Shel Silverstein (*The Giving Tree*, *Where the Sidewalk Ends*, and so forth), who also wrote "A Boy Named Sue" for Johnny Cash, "The Unicorn" for the Irish Rovers, and many other folk and country tunes. He was also a folksinger and wrote plays and screenplays. And, of course, Maurice Sendak, David Macaulay (RISD grad), Chris Van Allsburg (also RISD), and many others. While not always taken seriously by the high-end art crowd, these terrifically talented artists speak to human needs and feelings and even history and learning. With humor. To me, these are the things talented artists do. Or should do.

OPPOSITE: *Domestic Great Dane,* Canis lupus familiaris, 1998

ABOVE: Maggie, one of my animal subjects, grabbed the camera and turned it on me.

LAS VEGAS OF THE OZARKS (1995–1997)

The line was twenty or thirty deep for the bathrooms at the Soji Tabuchi Theater, so I started a conversation with the old guy in front of me.

"Having a good time?"

"I hate it here. Wife makes me come."

"Really? I think it's a lot of fun. Kind of like Las Vegas."

"No gambling, no booze, no broads. Like Vegas without the fun."

Branson, Missouri, is a town of not quite 10,000 residents, nestled deep in the Ozark Mountains. It is also one of the most popular travel spots in America. In fact, Fodor's once named Branson one of the Top Ten Family Destinations in the World. Other nominees included Belize, Washington, D.C., Italy, and any U.S. National Park.

Branson has broad appeal. It draws outdoors types with its lush landscape and fine hunting, hiking, and fishing opportunities. It also offers amusement parks, waterways, and bungee jumping. But Branson's unique appeal is its music theaters, more than fifty of them. Here you can take in two shows a day—or more—featuring international celebrities of yesteryear, newcomers, and any number of Branson-bred talents.

Over the years Branson's theaters have presented the likes of Andy Williams, The Lennon Sisters, Tony Orlando (without Dawn), the Osmond Family (minus Donny and Marie), Glen Campbell, Bobby Vinton, Pat Boone, Kenny Rogers, Charo, Anita O'Bryant, and so many others. It has also been the home of Soji Tabuchi, the Baldknobbers, the Acrobats of China, and the Presley family (no relation to The King).

I first went to Branson seeking country music in 1995 and immediately liked Branson a lot more than my bathroom-line friend did. But then I hate Las Vegas, despite the awesome gambling, booze, and broads.

What I liked most about Branson were the shooting opportunities and the stories I could collect. There are characters galore in Branson and many love to chat. I also liked the crazy colors. As a long-time black-and-white shooter, I was determined to see Branson through that lens. But I soon changed my tune and began shooting with two cameras—one with black-and-white film and one with color. This was before digital cameras, which allow you to make your choice after the fact.

Anyway, I shot for about a week and went to New York to try to sell a book on Branson. I managed a meeting with legendary publisher Peter Workman, because he was a big fan of illustrator Pierre Le-Tan, whom I worked with on the dog and cat diaries several years before.

OPPOSITE: *Cheryl Kartsonakis, The Grand Palace Theatre, Branson, Missouri,* 1996

OVERLEAF: *Mickey Gilley's Piano, Branson, Missouri,* 1996

Amazingly, Peter was also a country-music fan. Good luck for me, I thought. However, he was also a savvy publisher and saw this book more broadly—as an Americana story, not a country-music story. He sent me along to Leslie Stoker, who was heading up Artisan Books, Workman's then new illustrated imprint. She agreed with Peter about the Americana thing, and eventually I did, too. Especially after she offered me a $25,000 advance—short money for a best-selling novelist, but a score for a photographer on a personal journey. The money would pay for me to make several trips to Branson, eat at Olive Garden, stay at Motel 6, make a lot of pictures, and have adventures. And at the end someone would even publish a book of the work.

I did have adventures in Branson. Wayne Newton kicked me out of his theater; I hung out with a tiger in her cage; Anita Bryant's theater manager tried to pick up my assistant. For readers under sixty, Anita was a very high-profile antigay activist. Her manager was female. So was my assistant.

On one of my Branson trips, Tim Garrett was my assistant. Tim was a computer science student at Brown University when he took a Photo One class with me. He then decided to turn down a job at Microsoft and start a career as a fine-art photographer. Tim was into photo booths, the old-school type. A strip of four black-and-white pictures. He developed the first photo booth app and started a virtual community, www.photobooth.org. I felt a little guilty about the whole thing. Years later:

"Tim, I ruined your life. You could be a Microsoft millionaire by now, living the high life."

"Don't worry, Henry, I married a surgeon."

Mainly, in Branson I made pictures and met amazing people. At the top of the list was the Lennon family, dozens of them. The clan was headed by the Lennon Sisters, who starred at the Lawrence Welk Champagne Theatre. If you don't know it, the *Lawrence Welk Show* (1951–1982) was an early hit television show and the Lennons were billed as "America's Sweethearts," a beloved teenage singing foursome. Dee Dee, Peggy, Kathy, and Janet could sing a bird off a tree. Their music was relentlessly positive and more than a little corny. You watched them and thought what very nice girls they must be.

Were they ever.

"Are you having a good time in Branson?"

"Are you getting to photograph everyone you want to?"

"Andy Williams won't return your calls? Very naughty of him."

"Kathy, why don't you call Andy and ask him to meet Henry? Andy will do *anything* Kathy asks."

Kathy called, and I got a session with Andy Williams. Apparently I wasn't the only one who thought the Lennons were nice. It helps to know someone who knows someone. But it also helps to be nice.

The work was published as *Branson, MO: Las Vegas of the Ozarks*. I liked the pictures well enough, but I hated the book. My editor, Leslie Stoker, left before it went into production, a too-common occurrence in the publishing world. A book that loses the acquiring editor is referred to as orphaned.

In my view, the problem was design. My new editor saw the book as glitzy, not because of the pictures, but because she wanted to market it that way, and gave it to a designer who kitsched it up. Of course, I am not the only author who ever complained about design. Or marketing. Or the cover. Or …

DUBAI (1996)

My flight to Dubai wasn't the most fun trip I've ever had, but it was one of the longest. It took about eighteen hours, chicken class—squeezed between two well-fed plumbing-supply salesmen the whole time.

I got a ride from the airport to the Hilton from Hamal, an ex-boyfriend of a student of mine. Like everyone with money in Dubai, Hamal was vaguely related to the royal family. "Vaguely" because he couldn't quite explain how; related because he had more money than Allah. He also had a job at a bank, which he didn't work too hard at. What he did work at was having fun, and he wanted to demonstrate that right off the plane.

"Do you know Landsdowne Street in Boston?"

"Ahh. Yes."

"I spent many nights there when I was going to college."

Landsdowne is the club street for the binge-drinking twenty somethings in Boston. Hamal could barely remember the name of the college he went to.

Ignoring my pleas for sleep, he took me and my assistant, a former student named Amean J., for a ride across the desert. It was pretty amazing. Or maybe I was sleep-deprived. Sand dunes that stretched for miles. A landscape dotted with camels. I took some pictures. Hamal was patient.

Then, I knew I was sleep-deprived and maybe hallucinating because he took us to two large tents on a lake.

It was early evening and there was a heavy mist and drizzle in the air. We walked into the larger tent, and were greeted by four older men in traditional Arab dress and two young women in Western dress. And a couple of dozen cases of Western beer.

We stayed for about four hours, not understanding a word that was spoken. Except that the food was coming. Soon. Maybe. Finally, I asked Amean if it would insult our hosts if we left, given the eighteen-hour flight and the early morning work call. He said it would, but we bummed a ride to the Hilton anyway.

Amean has since moved on to a blistering career as one of the Middle East's top photographers, but don't blame me. The first thing I taught him was to be sure to insult your hosts. Then I showed him how to crash a private press conference with the defense minister of the United Arab Emirates. That didn't go well. And then I made sure he borrowed a camera to photograph a private dinner and concert where no cameras were allowed. He was caught and I escaped.

I was in Dubai to photograph the inaugural running of the Dubai Cup—the world's richest horse race. The purse was six million dollars and top horses from all over the world were there to contest it. My client was *Aramco World*, a PR vehicle from the giant Aramco oil company. The magazine was charged with telling positive stories

OPPOSITE: *Camel Jockey, Dubai, UAE,* 1996

Moving Day, Dubai, UAE, 1996

Camel Coitus, Dubai, UAE, 1996

PHOTOGRAPHER

NAME: HARRY HORENSTEIN

REPRESENTATIVE OF:

ARAMCO WORLD AND LIFE
MAGAZINE

No. 030

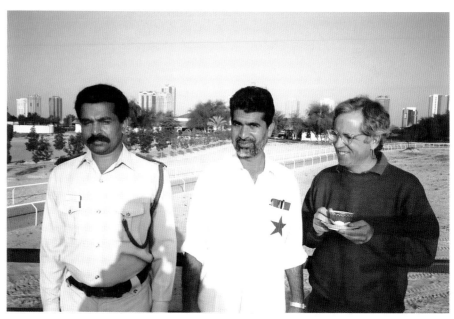

with Arab themes. *Life* magazine took an option on the pictures. They paid me $1,000 to have first look.

Racehorses are thoroughbreds, a breed that originated in Arabia. With colonization in the eighteenth, nineteenth, and twentieth centuries, horses migrated to the colonizers, especially Great Britain, France, and eventually the United States. Late in the twentieth century, the Arabs, with their newfound wealth, were determined to take back their horses and become major players in the world of thoroughbred racing. The Dubai Cup was a sporting event, but it was also a cultural one.

The Cup took place during the 1st Annual Festival of Shopping. I kid you not. Celebrities included the girls from Baywatch and the '80s rock band Simply Red. I photographed the race, of course, which was won by Cigar, an American superhorse who retired as the all-time purse leader in racing history. Ten million dollars or so.

The assignment was stressful for me. I had photographed a lot of horses, but I wasn't really a sports photographer. The guy from *Sports Illustrated* bullied me and even moved my tripod when I wasn't looking, so he could get a better view of the finish. That's what a lot of good photojournalists do. Reporters can write the story later. Photographers need to capture it in real time.

All in all, I don't think I did a very good job, confirming my suspicion I was better at giving myself assignments than taking assignments from others. But I got some good shots of the camel racing the next day, and I had some good stories to return home with. Bad news and good.

ABOVE: I spent much of my time in Dubai photographing the World Cup and drinking tea with hospitable handlers, 1996.

WESORTS (1997–2004)

One night I had dinner with Leslie Tucker, a writer friend I knew from my horseracing life, and she told me her life story. Not the story I knew—the theater degree from Princeton and the job with *Rolling Stone*—but the other one. Leslie was a Wesort. Her family was part of a tri-racial (African, American Indian, and European) clan from Charles and St. Mary's counties in Maryland. At the beginning, there were probably six families in all, which had intermarried for about 300 years. The family surnames were Butler, Proctor, Swann, Harley, Thompson, and Newman—all names that have survived to this day.

Much of the story is anecdotal, as the early history in particular has disappeared. The original Wesorts were almost certainly illiterate so they weren't able to write their own stories. And a fire in the early nineteenth century destroyed most of the government records. So, the history is subject to interpretation at best. But all history is, to some extent, and the one we have is probably as good as it gets, or close enough.

The Wesorts have survived somewhat, perhaps because they kept themselves apart and existed marginally on farming, construction work, and welfare. But their unique story is fading. It's a lot harder to stand apart these days, with television, Internet, and social media connecting people. And then there are the McMansions invading the once-isolated rural landscape of southern Maryland. The times they are a changin'.

Some years after our dinner, I saw Leslie again. She was living in Moscow but had returned home to interview family and other Wesorts. Her goal was to document and preserve the Wesorts' story before modern life gobbled them up. A disappearing culture? I wanted in.

I suggested I tag along and take pictures of the people she interviewed. Many were elderly and wouldn't be around for long. Leslie agreed, so I photographed people, buildings, and landscapes—whoever and whatever was available. I made pictures for Leslie's story and slipped in a few of mine. I shot in black and white, as usual. Leslie questioned the choice, and I said it was a matter of history—that I thought black-and-white images were more timeless than color. I'm not sure that's an absolute, but it's a reasonable assumption. Looking back, I think it's also a matter of style. Photographers like a certain look, and that's one of the things that distinguishes them, that separates them from other photographers. I was a black-and-white shooter. Mostly. So, I shot Wesorts in black and white.

Ignore the occasional color photos in this book as you read this.

The star of the story was Leslie's Great Aunt Mary Lonie Harley Butler (aka Lonie). She was 94 when I met her and lived in a shotgun shack along Route 301, a two-lane highway that runs through Bel Alton, the heart of Wesort country. She had been bedridden for most of three years, and she was happy for the company. Her

ABOVE: *Aunt Lonie at Home, Bel Alton, Maryland, 2008* OPPOSITE: *Mr. Leonard A. Scott, Hillcrest Heights, Maryland,*
1998

OPPOSITE: *Barber Shop Window, Waldorf, Maryland,* 1998 ABOVE: *Bartender, Proctor's Inn, Waldorf, Maryland,* 1997

son came by once a week with groceries, and he was her only regular visitor.

We took Lonie to a social at her church, one of her very rare trips out of the house. There, we met up with her best friend, Viola Swann, who Lonie spoke to by phone every day, but hadn't seen in three years. It was typical Maryland summer weather—90-plus degrees and crippling humidity. I worried that the trip was going to put Lonie in the hospital.

It's hard to come into a community as an outsider, especially one as closed as the Wesorts. Leslie had not lived in Maryland for a long time, but she could toss around names of her relatives for credibility. After all, on some level most Wesorts are related to each other. Also, she is dark skinned, albeit lightly shaded. I am neither Wesort nor dark.

There is another factor that's often not mentioned, probably because of political incorrectness. Leslie was young and pretty. I was old and not. This gave her an additional advantage in connecting with most people. One night we went to Proctor's Inn, along with Leslie's sister Robin and cousin Dana. Proctor's Inn was the local bar where Wesorts went to get skunked and generally misbehave. Imagine three foxy young women looking like they belonged and one guy looking like an FBI agent with a camera counting the days to retirement.

Because we were in a bar, the local Wesorts put up with us for a while. It was a matter of curiosity but also opportunity. Perhaps one of these women was single— at least for the night. Just about every man at Proctor's sat down at some point during the evening and made his pitch. After everyone had struck out, and the evening wore on, the atmosphere became less friendly. Things were said; looks were thrown. But by then I had my pictures. A couple of bouncers offered to accompany us out to our car, and we accepted gratefully.

OPPOSITE: *Aunt Lonie's Living Room, Bel Alton, Maryland,* 1997

ABOVE: *Proctor's Inn, Waldorf, Maryland,* 1997

PORTFOLIO: SOUTH AMERICA

I don't speak much Spanish, so why go to Venezuela, Argentina, Mexico, the Dominican Republic, Cuba, and Guatemala? Sometimes a trip was for a specific purpose, such as photographing baseball (Venezuela) or getting past being dumped (Cuba). Sometimes it was for exhibits or workshops (Guatemala, Argentina, and Venezuela, again). And once it was to watch Pedro Martínez pitch (the Dominican Republic). I can't remember why I went to Mexico.

ABOVE: *Blitto Falcone, Buenos Aires,* 2009 OPPOSITE: *Peter Pank, Buenos Aires,* 2009

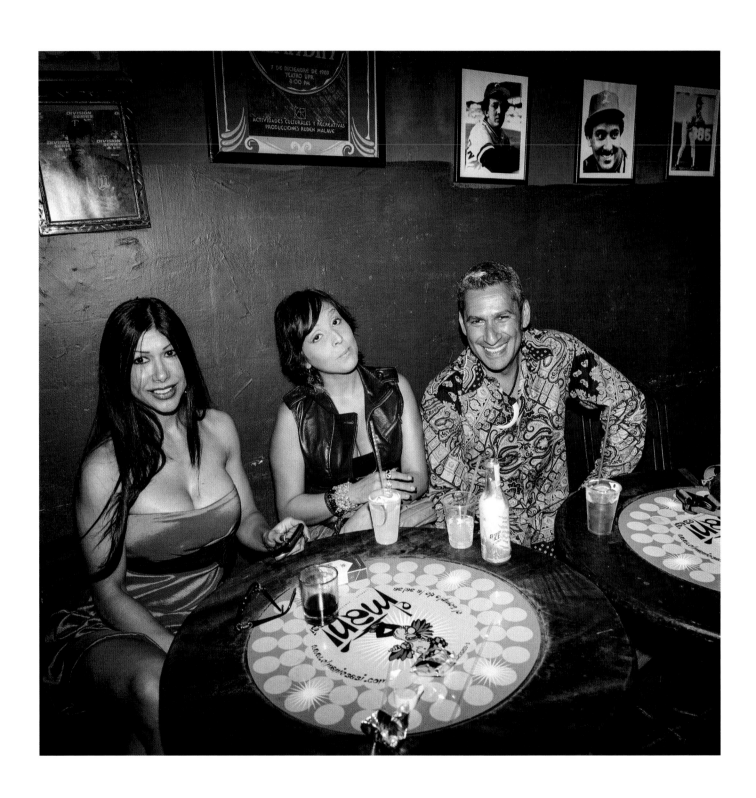

Amintore and Friends, El Mani Club, Caracas, 2011

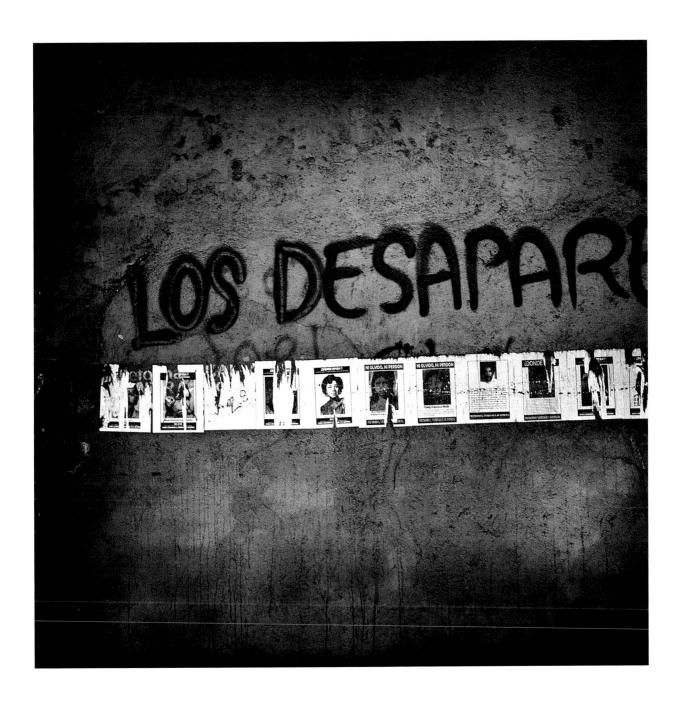

The Missing, Guatemala City, 2010

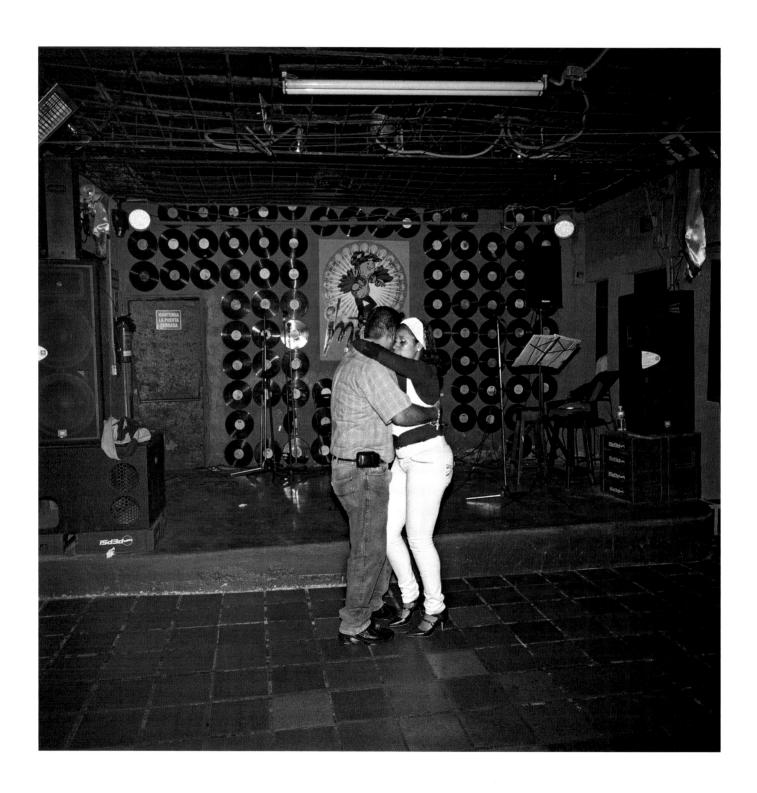

Slow Dancing, El Mani Club, Caracas, 2011

Wrestler Down, Guatemala City, 2010

HAVANA (2000)

During the Bill Clinton presidency Americans were allowed to go to Cuba, with restrictions. My friend Bob Hower had been there a couple of times, and I called to ask him about it.

"It was great, when are you thinking of going?"

"Not sure. Just considering it."

"Let's go next month."

So we did. Another friend, Lewis Wheeler, was headed there for the Havana Film Festival and the festival offered a package deal. Hotel for ten days plus airfare for $1,000. We took it.

The best part of the package was that we were going to stay at the Hotel Nacional de Cuba, legendary host to the likes of Frank Sinatra, Marlon Brando, and even Winston Churchill. It was also home to any number of pre-Castro mobsters. In the hotel's salad days, Meyer Lansky, the legendary Jewish mobster and father of Las Vegas, was the owner for a while and added a world-class casino. Actor Lee Strasberg was nominated for an Academy Award for his portrayal of Hyman Roth, based on Lansky, in *The Godfather*.

Castro put an end to all of that. The Nacional was now shabby, with little of its former glory showing beneath the Soviet-era grime. Elevators worked as they pleased, but a little more often than the hot water.

Havana is an obvious subject for photographers, with its amazing light, colorful architecture, and old cars. I remember walking through the main square of historical Havana and seeing a photo class from the Maine Photographic Workshops wandering around, making important street photos. That put me off a bit, but not too much. I was in Havana to recover from a failed relationship, not to make pictures. In fact, I brought along only a simple Canon Rebel film camera (entry model), a couple of cheap lenses, and maybe five or six rolls of color film to make snapshots.

But ten days is a lot of time to kill a relationship, so I walked up and down the Malecón, while Bob went off to take pictures and Lewis did what film festival people do. The Malecón is a five-mile-long coastal seawall and boulevard, and it's got rocks, water, some sand, and a harbor. But mostly it has people and lots of them, all day and all night. It's a great place to bring your family. Or, meet for sex.

By the second day I wanted to shoot. I needed black-and-white film, of course. Havana screamed color, which only made me scream black and white. Always best to go against the grain. But this was a problem. Havana had plenty of reasonably modern camera stores, but they all carried color film only—Kodak Gold, an amateur line. But I found some more professional stores, usually small and sometimes in subbasements, most of which catered to wedding photographers. Going to four or five of these places, I bought out their stocks—100 rolls of film in total. I could only find Kodak Plus-X film (now

OPPOSITE: *Young Man, Malecón, Havana, 2000*

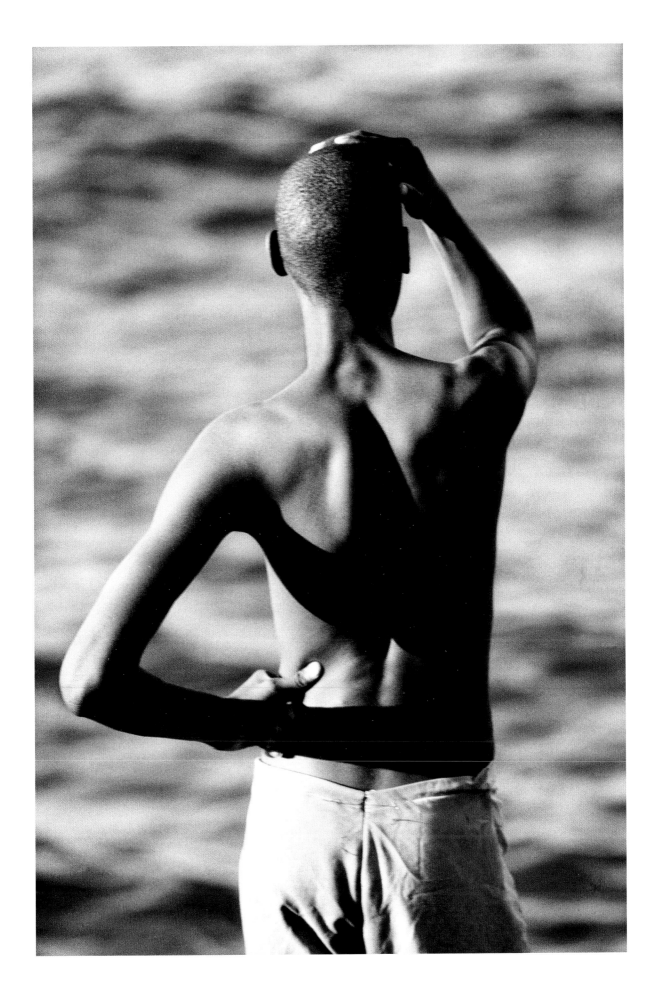

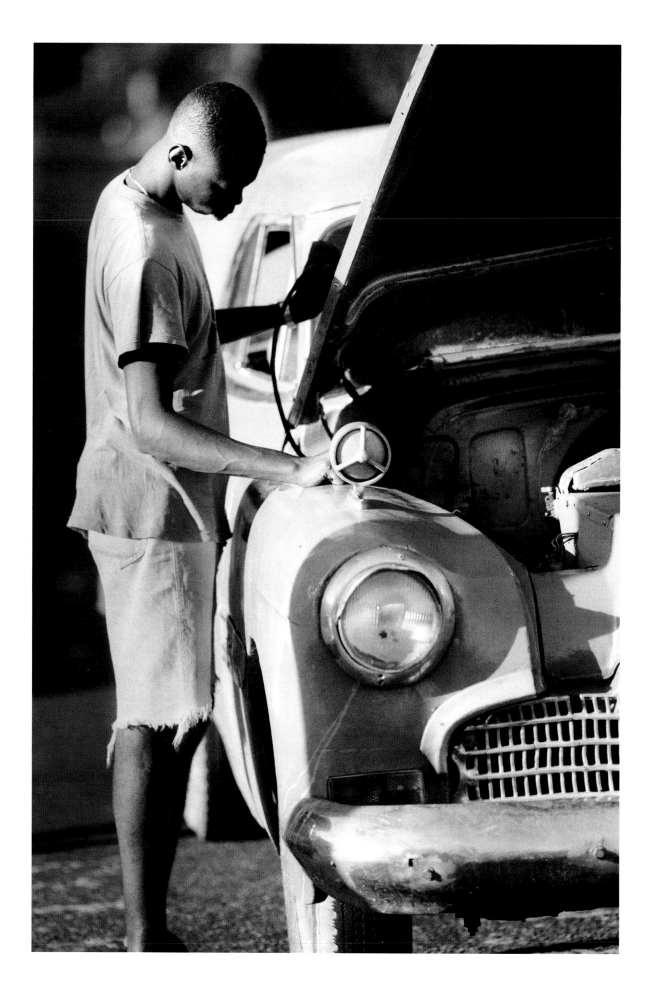

discontinued), which had a low ISO (125) so needed a lot of light. Good thing I was in Havana, where light was a lot more plentiful than freedom and fresh food.

Speaking of politics, there had been an embargo on American products in Cuba since soon after Castro ran Batista out of the country in 1959. Funny. I found Kodak film and Coca-Cola and just about anything else I wanted from the States. Only the film came from Kodak UK and the Coke from Coca-Cola France. Clever of these American companies. Too bad they kept people so poor, or American companies could have sold a lot more stuff.

Anyway, every day I shot on the Malecón. At all times. Midday when it was bright and family-filled, and very early in the morning when it was almost empty, except for random sketchy characters. People were friendly, and I felt very safe. If a Cuban approached me, within seconds there were policemen shooing the intruder away. I like to think that a socialist country was all about keeping the peace, but much more likely they were protecting the Yankee dollar, which they needed badly.

My trip to Havana coincided with the long-term project that eventually became my book *Animalia*. So I went to the Havana zoo and aquarium to make pictures. When working on personal projects, I try to double or even triple dip—work on more than one project on a single trip—to spread around the expenses.

I met with the zoo's director. He bemoaned the lack of funding. I could see why. This was the worst zoo I'd ever been to by far. Bad enough they treat their citizens poorly, but innocent animals . . . that was a real indictment of the system. Cages were a wreck. Animals half dead. The aquarium was much better. The tanks were mostly outside, using the beautiful natural light. This was great for me, because photographing marine animals inside or underwater is a challenge, especially with film. Digital capture is much more light sensitive (higher ISOs) than film, so it can handle low light that much better. Moreover, I had only low-sensitivity ISO 125 film.

The aquarium was set in a fairly well-maintained park, which also served as a lover's retreat—handy, given the lack of space and privacy most young Cubans faced at home. Couples were not shy to show their passion, and there were even some professional hookups. I declined at least three offers. Still, there was an innocence at the aquarium that trumped the early morning Malecón activities.

So, I got to hang out in Havana, the seat of the Cuban Missile Crisis, one of the seminal world events of my early life. I also shot 100 rolls of film, got some pretty good pictures, and had some adventures. This makes me a bit of a scofflaw in the Po Mo (postmodern) world, which dictates that I had no right to photograph "the other" (i.e. Cubans). Says Po Mo: Only Cubans can represent themselves.

I think this is hogwash. There's no end of examples of people coming from other cultures who did good and even important work. Forget photography for a minute and take music. Record producer John Hammond discovered and promoted blues and jazz legends Bessie Smith and Billie Holiday. In 1927 Ralph Peer first

OPPOSITE: *Engine Trouble, Havana,* 2000

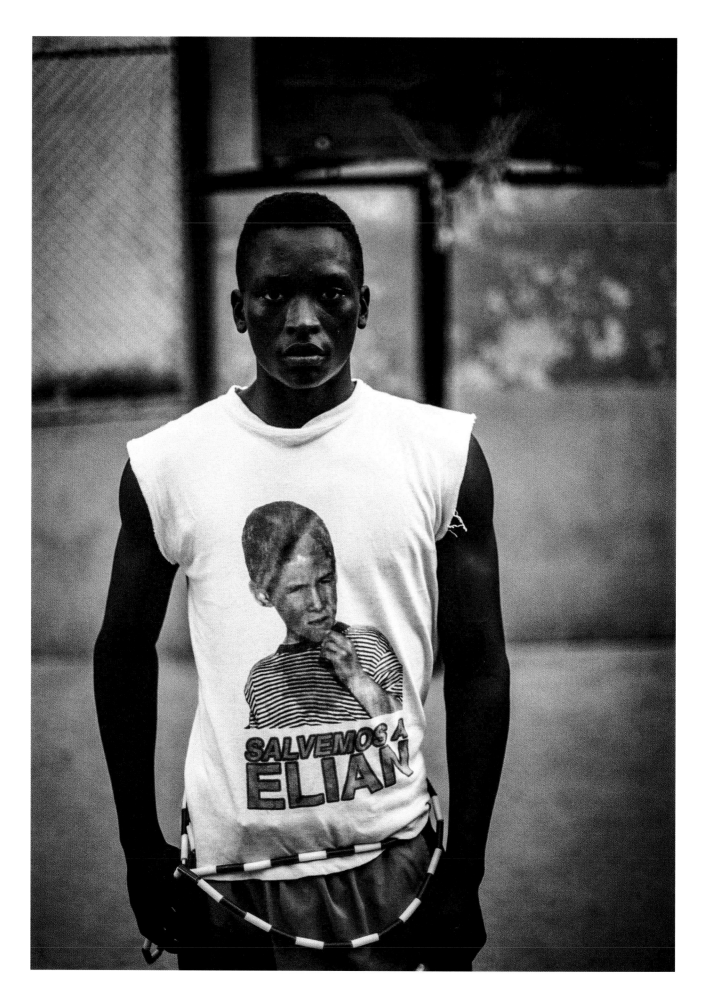

recorded foundation hillbilly acts the Carter Family and Jimmie Rodgers. These two white, privileged Northeasterners were huge factors in preserving their other—American blues and country music, which later mixed to produce rock and roll. Pretty good outcome.

Far from people avoiding the other, photographers swarmed down to Cuba from the United States (and other places). It was such a popular subject and generated many books, good and bad, editorial pieces, art shows, and other projects. All this discouraged me from trying to make hay from the Malecón pictures. Who wants to publish yet another photography book on Cuba? Still, I like the work, so I jumped on the chance to show a few images in this book.

OPPOSITE: *Remembering Elian, Havana*, 2000

ABOVE: Vintage photo of Hotel Nacional de Cuba. The Malecón is to the left.

OVERLEAF, LEFT TO RIGHT: *Man with Cigarette, Malecón, Havana*, 2000 • *Lovers, Malecón, Havana*, 2000

HUMANS (2004–2008)

Often when I work at a project, I know I'm at the end when I can't make another picture that I haven't seen and taken before. That's how *Animalia* ended. I went to an aquarium and a couple of zoos and shot blanks. I had more than enough work to make a book of it, so I did.

From animal subjects it was a hop, skip, and a jump to humans. My goals were the same—to see my subjects a little differently than the hordes of artists who had come before me and had worked with the human form. So…shoot close-up using one, two, or even three close-up filters on the front of the lens until I was close enough. Chop off parts of the subject and overdevelop the film to push the graininess. Use lenses that opened wide, as wide as f/1 and f/1.2, to capture enough light to shoot indoors without supplementary lighting, and to produce shallow depth of field.

And then hope for the best.

This was basically how I had approached my animal subjects. I took that close, somewhat abstract style and applied it to the human form. Funny what you notice when you're close. I thought about people I knew well over the years and their physical traits that you only notice when you are familiar or intimate with someone. The crooked eyebrow, the delicately placed mole, the strand of hair that somehow never gets shaved.

The other thing I did was to make sure to shoot a balance of male and female subjects. Historically, most artists worked exclusively with the female form, and a few worked only with men. I wanted to shoot both. It was the twenty-first century, after all.

Now that I had all that figured out, all I needed was a few naked bodies.

"What should I do?"

"Take off all your clothes, lie down, hold still, and turn over when I tell you."

I had no idea what I was looking for—for that matter, I had only an inkling of what I was doing. You never know what you're going to find when someone takes his or her clothes off. Especially when you move in so close.

"Do you want me to wear anything special, make myself up, whatever?"

Not really. It didn't matter what my models looked like in real life. I was going to transform them into something else, if I could.

It was a little awkward at first. I think photographer and subject need to find a comfort level. But that came with time and after a while it was quite natural. Especially given the shooting locations. Bedrooms, cheap hotel suites, backyards occasionally. I don't think Irving Penn ever worked like this.

Finding models was easy. I offered $100 for up to two hours of shooting. Once a few models realized I wasn't too sketchy, they passed the word to their friends and I

OPPOSITE: *Thigh and Belly, Boston, 2005*

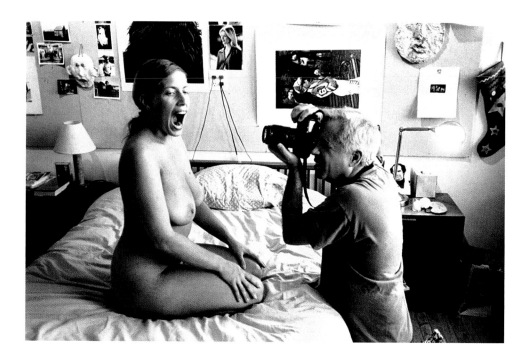

got plenty of offers. Models were asked to sign a model release, which was probably unnecessary since they were rarely identifiable in the photos. But it made the shooting session seem more professional, even if they were about to lie down naked on a Holiday Inn Express mattress with a stranger hovering over their most intimate parts a few inches away.

People have asked me if Chrissie, my girlfriend, was jealous. Did it bother her that I was photographing naked people in our bedroom while she was doing laundry in the next room? She says no and I believe her. Especially when she posed for me toward the end of the project.

"That's the least sexy thing I've ever done."

Made me wonder what *she* was up to.

Maybe my biggest surprise came later when I showed the work to galleries. The reaction was generally positive, but the galleries who did exhibit it chose to show only male or female nudes. Not the mix. I guess their collectors preferred either males or females naked, and the galleries were betting on what might sell. The one exception was the wonderful, short-lived Clifford Smith Gallery in Boston. Rob Clifford and Jim Smith gave me a large, beautiful show: *Humans*. The gallery closed not long after. Maybe the collectors/galleries had spoken.

Anyway, this is work I'm proud of and loved making, which was mostly what mattered. Good thing, since the book and photos bombed. A few shows, a few sales, and that was that. Still, for me work is never dead, just resting. I plan to drag it out from time to time and try to get it some attention. Maybe it will work out; maybe it won't. But at least I get to fill a few pages of this book with some examples.

ABOVE: Photographing Alicia in my bedroom, Boston, 2005

Teeth, Boston, 2006

Eyelashes, Boston, 2005

Breast, New York City, 2005

SHOW (2001–2009)

found myself in line in the French Quarter at the Shim Sham Club, drinking a cold Abita and chatting with fellow line people. I was in New Orleans photographing fish at the aquarium, and went looking for something to do in the evening. The city's alternative weekly listed something called Tease-O-Rama, billed as the first annual celebration of burlesque. Turns out I had stumbled onto an important event in the beginning of a revival, and it later won me no end of cred from the serious burlesque crowd.

There was still a touch of burlesque in my hometown of New Bedford when I was a kid. A popular performer at the Orchard Room was the legendary Sally the Shape ("52 by the Tape").

With modern burlesque, you might get clever routines, inspired dancing and music, and sophisticated humor. Early shows were held in the early-mid '90s in the back rooms of dive bars like Riffi's in the East Village or the Slipper Room on the Lower East Side. The audience was young and living on the margins—fellow performers and friends paying a $5 cover, when they couldn't sneak in, to sniff out the competition and give support.

Moving into the '00s, some of the venues became a little classier, such as Corio's in SoHo, where Murray Hill led the Pontani Sisters, Melody Sweets, Julie Atlas Muz, and others in an intimate weekly show—a salacious date for young professionals able to pay the $25 cover and inflated drink prices. Or, the Cutting Room in New York's Flatiron District, where Bonnie Dunn held her legendary Le-Scandal Cabaret for 14 years before moving it uptown, then down again to the Metropolitan Room.

The old burlesque celebrated sexuality and large women and so does modern burlesque. But there are significant differences. Men ran burlesque back in the day. Think overweight, stained-suit, cigar-puffing crude guys and you won't be far off. Women run neo-burlesque. They produce the shows, write the material, style and clothe themselves and each other. They own what they produce, and they make their own creative and business choices—where there's business to be had.

As time went on, I noted that there was burlesque in drag shows and drag in burlesque. A circus performer may also be on the bill as well, to knock a nail in his nose, or maybe molest a clown. Fetish themes and performers might show up. In *Show*, my book of the work, I tried to document and honor them all.

These alternative performances had a lot in common. They were marginal in their taste, audience, and performers. And they were homegrown and homemade. There was a lot of collaboration. But the shows were really about individual artists. To the degree their talent and budget allowed, they put out what they believed in. That could be good or bad, but it was usually heartfelt.

OPPOSITE: *Jess in Bear Mask, Boston,* 2008

OVERLEAF: *Flambeaux, New York City,* 2006

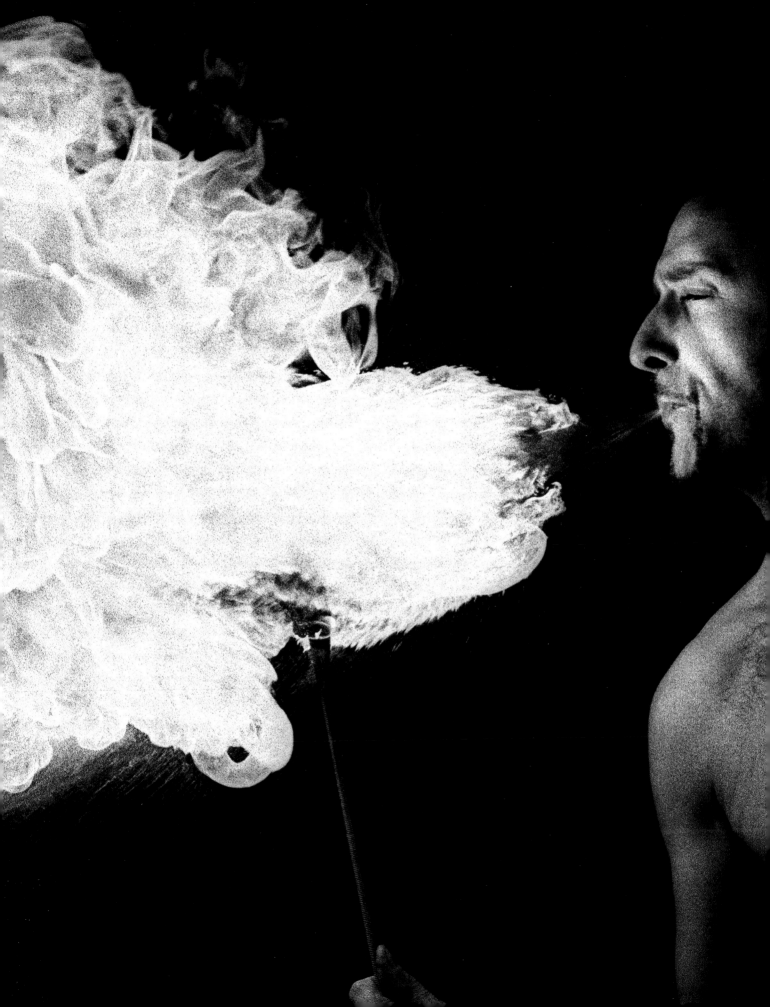

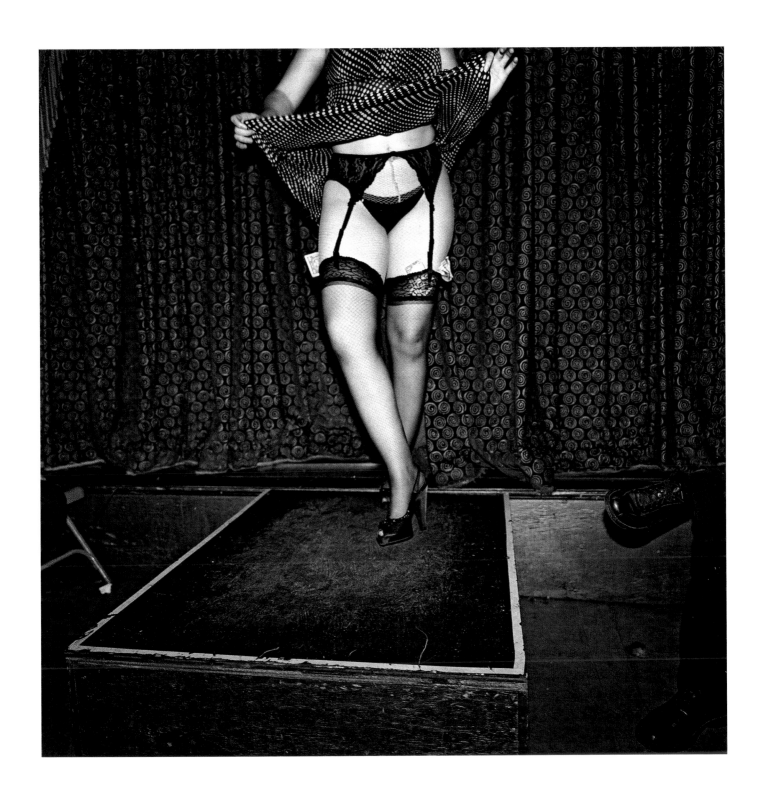

OPPOSITE: *Swords, Los Angeles, 2005* ABOVE: *Go Go Dancer, The Slipper Room, New York City, 2008*

ABOVE: *Jackie Beat, California Institute of Abnormalarts (CIA),
Los Angeles, 2007* OPPOSITE: *Drag King, Club Avalon, New York City, 2004*

PORTFOLIO: MARGINS

With personal projects, some photographers start with an idea and go about executing it. Others just shoot what strikes them, hoping that what they capture will have common elements. I like to noodle around until things coalesce. Friends who see things differently, people hanging out on the edge of town, panhandlers, churchgoers.

ABOVE: *L Street Brownie, New Year's Day Dip, South Boston,* 2008

OPPOSITE: *Aliza after Her Stroke, Boston,* 2012

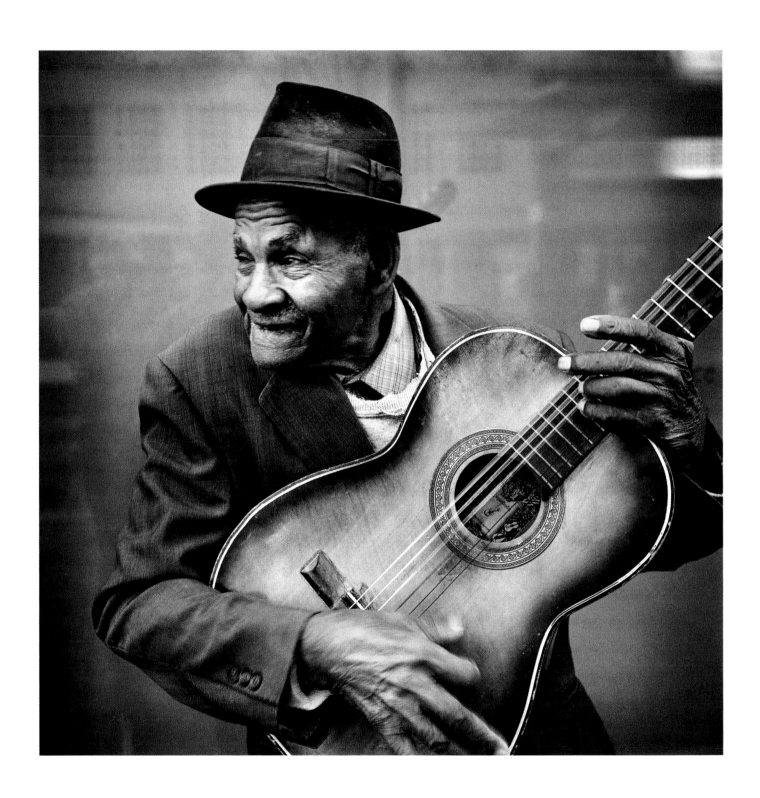

ABOVE: *Street Singer, Downtown, Houston, 2008* OPPOSITE: *Lucy Lu, Homeless, Waco, Texas, 2013*

ABOVE: *Preacher Jack, Tavern at the End of the World,
Somerville, Massachusetts, 2009*

OPPOSITE: *Brian Szela as Phoebe Klein, Jacques Cabaret,
Boston, 2007*

ROMA (2014)

RISD has a fabled study-abroad program in Rome called the European Honors Program (EHP). It's a kind of independent study, where students come up with projects and pursue them with the guidance of a RISD faculty member who is dubbed Chief Critic. There have been quite a few notable successes tied directly to EHP. The late Francesca Woodman made many of her best-known photographs at the Cenci, the building where EHP is housed. Architecture student David Macaulay turned to illustration while sketching at EHP and went on to become a best-selling author and MacArthur Fellowship awardee. In fact, four EHP alum have won that rarefied honor.

Students also study art history with Rome and other Italian cities as their classroom. The amazing Ezio Genovese is the director of the program and an art history professor. Dozens of students have left EHP vowing to name their first-born Ezio.

Ezio is all about family. And in many ways he treats the EHP kids as such. The year I was Chief Critic, I was the dumb uncle. My Italian was minimal, to be kind, and I had only been to Rome for a couple of brief visits. Still, following Ezio's lead, we all made it through. Almost all of the students worked like dogs, and they turned out great work.

The Chief Critic gig was a blessing. Five months in Rome with an apartment *gratis*. The school even paid my salary. But the real reason I applied was to escape from my colleagues in the Photography Department, a couple of whom had targeted me for extinction. In their opinion I was too old and out of touch. Debatable, but really, how out of touch could I be if I ended up in Rome?

Anyway, the position of Chief Critic usually goes to a "real artist," like a painter. Or, it goes to an architect. But the year I applied it went to two outsiders—a poet and a photographer.

I worked a ton, even giving myself an independent study assignment. I set out to document the other Rome—the things tourists aren't likely to see. I'm not sure I succeeded, but I got some pictures I liked, a few of which you see here.

The first thing I did when I got to Rome was connect with Jade Jossen, my teaching assistant from a workshop I had taught in Tuscany fifteen years earlier. Jade and I had stayed in pretty close touch, but I didn't know that she had become deeply involved in the polyamorous movement that was starting to get a lot of attention in Italy. Polyamory says you can have sex with whomever you want, as long as it's consensual. It's more complicated, of course, but something like that. Anyway, this fit nicely into my photos about subcultures, as well as my "other Rome" project. There was a pretty good chance that your typical Pantheon visitor was not bound for a polyamory party in the evening.

Jade introduced me to her friends and we made some portraits. More important, she introduced me to the

irrepressible Diego Glikman, video editor by day and party tiger by night. Seems like Diego knows everyone worth knowing in bohemian Rome, or will meet them soon. He became my fixer, taking me to squats, clubs, and wherever and introducing me to a variety of terrific people, many of whom agreed to pose for a portrait.

I always look for a fixer when I go to unfamiliar places to shoot—someone who knows the lay of the land and the language. A good fixer knows how to drive. Even better if he/she owns a car. Best of all is when you get along with your fixer, and Diego is a very easy guy to like.

It sounds as though my Rome was a series of wild parties and events and sadly that just wasn't the case.

Italians like to talk, and many of the places I went had far more talking than the other thing. Take the cuddle parties, for example. No alcohol. No dope. No sex. Just good old-fashioned talk, hugs, and maybe some nonsexual massage.

Most squats were more social centers than occupied spaces for the homeless. At a closed dog track, I had to make a presentation at their weekly meeting about why I should be allowed to photograph there. I passed with Diego's impassioned help. Being Italian, he could really talk and sling his hands around when the occasion arose.

ABOVE: *The Cenci, Rome,* 2016. Illustration © Genevieve Bormes

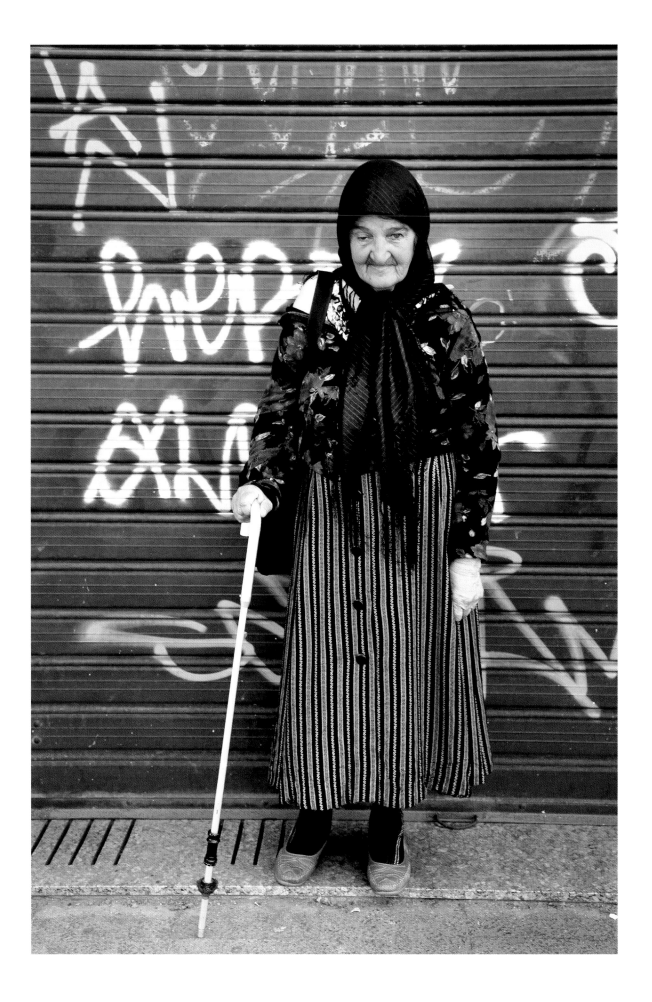

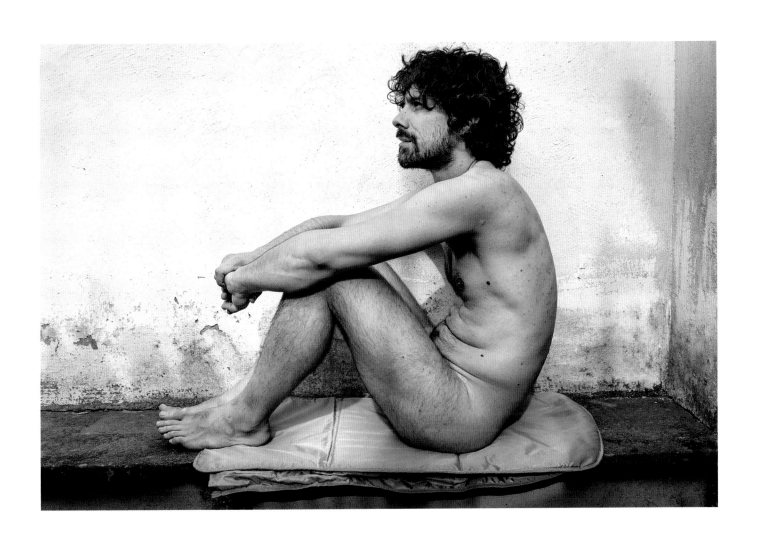

OPPOSITE: *On the Street, Trastevere, Rome, 2014* ABOVE: *Giovanni, Largo Argentina, Rome, 2014*

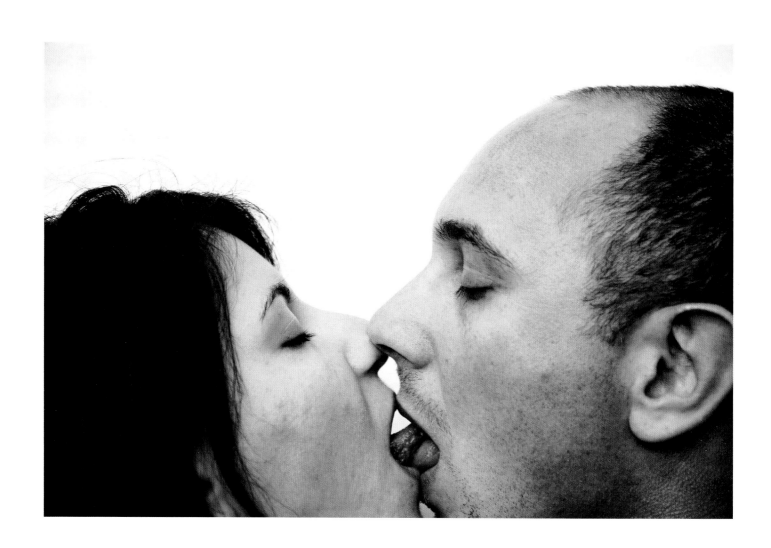

Couple in Love, Rome, 2014

Beggar near Campo de' Fiore, Rome, 2014

Of course, I met a ton of Americans, British, and even Romanians. Several countries have academies in Rome and I ate appetizers and drank cheap red wine at a lot of them. I even gave a talk at the British School and had photos in a show at the Romanian Academy. I met Cornelia Lauf, an independent curator writer, dealer, and teacher. Cornelia has terrific instincts and intellect, not to mention endless patience. She used to be married to conceptual artist Joseph Kosuth, who apparently gave her cause to hone her interpersonal skills. Anyway, I was having espresso and a croissant with her one morning in Campo de' Fiori.

"I have to drop off some cookies at Emilio Prini's. Want to come?"

"Sure, who's Emilio's Prini?"

"Last surviving member of the Arte Povera movement. Think conceptual art. 1960s. He probably won't see us anyway. I'll just drop the cookies."

So, I tagged along and amazingly he did see us. Prini was hobbled by health problems, which kept him in a wheelchair. He had a voice box from cancer surgery, which made speaking difficult. But not impossible. He managed to ramble on for an hour or so. In Italian, of course. Then, he took his cookies and we took our leave.

"Amazing. He agreed to let you photograph him."

"Did I ask to photograph him?"

"You don't understand. He never lets anyone take his picture. He must like you. He doesn't like anyone."

Which is how I got to photograph the great Emilio Prini. A week later I went to his apartment, loaded down with equipment. But when I got there, he insisted I take one picture. One exposure. That was it. I wish I had read his Wikipedia entry before I agreed to do it.

"His concerns with the complexities of reality and perception left him to leave much of his works undocumented so that the art is experienced in the instant it is created not in the reminiscence of stale objects."

No stale objects here. Personally, I prefer art experience now *and* later. I like the picture I got well enough, but I'm sure I would have done better by him if he let me do my thing. Nice man, though.

ABOVE: Emilio Prini at home, Rome. One exposure only.

OPPOSITE: *Franco, Rome,* 2014

MOVING PICTURES (1998 ONWARD)

Today's cameras are hybrids, making both still and moving pictures. This has led to a host of conversions. Photographers are now cinematographers—or even directors. Or so they think.

When I said I wanted to make a movie, my good friend and top editor Bill Anderson tried to talk sense into me.

"How many still photographers have made a successful move to film or video?"

"Stanley Kubrick."

"And ?"

No need to rub it in, Bill. But my ambitions were a few notches lower. I mean I was no Irving Penn, so why should I expect to be Stanley Kubrick? I just wanted to do something a little different and have some fun doing it. And like many photographers, I harbored a secret desire to make movies. In the early '80s I even went to Los Angeles to take an industry exam to become a third assistant director. I failed it.

I had another reason that I usually kept to myself. I still liked to shoot still photographs, but I had completed any number of still projects that will probably never see the light. Most will sit in boxes or on hard drives, never becoming a book or exhibition or anything, really.

So why produce more still projects? Especially now that digital technology had handed me a gift—a relatively easy and cheap way to make movies. I didn't even have to pass an exam!

Of course, that didn't mean that any movie I made was going to be good, but I was enjoying myself and getting the feel of it, I think. And most important, I had a lot of help. My skeptical friend Bill ultimately humored me by working with me—shooting some, editing all, strategizing, handholding. I also got some terrific help from cinematographers Hillary Spera, Lee Daniel, Andrew Frieband, Jon Gourlay, and others. Not to mention sound people and sounding boards.

RIGHT: *Page Six* heard about my film about Murray Hill. And spelled my name wrong!

It takes a village to make a film, and this is where Bill's original question was spot on. Still photographers are more like lone wolves, while moving-picture people move in packs. Learning to work together with the right blend of talent is critical and a tough nut to crack. I'm trying to learn how.

Fortunately, there are some things I learned as a still photographer that cross over. The importance of subject, for instance. The right subject can hide a lot of flaws in execution. This was key in *Preacher*, the first film from Bill and me. The subject was Preacher Jack Coughlin, a local piano player who had a ton of talent but even more substance abuse (see still photo of Jack on page 194). It's a rough effort, but it does give a pretty good picture of a charming, troubled character from a soon-to-be bygone era.

The second film with Bill and Hillary Spera was *Murray*, about Murray Hill, the drag-king MC, comic, and toast of modern burlesque. It's about twenty minutes long and meant to mirror the style of photography in my book *Show*. Black and white. Noir. It's pretty good. At least Murray thought so, too. And then he didn't. Something like that. It's not clear why he stopped participating, but he did and now I show it only occasionally in rogue venues, hoping that eventually he will change his mind. But even if he doesn't, the film will eventually serve as a history of sorts of the early days of modern burlesque. And history is my game, after all.

The next film was actually completed. Beautifully edited by Bill, it's called *Spoke* and celebrates the Broken Spoke in Austin, one of the last of the true Texas dance halls. I got a grant from the Annenberg Space for Photography to make it, and it was screened at several

ABOVE: Poster for *Spoke*. Design by Ernesto Aparicio

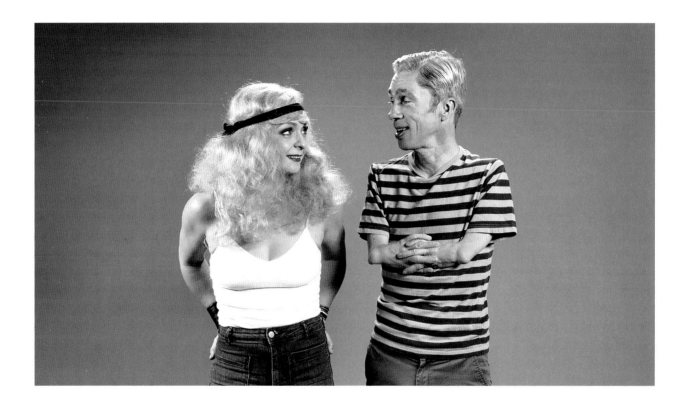

film festivals. But it has had limited distribution because I have limited music rights. If I want to stream it or sell it or do just about anything else with it, I have to pony up almost as much money as it cost to make it. I told you I was just learning.

Partners is a film I'm working on as I write this. It's a celebration of making your own choices in relationships. It's simply shot, interviews against a plain, seamless backdrop. The subjects speak to each other and the camera. A couple who married after he went to prison. Friends not involved romantically who married to raise a child. A man whose only relationships in the past thirty years have been with his cats, Valentine and Stanley (also not involved romantically). A couple in an open relationship. A couple in an arranged marriage. And so forth and so on.

Stay tuned.

ABOVE: Still from *Partners,* with Julie Atlas Muz and Matt Frazier

OPPOSITE: *Walking the Dog, Philadelphia,* 2013

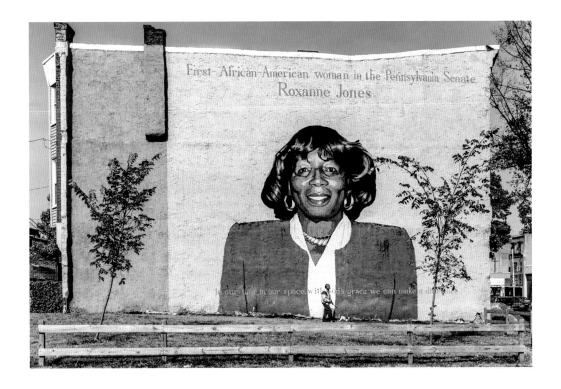

First African-American woman in the Pennsylvania Senate
Roxanne Jones

In our time in our space with God's grace we can make a difference

ACKNOWLEDGMENTS

I've shown an early manuscript of this book to several friends, all of whom have asked the same question.

"How do you remember all of this? Especially when you quote people. Do you keep a diary?"

The answer is simple. I don't remember. Not exactly. I remember the sense of what was going on, sure, and roughly the conversation. But exactly? Forget about it. And for the people I quoted, please forgive mild misquoting.

Sounds lame from a former historian, I know. Maybe that's really why I got kicked out of school—and out of history. And I'm not kidding. One of the reasons I was okay with leaving is I was sick of the pedantry of academia. I wanted the feel of things, more than the facts *per se*. And such things are open to interpretation even more than facts are. So best to consider this text my sense of what happened. Not the pure, boring facts, necessarily. But not a fiction.

Many thanks to all who worked on this book and those who helped in a variety of ways. These include Ernesto Aparicio, Alli Defeo, Bob Fierro, Allen Frame, Amanda Fratrik, Tyler Healey, Paige Kooyenga, Greer Muldowney, Kathryn Riley, and Christiane Robinson. And a few others, I'm sure.

Special thanks to Mark Doyle and his trusty sidekick Danold Ampagoomian who made the awesome scans, corrected the files, and did so much more to get this book ready for press via Monacelli production guru Michael Vagnetti, who took a complicated project and made it look easy—and great.

Especially great working with my former student from RISD, Jenny Beal Davis, now an ace book designer and creative director at Monacelli Studio and elsewhere. She is endlessly professional but warm, sympathetic yet independent. And hugely talented. In short, everything a good designer should be.

And, of course, my endlessly patient and forgiving editor Victoria Craven, who dreamed up this book and pursued it with a perfect mix of sensitivity and vigor.

INDEX